LAUTREC

LAUTREC

NORMAN ZOLLINGER

DUTTON NEW YORK

DUTTON

Published by the Penguin Group
Penguin Books USA Inc., 375 Hudson Street,
New York, New York, U.S.A. 10014
Penguin Books Ltd, 27 Wrights Lane,
London W8 5TZ, England
Penguin Books Australia Ltd, Ringwood,
Victoria, Australia
Penguin Books Canada, 2801 John Street,
Markham, Ontario, Canada L3R 1B4
Penguin Books (N.Z.) Ltd., 182–190 Wairau Road,
Auckland 10, New Zealand

Penguin Books Ltd, Registered Offices:
Harmondsworth, Middlesex, England

First published by Dutton, an imprint of Penguin Books USA Inc.

First printing, June 1990
1 3 5 7 9 10 8 6 4 2

LIBRARY OF CONGRESS CATALOGING-IN-PUBLICATION DATA
Zollinger, Norman.
Lautrec / Norman Zollinger.—1st ed.
p. cm.
ISBN 0-525-24784-X
I. Title.
PS3576.045L38 1990
813'.54—dc20 89-25647
CIP

Printed in the United States of America
Set in Primer
Designed by Bernard Schleifer

Publisher's Note: This novel is a work of fiction. Names, characters, places, and incidents either are the product of the author's imagination or are used fictitiously, and any resemblance to actual persons, living or dead, events, or locales is entirely coincidental.

For Peter, Ann, and Robin
And with thanks to Jim and Charlotte Mary

"... all lawyers were children once."
—CHARLES LAMB

1

After he put the black girl's body in the back of the old pickup and covered her with the paint-spattered drop cloth, it didn't take half a minute to decide where he would bury her.

He checked his watch. At two in the morning the bosque— the tangled cottonwood bottomland on the banks of the river between the city and the truck farms two miles farther south— would be deserted. He knew the west-bank bosque as well as he knew the backyard of the house he had lived in all his twenty years. Every fall—until the old man died—he and *el abuelo,* his grandfather, had hunted there.

In her garage he found the long-handled shovel he'd guessed would be there and a pickax that might save him a lot of time when he dug the grave. When he had thrown them both in the pickup along with the broom from the front porch, he moved fast.

Twenty minutes later he crossed the bridge over the big river and bounced over a string of potholes on the far side. A car was following close behind him and he knew a bad moment. If the drop cloth had worked free, and with his broken tailgate hanging open, the driver of the other car couldn't have failed to see her.

The other car passed him when he turned on the blacktop that ran alongside the bosque; it was soon lost in the blackness down the road. He stopped the pickup, and breathed easier when he found the drop cloth still in place.

He hit another snag when he coaxed the pickup from the blacktop into the ruts leading to the riverbank clearing he remembered. A decayed cottonwood had keeled over, blocking the ruts a hundred feet this side of the clearing, its trunk too thick and heavy to be pulled aside. He wouldn't be able to drive in all the way. He switched the lights off and killed the engine. A full moon was rising above the woods. It would make it easier for him to see as he worked, but the pickup would be easier for others to spot, too.

At the back of the pickup, he took hold of the drop cloth. Her blood must have dried and made it stick, and as he pulled, it was as if he were ripping her flesh away.

He had laid her on her side and had tucked her legs up under her chest, but the bouncing had turned her on her back. Blood from the wounds between her breasts had soaked the drop cloth. He would have to burn it and his jeans and shirt and with them the nightgown and robe he had stripped from her after he put her in the truckbed.

He grasped her ankles, shuddered, and let go. He should have known how cold they would feel. The drop cloth was too threadbare to have kept the wind of the ten-mile drive from chilling her, even on a night as hot as this.

He took hold of her again and drew her toward him until her hips rested on the tailgate. Then he took her by the wrists and pulled her upright, bending low to let her arms fall across his shoulders. Was she stiffening already? Was it his imagination?

He had carried her from the house the way a groom lifts his bride across a threshold, with her head lolling like that of a doll with a broken neck. Now he hoisted her over his shoulder. He didn't want to see her face again, but he couldn't forget the hundred or more times when he lived only to see it.

He carried her to the clearing as if he had been there last just

the day before instead of seven years ago when he shot his only fox. There were no foxes in the bosque now. With the city bearing down on it and with the road behind him humming with traffic all day long, nothing but stray dogs lived in these woods any more. Even the owl *el abuelo* had tried to tell him once was *la llorona*, the wailing woman whom the valley old ones talked of in whispers, was gone now, too.

When he felt the ground get soft as he neared the riverbank, he put her down and went back to the truck for the pickax and the shovel.

It took an hour of digging before the hole was deep enough. The dirt was damp and loose, but the roots of the nearby cotton-woods stopped him several times. He was lucky to have found the pickax.

As he lowered her into the grave, something rustled in the nearby brush, and his breath stopped for a second.

He looked for stones big enough to keep whatever he had heard, or one of the castoff dogs that roamed the bosque, from uncov-ering the body. When he had more than a dozen stacked by the edge of the grave, he forced himself to look at her. Tonight was the first time he had ever seen her completely naked. When she had posed in life class a year ago, she had worn that string bikini bottom.

It had been easiest just to take her by the legs and drag her into the grave face up, but he would never be able to roll the stones in on top of her with her looking up at him. He turned her over. As he did her back buckled, and he had to put his hand in the small of it and press her down. The push turned her head, and with her hands above it and its cornrow braids and with her palms flat to the earth, she looked in the moonlight like a figure in an Egyptian frieze, a woman dead four thousand years, not just a little longer than an hour.

When the last shovelful of earth had gone on top of the stones he got down on his knees and pulled dead branches and leaves over the grave. It appeared a little different from the rest of the bosque floor, but once the thundershowers sure to come in a day

or so had pelted it no one would be able to tell the bottomland had been disturbed. He picked up the pickax and the shovel and started for the truck.

It would be years before anyone found the body, if they ever did. The river itself would have to change its course, and here it had cut a deep, stable channel with high banks to hold it in. It wasn't likely it would move to the grave within his lifetime. Once he brought the broom from the pickup and brushed away his tracks, not even *el abuelo* could have found her.

In the morning, after he burned the clothing and the drop cloth, he would go to her house and take care of anything he might have missed. The knife he had dropped on the floor of the living room where she had died would have to be done away with, destroyed completely, not just hidden or thrown way.

Not one of her neighbors would notice she was gone. They might have, if she had rented in the city's black ghetto instead of in the old settled barrio, where they ignored even new Hispanics. They probably didn't even know her name. No one would look for her until the landlord, old Cisneros, came to collect the rent in August. After a few such visits, Cisneros would let himself in, and when he found the closets empty and no luggage anywhere and none of her few belongings in the house, he would go to the police and complain. The police would smile and remind him that tenants skipped all the time.

At the truck he pushed the shovel and the pickax under the bloody drop cloth and picked up the broom. Another ten minutes and he would be out of here.

He didn't get ten minutes.

As he started for the clearing again, a car swung into the ruts behind the pickup and flooded him with its headlights.

On top of the car a blinding blue light was flashing.

Orville Blakely, New Mexico State Penitentiary inmate no. 057683, had finally fired Jack Lautrec this morning.

"You're off my case, you gimpy old sonofabitch," he had said in the visitors room after Lautrec told him of the turndown of his last appeal. "I never did think you had the balls to defend me right, nohow. You sure done a piss-poor job." There had been the expected threats, too, but Lautrec had never paid much mind to what disgruntled, incarcerated clients said they were going to do to him when they got out. Well, it was good riddance—on both sides, probably. Good riddance, too, to Orville's scruffy, fat girlfriend, Betty Blount, whom the strong-arm robber had some-how acquired during the trial last September. Betty had already seen Orville once this morning, and as Lautrec left the visitors room he could see her pleading with a guard to get one more chance with him. Poor, pitiful Betty. If Orville were out on the streets, he wouldn't spit on her. Lautrec had seen hundreds of women like her in visits to the pen.

Lautrec's foggy brown mood didn't leave him all during the hour's drive south from Santa Fe to Albuquerque, nor as he turned off the freeway and rolled down San Mateo Boulevard into

the traffic-choked business heart of the Northeast Heights. If any man he had ever defended deserved a long stretch on what passed for a rock pile in modern penology, Orville Blakely did, but damn it, he was a client—or had been until an hour ago. It was no fun being fired, even by a senseless sociopath.

When Lautrec crossed Candelaria and turned into the parking lot of Sierra Office Plaza he got his first look at the new sign going in above the double doors set in the adobe brick wall of his suite of offices.

The sign company's van blocked the space he thought of as his, even if he had never had "reserved for Jack Lautrec" painted on the curb. He muttered "Hell's bells" into his beard, drove across the parking lot, and found a place in front of the psychiatrist's office. When the noise of the Imperial's engine died away, he heaved himself out of the car and propped himself on his two canes. He looked up toward lofty Sandia Crest. "Home again, safe and sound, Jane," he said. Even at eight miles' distance he could pick out the spot where her ashes lay in the rocky slope under the ponderosas.

He rested his 215 pounds on one cane and pushed the car door shut with the other. Pain shot through his knees before he got the rubber cane-tip back in the asphalt. He had pockmarked the door with scores of small round smudges from doing this since he bought the car four years ago. He flexed his legs to see if they would still bend, and started for the office in the engineered struggle that he always hoped no one he cared about was watching. The midafternoon sun had softened the asphalt enough to let the canes sink in a little, and the walk to his office was a sticky business.

A young man perched on a stepladder was putting the finishing touches on the new sign. Hell, it wasn't a real sign at all; just a string of skinny, modern-gothic, black metal letters lagged into the adobe: l a u t r e c & l a u t r e c — a t t o r n e y. The young man hadn't yet tacked the s on *attorneys*. From where he stood the legend looked no more consequential than the name of the chiropractor on one side of his suite of offices nor that of

the credit union on the other. The old sign had been a three-inch-thick, six-foot-long plank of solid, varnished mountain oak and had read JACQUES H. LAUTREC — ATTORNEY-AT-LAW, in big, uncompromising gilt letters. The new one looked like a computer printout. Jack hoped Marty Lautrec was satisfied.

By the time he reached the door the young man on the ladder, a Hispanic wearing a University of New Mexico Lobos T-shirt, had tacked on the final *s* and was climbing down. He nodded to Jack and jumped to hold the door. Jack mumbled, *"Gracias."* He had stopped brushing aside that kind of help two years ago, but it still rankled a little that he looked as if he needed it.

The door hadn't closed behind him when Fran, the receptionist, said, "Marty wants to see you, Jack." There was a strained note in Fran's soft voice. Something must be up in the office, or else he looked more intimidating to her than he assumed he ordinarily did.

He checked himself in the full-length mirror just inside the door. Hunched over the canes and with his beard and graying hair needing a trim, he looked like a superannuated bison about to charge. Poor Fran had a perfect right to a little mild terror. He had better say something sweet to her before he left work today.

By now, though, after thirteen years with him, she should know the image in the mirror was a fraud. The pose was one he had cultivated for that rare jury which instinct told him would yield to bullying instead of sly, sweet reason. Sometimes he lapsed into it outside the courtroom when he wasn't careful. "Marty say why, Fran?"

"No, Jack. Must be important, though. Been out here checking the lot for your car three times since lunch." Fran wasn't looking at him. She knew what Marty wanted, but thumbscrews wouldn't have gotten a word from her that Marty didn't want given out. Since Marty passed the bar, Marty and she had become as close as coats of paint. "Shall I buzz?" Fran asked.

The buzz wasn't needed. Martine Lautrec broke from the hall leading to her office in a walk as brisk as that of any color-guard marine. Jack remembered how she had worked on that walk

when she was in the drama club at Albuquerque Academy, marching around the old house on Nob Hill every morning before school with a copy of Blackstone balanced on her head. Her hair had been buttercup yellow then. Now it was what he thought they called ash blond. Attractive young woman; lucky she got her looks from Jane. "You want me?" he said.

"You *bet* I do!" Marty said in a voice that sounded like the escape of steam.

Something *had* gone wrong today. When he left for the prison in the morning, she had been all tenderness with him, smiling that slanted little smile he loved. It was the way she always was when he finished something as ugly as this Orville Blakely business. Expecting the same Marty this afternoon, he hadn't realized how much he needed her to *be* the same. She sure didn't look tender and smiling at the moment, but perhaps in the long run that was better. "Well?" he growled. The growl hit exactly the note he had hoped it would. It wouldn't betray how much he had wanted his feelings massaged for a maudlin second there.

"Not out here!" Marty nodded toward Fran. Ridiculous. There were no secrets worth keeping here at Lautrec & Lautrec—Attorneys, and none at all between the trim, blue-eyed Lautrec in front of him and the quiet woman at the desk with her nose deep in a newly typed brief he noticed now was upside down. Marty turned and marched into her office. She was ticked with him about something, all right. He waited a full, slow count of ten before he followed.

Marty's office was too smart and modern for Lautrec's settled taste, and a hell of a sight more neat than that village dump of his. He stumped to the front of the clean desk she had already circled, his feet and cane-tips thudding on the cork floor. His knees hurt even more than they had in the parking lot. Until he got back to the apartment and got them into the Jacuzzi they would give him seventeen kinds of fits. The easy chair reserved for Marty's clients looked temptingly, luxuriously, and almost indecently comfortable. The hell with it. *She* was standing—*he* would stand. If he collapsed, as every nerve was demanding he

collapse, she would stay on him sixteen hours a day until he saw Steve Gregg, his doctor.

"All right . . . daughter! Let's have it." The "daughter" got to her, all right, as it always did, but he could tell from the set of her jaw it wouldn't stop her today. Her eyes caught his and held them. Feisty girl. It still pleased him, even when the feistiness was turned on him.

"How do you do it?" she said. The voice that could often be lilting song came now like the sound of a rasp.

"What the hell are you talking about?"

"I don't know how these cases always find *you.*" She shook her head. Along with the irritation her voice betrayed, there was real wonder in it. He must have misread things. He would have bet a year's fees she would never bring up Orville Blakely on her own again. She wasn't looking at him now; she had picked up a pencil from a holder on her desk and was tapping it against her lower teeth, the way she did when she was thinking hard and it wasn't working out, or when she was about to unload something on him. "Hey!" she said next. "Maybe these cases *don't* find you. Maybe you find *them.* This isn't the first time I've suspected you of actually soliciting clients. If I ever get *proof* you're doing that, I'll blow the whistle. Father or not, I'll head straight for the bar association!"

"Come on now, Marty, the man is probably going to spend the rest of his life up at Santa Fe, all of it in max, plenty in solitary if my guess is right about how he'll comport himself. The very least I could do is—"

"Good Lord!" she broke in. "I'm not talking about Orville Blakely. He's ancient history."

"Then will you kindly tell me what this huffing and puffing is all about?"

She sank into the chair behind her. "The Esquibels are here to see you. They've been here since one o'clock. I tried to get them to come back tomorrow, but they insisted on waiting for you. I put them in your office with a stack of magazines."

She seemed suddenly weary, and just as suddenly, he didn't

enjoy the advantage he knew it probably gave him. Maybe he
had better rattle her cage a little, let loose one of those fine, put-
on rages he enjoyed teasing her with. "Damn it . . . daughter!
You know how I hate having anyone in my office when I'm not
there."

"What?" she said, blinking. "For openers, I don't know any
such a damned thing! Besides, Rudy and I had clients, clients
who pay the feed bill here. Mrs. Esquibel breaks into tears if
anybody so much as looks at her, and it was giving Fran the
willies. There was no place to put them *but* your office!"

"Forget it," he said. "Now tell me just one thing more. Who
the hell are the Esquibels?"

For all her near fury of a moment earlier, the question seemed
to knock the props from under her. Her mouth was wide open.
Funny. He had somehow scored without even knowing how. "By
God," she said. "You really don't know, do you? Hey, I *am* sorry,
Dad." She drew a breath. "Luis Esquibel's parents, Orlando and
Graciela."

"And who," he said, "is *Luis* Esquibel?" Then it came to him.
"Wait a minute . . . wait just a darned old minute. Luis Esquibel?
Is that the kid the city cops busted in the bosque Saturday night
or Sunday morning—or whenever this morning's *Journal* said it
happened? The one who was trying to plant that black Jane Doe?"
Marty nodded. He leaned across her desk. "And," he said, "the
Esquibels want me to defend him, don't they?" She nodded again.
Lautrec didn't see the second nod. He didn't see his daughter
wince as she watched his face, and he didn't hear what she said
when she spoke again. "Dad . . . *Please don't take this case!*" All
he really heard was the sudden roaring in his ears, the actually
audible, rushing sound of blood pumping through his head. He
could feel a smile beginning, the first smile of a long, unsmiling
day.

"They've got an absolutely airtight case, Dad. Luis Esquibel
murdered that black girl," Marty was going on, "and beyond any
reasonable doubt."

He lifted one cane from the floor and stabbed its rubber tip

squarely into the center of her desk. "Hold it, counselor!" he said. "Hold it right there. You just said this Luis Esquibel *murdered* someone. Are you privy to a fact or two that wasn't in the *Journal*? All anyone knows at the moment is that one Luis Esquibel, Caucasian, twenty, was picked up the other night on what amounts to some kind of police suspicion. No one has said they saw this young Esquibel *murder* anyone or even kill them . . . and there is a difference. After the cops picked him up, they found *someone* had buried a young black woman near the river. Now, I will admit that with all those knife wounds the *Journal* described, it scarcely looks like the woman was a suicide, but it still fails to constitute *murder* yet in my understanding of the law."

"Dad . . . it's open and shut. According to the cops *and* the *Journal*, Esquibel was practically caught in the—"

"Hold it. Hold it!" He couldn't help himself. His voice had risen to a courtroom level. "No client of mine gets convicted off the blotter . . . or by the headlines!"

"Please, Dad. I beg you. Don't take this case."

Fran's typewriter was going full blast in the outer office. From the dentist's across the alley he could hear the syrupy sound of Muzak. At least when he and Marty were shouting at each other, he didn't have to listen to it. But right now she wasn't shouting. Strange. She should have been fighting him tooth and nail, at least raising hell about the mark his cane had left in the middle of her spotless desk, but she looked . . . God save him . . . *subdued*. Except at Jane's funeral he couldn't remember her this way. He lowered his voice when he spoke again. "I don't recall hearing myself say I was going to take this case, Marty. But I do owe it to the what's their name? the Esquibels, to hear them out, don't I?"

"You said 'no client of *mine*,' remember?"

"I guess I did." He tried to smile. "Slip of the tongue."

Who was the idiot who said a watched kettle never boils? The ash-blond kettle he was watching now boiled over in a second. *"Slip of the tongue, my foot!"*

"Marty," he said, "everyone accused of a crime is—"

"—entitled to the best possible defense!" she finished it for him. "I know, I *know!* I've heard that old stuff as much as I ever want to! First from you and then all through law school from professors who never spent a day out in the real world. Fine, but just where the hell is it written that world-class muggers like Orville Blakely, and now stupid young killers like Luis Esquibel, are always entitled to Jack Lautrec?"

That was a little better, but she still seemed to lack the lust for combat she usually displayed. Perhaps if he took another tack. "What did you have them do with my old sign?"

She didn't even look up at him now. "Thought you might want it as a souvenir. It's in your office." That reminded him there were *people* in his office, people who wanted him to defend again, to *defend,* praise be! The itch to see them became unbearable. "I'd better talk with the Esquibels," he said.

She started to say something, but it seemed her breath was gone. She sagged into her chair. Well, maybe she would rally by the time they saw each other later. She would give him then all the shots he could ever want—more, in all likelihood.

3

"Are the Esquibels still with him?" Marty asked when Fran entered her office half an hour later for the coffee break they shared every day Marty was not in court. Fran nodded and set the two mugs on the desk that Jack said looked like the flight deck of the *Forrestal*. "Has he called you in about the retainer, Fran, or to take notes or anything?"

"Haven't heard a peep out of him, and of course he told me to hold his calls."

"Then maybe—just *maybe*—there's a chance he won't take this case." Marty told herself she wasn't being unrealistic, that the hope she heard in her voice was justified. It generally took Jack Lautrec only ten or fifteen minutes to say yes, even to the most unsavory clients. It took longer for him to turn people down. He always heard them out. Time was on her side, wasn't it? She checked her watch, and then realized she had begun to tap her teeth with her pencil. She tossed the pencil on the desk. It rolled across it and dropped at Fran's feet and Fran bent from her chair and picked it up.

"Marty," she said, "what's wrong here? I've seen you upset about your father's taking a client before, but never to this extent,

nor in quite this way. Why are you almost"—she stopped, then went on—"*afraid*, it seems, of Jack's taking this one?"

Marty felt the red creeping into her face. Fran Crowley sure could cut right to the heart of things. Afraid? There were other things, but yes, whe *was* afraid. "I've just got this feeling," she said. "I guess you could call it . . . oh, for Pete's sake! . . . *intuition*." That was a cop-out. Sooner or later she would have to level with Fran. But—did *sooner* mean right this second? No.

Marty turned to the console behind her, turned back with the Monday-morning *Albuquerque Journal*. "Have you read this? This case has everything bad about the cases he's handled in the last five years rolled into one. Dad needs a win, and he won't get one here any more than he did with Orville. You'll see. This will turn out to be a classic premeditated murder one. It's not manslaughter when you're discovered burying the corpse of a good-looking woman in the bosque at three in the morning. The fact that she was black won't help this killer a bit. A jury can salve its conscience about any bigotry it harbors about *Hispanics* by standing up for the rights of another minority victim. Ben Scanlon's no fool. He'll work that angle to the hilt. He'll go for the death penalty. Feeling the way Dad does about capital punishment, if the Esquibel kid is sentenced to death, it might be too much for him. Remember Harry Schmidt? Nothing likable about Harry. He beat his wife to pulp with a tire iron, but when the state gassed him, Dad didn't come out of it for a month." It was all true, darn it. Perhaps it was enough to keep Fran off the track.

"And there *is* something likable about Luis Esquibel?" Fran said.

"There sure is. He's the sweetest-looking youngster you've ever seen. He looks as young and innocent as Tony Roybal. Remember Tony the rapist? Dad despises rapists even more than he does murderers, but by the time Tony went up the interstate for twenty years, Dad was treating him like the son he never had. Luis Esquibel will charm the socks off Dad."

"Jack might just plead him guilty and end it quickly, Marty."

"Plead him guilty? Fat chance! He wouldn't plead Bluebeard guilty."

Fran was searching her face. "Maybe you ought to stay out of this."

"Damn it, Fran! Dad's not as young as he was. This thing with Orville Blakely has taken a lot out of him. I don't want it to happen again. Orville was as close to his being personally defeated as I've ever seen him come."

"Jack isn't too old, Marty. Except for his knees he's every bit as good as the day I started here. What is he? Fifty-eight?"

"Fifty-nine. That has nothing to do with it. Haven't you seen him suffer with these low-lifes he defends?"

"He would suffer more if he didn't try to help them."

They looked at each other for a full minute before Marty, hearing the plea for help in her own voice, said, "And you honestly think I should stay out of it?"

Fran leaned toward her. "Yes," she said. She sat back again. "Unless . . ."

"Unless what?" Good old Fran. She was going to come across with a line Marty could use to turn her compulsive father away from what could seriously damage him—and more than merely embarrass *her*.

"Unless," Fran said, "you could to stand shoulder-to-shoulder with him this one time, Marty."

"Help him?"

"Yes."

"Oh my God!"

"From the way you describe young Esquibel, he might be worth defending." Fran had picked up the newspaper and was looking at the page of photos of the scene of what the *Journal* was already calling the Bosque Murder, despite the fact that the police seemed to think it had taken place somewhere else.

Suddenly she looked up at Marty. Her eyebrows had lifted the way they did when she was curious. "Marty, how do you know that this kid the cops have is such a sweet-looking youngster?

There isn't a picture that shows his face anywhere here. Did you see him in the TV coverage this noon?"

Marty shook her head. There went that cop-out about intuition, right down the tube. "Sooner" had arrived in a hurry. She took as tight a hold on herself as she could get. "I *know* Luis Esquibel, Fran," she said. "I've known him since he was twelve years old." She had tried to keep it light, but she knew she had failed. She knew, too, what Fran's next question was going to be.

"How did you get to know him, Marty?"

Yes. In for a dime, in for a dollar. Fran had long ago earned the right to any secret Marty had. She would have to tell her now about her connection, remote as it was, with Luis Esquibel. And Fran's memory would tell her all the rest. "He's Ana's kid brother, Fran. You remember Ana."

It was Fran Crowley's turn to say "Oh my God!"

They sat in silence for a moment.

"There's still that outside chance Dad won't take this case, Fran," Marty said at last, hearing the slight desperation in her voice. "After all, he still has that thug Orville and his gross groupie Betty to worry about. Dad really doesn't like to handle more than one criminal matter at a time. Didn't think I'd see the day when I could generate any enthusiasm for Orville Blakely, but—"

"Marty," Fran said. "Just before he went in to meet the Esquibels, Jack asked me to close Orville's file. Apparently Orville dismissed him when they met this morning." She was at the point of saying something more when Jack Lautrec appeared in the doorway.

"Nobody minding the front of the store?" He was all smiles. "Don't rush your coffee, Fran, but I'll need some help starting a file for the Esquibels."

When he finished with the Esquibels, and Fran—an awfully sober Fran, he noticed, even under the circumstances—had ushered them out, Jack leaned back in the ancient swivel chair he had rescued from Marty's interior decorators the year before, when they tried replacing it with some Danish Modern torture device. He laced his thick fingers together behind his neck and stared across the room. The old sign, JACQUES H. LAUTREC — ATTORNEY-AT-LAW, leaned against the far wall alongside the relief map of New Mexico and obscured part of his photo gallery of old political friends—and not a few foes.

Three different painters had regilded the letters on the sign through the years of Jack's practice, and he could still pick out where one of them had used plastic wood to patch the holes old Abe Hackett had put in it with his .38 back when the office was on Central Avenue. Jack had taken Abe to court on a South Valley land claim brought by Antonio and Yolanda Lopez. The court had found in favor of Jack's elderly clients and Abe came calling with his revolver. When Jack investigated the gunfire erupting outside his office he found the retired rancher blasting holes in his name. Abe lowered the .38 from the sign and took aim at

Jack's head. Jack charged Abe on legs that were still good then, sat on his chest and wrested the gun from him. Abe had screamed obscenities at him. It wasn't the last time someone had accused Jack of "going against your own kind!" Jack hadn't called the cops.

The next year the old sign had been draped with red, white, and blue bunting when Jack ran for the D.A.'s office and the second Eisenhower landslide buried him and all the other Democrats in New Mexico.

The Lopezes and Abe were dead now; so was Clifton Thomas, the man who had been only fifty-seven votes ahead of Jack when the final results came in. By God, Jack Lautrec wasn't dead. He had never felt any more alive than he did this moment. He felt *good!*

His sense of well-being hadn't been brought on by anything said in his meeting with the Esquibels. The session hadn't exactly been productive. They knew absolutely nothing, and neither could even guess why their son had been found in the bosque two nights before with the body of an unknown black girl. They weren't hiding anything; they honestly seemed as much in ignorance as Jack was.

"Who was the girl?" he had asked.

"We do not know," Graciela said. Orlando shook his head.

"What has Luis told you?"

"*Nada*," Orlando said. "They have not let us see him yet."

"You will get them to set my *niño* free, will you not, Mr. Lautrec?" the woman said. "Luis could never do the thing the police said he did." She was as distraught as Marty had pictured her, but Jack could deal with her. Tears, trembling, the wringing of her delicate hands: they were good signs, not bad ones; normal signs. Strength hid in that fragile body and in the fine-boned Spanish face. Somehow, if Jack helped a little, she would hold together.

Her husband was a different matter. Orlando was clearly still half in shock, but he sure was making an attempt to look tough and macho. Why did some men feel they always had to act as if

they were completely in command all the time? It only made them more useless when they fell apart. If Luis's case went as Jack imagined it would go, he would need his father at his strongest and most loving to see him through the trial, the sentencing Jack would plead for, and the years he would probably have to spend rotting in the pen where Jack had left Orville Blakely. To judge by the picture of Luis Esquibel his mother had left with Jack, the boy would need one hell of a lot of love and strength, from both his parents. No matter what he had done, he couldn't possibly be as tough as Orville. Jack couldn't say any of that, of course. For the moment the Esquibels seemed shakily confident that he—or maybe any attorney—would get Luis free of the charge the cops had made. It wouldn't upset the natural order of things to let them hope for a while.

No, he hadn't gotten a thing from either of them he could use, not even a clue as to the best way to approach his client. Still, he felt good because he had someone to defend again.

Fran's voice came over the intercom. "Jack, the metro edition of the *Tribune* just got here. Another front page full of Luis Esquibel. Want it?"

"I sure do, Fran. Thanks."

Before he could blink Fran was placing the evening newspaper on his desk. "Fran," he said as he reached for the paper, "I'd like you to call the dockets clerk and find out if a day has been set for the preliminary hearing."

"It's after five, Jack."

"My, my!" He grinned at her. "Time sure flies when you're having fun. First thing tomorrow then, okay?" He pointed to the *Tribune*. "What's your gut feeling, Fran?"

Fran hesitated, then said, "I think they've got your client dead to rights. It's going to be a tough one." That didn't comfort him. Fran had always been a clear thinker about his defenses. Amend that. She was a clear thinker on almost everything.

"Am I in trouble with my daughter, Fran?"

She shook her head, perhaps a shade too quickly, as if she had anticipated him. "Read the *Tribune*'s story, Jack." She turned

around and was gone. That was brusque for Frances Crowley. He would have speculated on it, but the paper, now that she had mentioned it again, was suddenly clamoring for his attention.

The *Journal*'s account in the morning paper had been straight-forward and factual, but without anything he could sink his teeth in. Even before reading the *Trib*'s version he knew he would find more meat; Sally Bentley's byline appeared under a two-column head announcing Luis's arrest. Jack had had run-ins with Sally from time to time, but he sure admired her. She had the nose of a hypersensitive beagle for the underside of the news, faced the most grisly situations on her beat without fear or aversion, and wrote her stories in a lean, tough style. Sally had somehow gotten past Captain Phil Gilman of the Albuquerque Police Department, the officer in charge of the investigation, a senior lawman who didn't trust the press, and had interviewed the two young cops who discovered Luis in the bosque.

The patrolmen had been closing out their regular Saturday-Sunday graveyard shift, counting themselves lucky that there hadn't been even one domestic squabble on their watch. On a routine check of the river road at three-ten A.M., their black-and-white had already pulled past some ruts leading into the bosque when Jim Blake in the passenger's seat realized he had caught something like a reflection from inside the woods. His partner Tibo Espinosa stopped the patrol car, backed it up, and swung into some weed-choked ruts, where the headlights flooded an old pickup . . . and at the back of it this young Hispanic, holding a broom. It wasn't in itself criminal behavior, but it sure aroused their suspicions, the officers told Sally.

A check of the bed of the pickup yielded a shovel and a pickax, both with clumps of damp earth clinging to them, and an eight-foot square of fabric blotched with dry paint and stiff with what the two young cops knew at once was blood, a lot of it. Jack frowned, reading this. There went any chance of making a legal fuss about unlawful search and seizure. They hadn't even had to open a trunk or ask permission to look. He knew Espinosa and thought he remembered Blake.

From that point Sally's story turned graphic, bringing the scene in the bottomland starkly to life—or rather death. Espinosa and Blake had discovered the trail their suspect had intended brushing away with the broom; it led them straight to the grave. Sally zeroed in on how it must have felt for Blake—smart enough to do the digging with a shovel fetched from the patrol car rather than the one he had a pro's sure feeling would turn out to be evidence—when some dark springiness under the blade alerted his instincts that he was up against flesh. In far less time than it had probably taken to bury her, the black girl's naked body lay exposed to the moonlight. Yes, Sally had used the word *naked* instead of the more decorous *nude* of George Jones in the morning *Journal*. It somehow augmented the obscene violence of the "murder" they booked Luis Esquibel for an hour and a quarter later. Smart officers. Not much likelihood of their having slipped up on the Miranda warning, either.

Sally's story settled one little thing for Jack. There was no need for Fran to find out for him the bond young Esquibel was under; Sam Perry, the metropolitan court judge hauled out of bed to answer the call from APD, had ordered the boy held without bail, perhaps out of pique, perhaps because the police had persuaded him that Jack's new client was truly dangerous.

One rather extraordinary other thing fairly leaped from the pages of the newspaper. By the time the metro edition of the *Tribune* had gone to bed, the police had learned no more from Luis Esquibel than Jack Lautrec had learned from his parents. Sally apparently had discovered absolutely nothing she could attribute to Luis, and you could bet that if the cops had gotten anything from the kid, she would have tumbled to it. Interesting. Maybe it was a sign that the youngster had a few more brains than Jack's clients usually possessed, although one of the arresting pair had confided in Sally that the young man they had cuffed and brought in for booking had refused their offer of that one traditional phone call. That wasn't too ricky-ticky smart.

And Sally, with that bit of news—or non-news—had solved another minor problem. Jack hated going to the Bernalillo County

Detention Center at any time, but he particularly loathed going there at night. Whether imagined or real, the smell of male rot up on Three West, where Luis was in all likelihood being held, was even more repelling when darkness fell.

Jack's first inclination had been to rush right down and see his new client, but now he decided that Luis—as long as he didn't seem to be talking—could wait till morning. Jack breathed easier. He could head straight from his apartment to APD head-quarters after breakfast, read the report and see what Phil Gilman thought he had, something he couldn't do at this late hour. The Sunday daylight search of the bosque, according to Sally, hadn't turned up the murder weapon, and neither Sally nor the police seemed to have a clue at the moment as to the girl's identity or what Luis's motive for killing her had been. But that was this afternoon. What would they know by tomorrow morning? Jack intended to know everything the cops knew by the time he reached his client.

5

"I sure don't know why you need this, Mr. Lautrec," Ron Chavez said as he applied the rubber stamp to the back of Jack's big hand. "You've got more time in the D center than any of the dudes up on Three West. Does anybody even check you with the light up there?"

"Haven't for twenty years, Ron. Not since long before they tore down the old tomb and built this new one." Ron was a conscientious young officer, with nothing of the smart aleck about him of so many other guards in the Bernalillo County Detention Center. He'd been on the job three years, and Jack's name still came out "Mr. Lautrec." Jack couldn't pretend it didn't please him. A whole lot of young people in and out of the penal system could take a lesson.

"Who is it today, Mr. Lautrec?" Ron said.

"Esquibel, Luis Esquibel." A shadow crossed Ron's face like the beginning of a beard this young man wouldn't ever be caught on duty with. "Has he been trouble, Ron?"

"Well . . . not in the ordinary way, sir."

"In *what* way then?"

"You know how new dudes are, Mr. Lautrec. How they keep

to themselves at first . . . like they're afraid they'll catch something, and I don't mean AIDS, although I guess that's up there, too. According to Lieutenant Gantry and the staff up on Three West, Esquibel has kind of carried it to extremes."

"Doesn't mix much, huh?"

"No, sir. He's a regular hermit. Lieutenant Gantry says he hasn't said a single, solitary word in the three days we've had him. The lieutenant thinks he's nutty as a fruitcake." Chavez snapped his mouth shut and blushed. Jack could read his mind. Ron should never have said that to a defendant's lawyer; the D.A. would have his heart for lunch if he found out about it.

"Relax, Ron," Jack said, "I didn't hear that." For all the reassurance in his voice, Jack filed Ron's slip of the tongue away. You never knew when a loony plea was the only route through a murder case. If he should have to take that route, he didn't want to wait until the trial was nearly over to decide his client was crazy, as he had in Orville's case. He would try to get Gantry's remark on the record out of the chief guard's own mouth without quoting Ron, but he knew that in the end he would throw Ron to the wolves in the D.A.'s office if he had to. It would grieve him, but he would do it. Jack Lautrec's client came first . . . always.

He rode the elevator to the third floor, not the one visitors used, but the steel-clad one that transported prisoners, and as its cables slapped and whined, he gazed at the back of his hand, where Ron had pressed the rubber stamp with its invisible permit for the upper floors. It wasn't the only unseen mark the D center left on you. He could smell Three West even before the elevator stopped and its doors opened. It was still an insult to his senses after all these years.

Gus Gantry looked up from his desk in the small office across from the elevator and tossed Jack a salute halfway between a brushoff and a genuine gesture of recognition. "Hi, Jack, you old bastard," Gantry said. He didn't like Jack, and while not reportably insolent, he let it show.

Jack played the game. He didn't speak, but he pointed one of

his canes at Gantry like a pistol, curled his index finger, and pulled an imaginary trigger.

"Who do you see today?" Gantry asked. He had grinned at the mimed gunplay. Not everything about the grin was pleasant.

"Esquibel."

Gantry looked doubtful. "I ain't seen no paperwork yet," he said.

"I'm not surprised. Just got him as a client late yesterday afternoon. This is only preliminary. I won't take him away from you until after the bail hearing, or at the latest when the D.A. makes his try for an indictment."

"Well now, Jack," Gantry said, "I don't know if I could . . ."

Jack felt a rush of anger he was too old a hand to let the chief guard see. Technically, Gantry couldn't keep him from his client even if court orders *weren't* on his desk, but Jack knew Gus could stall him for hours, waste the day, and he could see the man was tempted. He had shut Jack away once before, five or six years ago. Jack had raised such a howl with the presiding judge the bars of the D center had hummed like the slats of a vibraphone. Neither he nor Gantry had mentioned the incident since, but it still loomed between them.

Gantry put the tips of his fingers together and let his heavy black brows knit themselves into one beetling hedge. He *was* going to make Jack wait for a few moments anyway before he passed him through. It was childish, but how much more childish would Jack be if he made a fuss? He resigned himself to patience, but part of him spoiled for the fight this surly sonofabitch could so easily push him to.

"Okay," Gantry said at last. "Go ahead. But don't give me no shit about beating this rap, either at the bond hearing . . . or the goddamned trial. This punk will be mine until they send him up the interstate in the van. Ain't a bondsman in town who'll go the bail they'll ask for this dude." Jack turned and walked down the corridor to the barred gate opening on the rec room.

Gus had seemed a shade more hostile than usual today, and Jack could guess the reason. From what Ron had said Jack could

be sure that Luis hadn't given the snitches in the D center a single thing they could use to pry favors out of Gantry, or that Gus in turn could pass along to Ben Scanlon's people in the D.A.'s office. Espionage against D center prisoners was seldom admitted to, but it went on all the time.

The guard at the end of the corridor had the gate to the rec room open for Jack and he clumped through with a nod to the man, a black man he didn't recognize. The guard had to be new up here.

Once through the gate Jack stopped, planted his two canes in front of him, and braced himself. They would be on him half a second after they noticed him: six, eight, a dozen of the figures in the blue D center jumpsuits he saw playing Ping-Pong, watching television, haggling with each other in that peculiar jailhouse commerce that went on here all the time; the trading for cigarettes and candy, for "futures" in crack or some other dope (if it wasn't out there already), or for sexual favors. They would invade Jack's personal space with the cocky certainty of impunity they always showed, the repeat offenders, anyway. Odds were good that one or more of them would be men he had defended once, or who had figured in his trials as witnesses or accessories.

A big, black-haired man, Hispanic by the look of him, grinned at Jack and yelled, "Hey man! You wan' see *me*?" That was all it took to bring on ten of them, pushing and shoving each other into a tight circle around him.

"I got no lawyer, man. How 'bout you take my case?" "Take a letter out for me, mister? Fi' bucks?" "Gimme a smoke, pal? These creeps are tightwads." "Can you tell the D.A. about the crooked screws in here? They been shaking me down for a week."

They didn't touch him. They reserved touch for each other— or themselves—but a palpable wall of pressure had built up between them and Jack. At times like these he was almost thankful for his canes. With his weight on them, they kept his hands from shaking as they had back in the early days. Funny that a man who had gone through the heavy combat of a war, and who had faced killers in the streets, should feel this way. He wasn't in any

physical danger here and his reason told him so. It must be fear of contagion, the dread that he might "catch something," as Ron Chavez put it. The immunity against becoming part and parcel with this carrion weakened in a hurry on Three West. There was no vaccine, even for the innocent. "Cool it, dudes," he said, "I only handle one client at a time . . . and I already have one." Curiosity took the place of the mob's understandable eagerness to escape boredom. Their eyes became as alert and bright as those of wild creatures caught by firelight, and as worrying. He had never gotten used to this, either.

But he couldn't rush. The only way he was going to get clear of this unwelcome welcoming committee was to let them have their fill of him, let their curiosity subside back into apathy.

"What's the weather like outside, Mac?" The questioner was a gangling young blond who looked like a farmer, and who could have seen the weather for himself if he looked out any of the windows.

"Hot and sunny. A hundred plus . . . more coming," Jack said. "Good for the bean crop." More questions spattered Jack as the circle lost one more jumpsuited segment and then another, and finally the question he had waited for was asked by someone he couldn't even see.

"Who you here to see, Dad?"

He had to answer. He would have been happier searching Luis out for himself, recognizing him from the picture his mother left behind, but everything that happened on Three West had to be a shared experience. If Jack didn't share this one now, life might turn nasty for Luis after he left, "regular hermit" or not. "Esquibel," he said, "Luis Esquibel." There was dead silence.

Not good. One or more of the men in front of him should have shouted, "Hey, Esquibel! Your lawyer's here," with the words then picked up in relays and sent winging through the rec room, the mess hall, the corridors and meeting rooms. No one set the cry in motion. Suddenly Jack knew that when he found his client he would have all the privacy he could have asked for, and more perhaps than he wanted. It wasn't normal.

None of the men remaining in the broken circle pointed, but their eyes were telling him where he could find Luis Esquibel, and Jack's eyes followed where theirs led, straight to a slim young man standing by a window, his back to the rec room and its occupants.

Luis Esquibel's hands were clamped to the sill of the window and Jack had the horrible instant certainty that only the security grille kept him from smashing the glass and jumping.

Jack hurried toward him as fast as the bad legs would carry him.

Luis Esquibel turned and faced him. Nothing in the high school graduation picture Graciela had shown him prepared Jack for what he saw. The boy was beautiful . . . angelic. There were no other words for him. Large, moist, black eyes were set wide apart and deep in a face of flawless shape and coloring. The eyes had pain glowing in them, but banked like a nighttime fire. "I'm your attorney, Luis," Jack said when he found his voice. "Your mother and father have retained me to handle your . . ." The black eyes flared with terror.

"I didn't ask for an attorney," Luis Esquibel said. His voice was low enough, but it threatened to soar on the winds of hysteria. "I don't want one!"

Jack watched Luis Esquibel's dark eyes until the panic seemed gone before he spoke. "You say you don't want a lawyer?"

"No, sir." The boy turned away. Even though Luis had certainly calmed himself since their first exchange, Jack felt again that the youngster would hurl himself through the window if he could. It looked like another of the many different guises remorse could take. Jack had pretty much seen them all.

"Going to throw yourself on the mercy of the court, are you?" Jack said. "Let me tell you the court sometimes needs a little professional instruction in the art of mercy." Luis shrugged, but as if the shrug had drained him of all vitality.

Well, it might take a few more minutes to get his attention. Jack fished an envelope from the inside pocket of his jacket. "Have you seen this, Luis? It's the police report." The boy shrugged again.

He read Luis the important details in the report Captain Phil Gilman had let him abstract when he stopped at Albuquerque Police Department headquarters on his way to the detention center. When Jack asked Luis to verify the facts as the cops had them, he did it readily enough, but only with nods, no words.

There were no answers at all to Jack's questions on things that didn't appear in the report, not even a flicker in those deep eyes, when Jack asked, "Who was she, Luis?" and later, "Were you sleeping with her? Was she cheating on you? Was it just a robbery that somehow got out of hand? Did you do it for a thrill?" and near the end, "Why *did* you kill her, Luis?" Surely one of the questions should have brought a response. None did. Jack nearly exploded. "Look, son. We're not playing games. You're in as much trouble as a man can get into. *I'm your attorney!* The cops don't get a word of what you tell me." To that point Luis had not yet given his consent for Jack to represent him, but Jack, pressing hard for something, anything, he could get his teeth into, had forgotten.

Luis set him straight. "I told you I don't *want* a lawyer." Unlike the voices of Orlando and Graciela, Luis's betrayed only the faintest trace of a middle Rio Grande accent.

There certainly hadn't been enough in the boy's infuriating silence for Jack to assess his intelligence properly, but he somehow got the solid feeling that he was negotiating with a formidable intellect, something above and beyond mere quickness. Looking into the large black eyes, Jack felt he could drown in them.

The shrugs had, of course, irritated Jack. He knew then how a doctor must feel when a patient lacks the will to live, not only lacks it, but creates something defiantly triumphant out of that very lack. Next came Jack's sudden realization of how *tough* Luis Esquibel must be, despite his look of sweet, pliant beauty. (It still made the lawyer uneasy to be thinking of any male past the age of twelve as beautiful, but in this case he couldn't help himself.) This notion wasn't due to hunch or guesswork alone. There was solid evidence of Luis's toughness, or rather there was a *missing* piece of evidence that by its absence constituted proof of the boy's rawhide fiber in a frighteningly conclusive way.

Luis Esquibel, Jack remembered from his talk with Gilman (and from the notes he had made on the report), hadn't signed a statement for the cops. When first asked about it, the police

captain had been evasive, and had only admitted there wasn't one when Jack insisted on seeing it. It was no oversight on the part of Gilman or his men. Luis had to have refused several times, and in the face of awesome psychological—and probably physical—pressure. Some of the police (Jack knew from sickening experience) were every bit as recklessly violent as the criminals they dealt with. It must have driven Phil's goons right up the wall not to get the confession they wanted from Luis, or at least something like the boy's seal on what they *said* had been done, and what they *said* they found, in the moonlit bosque on Sunday morning. Bloody-handed and damned near "caught in the act" as they might have found him, they would still want every last detail of the killing in writing, and Jack knew they would get blowtorch heat from Ben Scanlon if they couldn't produce that statement. He would have chuckled at the predicament of the police and prosecution . . . except that in a way it was even worse for him, particularly if the cops had (with or without Gilman's approval) worked Luis over.

If the highly developed art of police persuasion as practiced in the APD interrogation rooms couldn't get Luis to talk, how on earth were the gentler, albeit slicker, methods of Jack Lautrec going to succeed? On the plus side, Luis's silence *was* a straw to grasp at. With the danger of Luis making dangerous admissions to the police now largely past, and with Jack fairly sure the boy wouldn't easily spill his guts to some snitch here in D, Jack could pursue this a little further. Even the merest mention of police brutality swayed some juries . . . and more than a few sensitive judges. "How did the arresting officers and the ones who questioned you at headquarters treat you, Luis?" By this time, forty-five minutes into the interview, Jack might have expected the reply, another infuriating shrug. "Did they beat you up or abuse you in any way?"

"I don't want to talk about it."

Jack blew. "I don't give a good goddamn whether you want to or not! Tell me. I'm your law—"

"No, you're not, sir." Luis turned away from him. There wasn't

going to be one word about what Jack guessed had happened at
the questioning, and Jack knew it. "Sir"? What was that crap he
had given himself about how nice it was to meet courteous
younger people?

Yes, Luis was tough. Jack supposed it took a certain amount
of toughness to stick a knife in someone, even a girl.

Jack spent the last half-hour trying, with no more success than
before, to pry loose the one fact that might give him the only
head start he could reasonably hope for at this juncture: the
identity of the black Jane Doe. As far as he knew, the police had
turned up nothing on her yet, or hadn't when he talked to Gilman,
who had tried to conceal his embarrassment that they hadn't
made the victim. Gilman, a prototypical old-fashioned cop whom
Jack had dealt with before, and who looked as much gunfighter
as peace officer, wasn't frequently as nonplussed as he had been
today. Bad omen in a way. He might just make something per-
sonal out of this. Gilman had let slip that they had photographed
the corpse. They were probably showing the pictures, the head
shots anyway, up and down South Broadway and all over the rest
of the black district. Even as Jack sat here with Luis, feeling
himself a ham-handed dolt at the way he was striking out, some
South Broadway storekeeper or motel clerk or pimp was telling
Les McMasters or Morris Carnes (sure, they would have sent
black detectives; the ghetto residents wouldn't come across for
an Anglo or an Hispanic even for triple the usual informer's bread)
who the murdered girl had been. That could flush out motive,
opportunity . . . everything.

At best the defense of Luis Esquibel promised to be a rear-
guard delaying action. It was some consolation to find this one
weak link in the prosecution's strangling chain of evidence, but
Jack would need many more to save the boy from the gas chamber
or the needle.

But, hell, wasn't this all academic? He was putting his own
personal ego cart way before this dangerously foolish young
horse. The boy didn't want him, and that was that. It was over.

He made one last feeble try. "You're absolutely sure you won't let me represent you, Luis?" My God, was he pleading?

"I'm sure," Luis said.

Jack moved away from him a few feet. He managed to make it to the bench of one of the mess tables only half a breath before the bad knees gave way. The boy's firm no had been quieter and more respectfully uttered than had been the seething, contemptuous words of Orville Blakely, but the wound it left was just as raw and would fester just as much. "All right, Luis. Maybe it's just me you don't want. Get somebody, though. This is a meat grinder you're in, and you've got to have adequate counsel. My feelings won't be hurt if you think another lawyer can serve you better." That last was pure fabrication. He felt as if he had been disinherited.

Then his eyes searched the room. It took no special sense to know that he and Luis were under close scrutiny by the other inmates. The big Hispanic who had accosted him earlier was talking with some of the other cons, and casting glances from time to time at the slim figure by the window. Sure, Jack was jumping to conclusions, but the man's interest in Luis seemed all too obvious. Sadly, Jack decided that warning the boy would do little good.

He sighed and stood up, reluctant to leave, but painfully aware that he must.

"Good-bye, Luis," he said. "Sorry we couldn't work together."

Then he noticed that the new guard, showing a sense of decorum almost laughable up here on Three West, was waiting ten feet away. Jack motioned him forward, leaned toward him and read the name J. J. BROOKS on his nameplate. "Yes, Brooks?" he said. The man looked a decent sort, but at the moment a little apprehensive at having just come through the tossing sea of blue jumpsuits between the barred gate and the windows. When the newness wore off, he would probably stop coming out here at all, and like Gantry's veterans, send messages into this zoo via one of the animals. "Excuse me, sir," Brooks said. "Esquibel has

other visitors downstairs . . . his folks . . . and his brother-in-law."

The words dropped into Luis Esquibel's lake calm like a depth charge. *"No!"* It was almost a scream.

Poor Brooks looked as if it were he who had come to call and had been rebuffed. Luis was quivering, and the smooth muscles Jack had noted in his slender neck were suddenly knotted, almost ugly. Then something like the ripple-free calm returned.

Jack started toward the gate.

"Mr. Lautrec!"

Jack turned back.

"Could you keep everyone away from me, Mr. Lautrec?" Luis asked. *"Everyone?* For today at least?"

"Sure," Jack said, knowing with instant certainty that by "everyone" Luis meant the people waiting in Ron Chavez's lobby. This was interesting, but he had better test the waters, not plunge right in and have the flame of hope doused as instantly. "Everyone, that is, except the gumshoes from the D.A.'s office."

"They wouldn't matter," Luis said.

"And I might even be able to limit *their* access to you." Luis thought that over. Indecision wrinkled his forehead and made it a shade less placid. Jack leaped to take advantage of it. "Will you let me represent you, then?" That's when the nod came. It was the only real result of the meeting, and Jack decided not to press for more for a while. Let Luis have another day. Perhaps he would finally grasp the enormity of his situation, and invite his lawyer into his confidence. He shook hands with Luis. It wasn't exactly what Jack would call a hearty grip, but strong enough under the circumstances, and clearly not the boy's usual response to the touch of another human.

"Brooks," Jack said. "Please tell Ron Chavez there will be no visitors for Mr. Esquibel . . . on advice of counsel."

As he rode the elevator down to the lobby Jack shook his head. Why did he feel so guilty over just doing his job? He couldn't rid himself of the notion that he had forced himself on Luis. Well, damn it; if he had, why not? That kid up on Three West was

going to need an attorney, and a good one, too. There had been a time when not many people in the city would have denied that in young Jack Lautrec he had the best. Maybe *old* Jack Lautrec still had enough left to do Luis a little good.

As he left the elevator, he saw Ron Chavez talking to the Esquibels, apparently breaking it to them with as much gentleness as he could that Luis had refused to see them. As tearful as Graciela had been in Jack's office yesterday, and as traumatized as Orlando had appeared, they had both been easy and relaxed compared to the way they looked today. The bewilderment, and then the agony, brought on by the unwelcome news Ron was giving them had aged them ten years in as many seconds. Jack would have to face those looks, too, when the Esquibels were told of his part in their being denied this meeting with their son. He wouldn't face them now. He had work to do.

Fortunately for Jack, the Esquibels were sitting on a bench in the hallway to the washrooms, and just as fortunately, Ron had his back to Jack and the elevator, and wouldn't see him. If he put on all the speed his legs could make, he could be out into the heat of Roma Avenue—heat he was ready to welcome after the chill of D—before the Esquibels saw him, or before they saw him in time to intercept him.

Then he saw the tall man in his mid-thirties standing beside the bench the Esquibels were sitting on in their state of near collapse.

Hector Velasquez y Mendoza! Hector must be the brother-in-law the black guard Brooks said was waiting with the Esquibels.

Jack skittered across the pockmarked concrete floor of the detention center lobby as fast as two suspect legs and two clattering canes could take him. No one called him.

Behind the wheel of the Imperial, his first impulse was to start the engine and make a getaway; but prudence made him decide to stay parked until his hands stopped shaking. If the Esquibels and Hector Velasquez came out of the lobby entrance before he felt up to driving, he could scrunch down out of sight, demeaning and undignified as such a move would be.

He didn't have to. When Velasquez and Luis's parents emerged, they made a sharp right turn without looking in his direction and walked to where a dusty red '82 Pinto was parked, a dozen cars ahead of Jack's. He knew they wouldn't have noticed him, anyway, not after he saw the looks of anguished self-concern on all three faces. He had seen mourners at a funeral show more elan.

The Pinto must belong to Heck Velasquez. At least it was Velasquez who stepped to the door on the driver's side, after helping Graciela and Orlando squeeze into the backseat of the little car. Jack didn't draw a full, free breath until the Pinto found an opening in the Tijeras traffic and pulled away.

Hector Velasquez! Luis's brother-in-law? How on earth had George Jones and the *Journal* missed on that? . . . Or the *Tribune*'s Sally Bentley. He could understand easygoing George dropping the ball on something this juicy, but Sally?

That Hector Velasquez y Mendoza was the brother-in-law of an accused murderer would surely make for the biggest, blackest headlines in the election campaign just under way. It had been a slow race so far. With news like this it wouldn't be for long.

Jack had first met Heck Velasquez (who had dropped the fancy-sounding "y Mendoza" when he entered politics) at a Democratic fund-raiser during the winter, and had liked him from the start. The man exhibited none of the lofty cloistered extremism of most liberal PhD's, who flew their ideas like battle flags when they tossed their mortarboards into the political ring. The lean and tweedy Ivy League–ish professor of political science seemed a natural. Indeed, he had already rolled right over the incumbent in New Mexico's state senate race two years before. Jack remembered Heck's wife now, too . . . a stunner. A sloe-eyed Hispanic Nefertiti, she just had to be Luis Esquibel's sister. Although they looked like twins, she was probably older than Luis by a few years. Jack seemed to remember the mention of children.

Actually, Marty, who served as a precinct committee chairwoman in Heck's district, Los Griegos, knew the professor-politician and his wife a good deal better than Jack did. Marty's

liking for the man as person and candidate bordered on adoration. Jack remembered her cry of pleasure when Velasquez announced his bid for the new seat in the U.S. House of Representatives opened up by the state's redistricting after the last national census.

Rotten break for Heck. Aside from his natural familial anxiety about the fix Luis had gotten himself into, the man must be sick about the effect a scandal such as this would have on his run for Congress. The pollsters had been predicting an easy victory for him over real estate tycoon Rayburn Henderson, a shrewd businessman from Jack's own Northeast Heights, but a political cretin who had nothing but his money going for him. It might not be so easy now. There could be no solace for Heck in the fact that the media and his opponent hadn't yet discovered his connection with the prisoner on Three West, not by the time this morning's *Journal* had gone to press, anyway. They soon would. *"Murder, though it have no tongue . . ."*

It wouldn't necessarily be an insurmountable obstacle, but it wasn't going to be any plus, not in a state where a good many old-settler Anglo prejudices still required anyone with a Latin surname to start from a considerable distance back of scratch. In all probability, it would be a lot better for Heck if the news were trumpeted into the campaign immediately. It wouldn't do if anyone suggested the candidate was hiding the relationship. To Heck's credit, with Jack at least, it hadn't looked as if he were ducking the issue, not when he had come to the D center with the Esquibels so openly.

It was too early for Jack to determine his own feelings about the connection between Velasquez and his client; the only thing to be thrown into the balance at this point was whether or not this coming revelation would hurt or help Luis, and he couldn't know that yet.

First things first. Jack had the gut feeling a number of possibilities might present themselves if he could only pin Luis's victim to *her* place in the scheme of things. Who was she? Why wouldn't Luis tell him? Did the young fool suppose that if the girl remained

unidentified it would be something like the cops not having a body to connect him with? Jack had known sillier suppositions among his clients.

How did Luis know her? *Were* they lovers? Probably, but badgering the boy about it wasn't likely to bear fruit. Badgering him about anything was likely to be a total failure. He had learned that much on Three West if he had learned nothing else.

But . . . if Jack turned her on his own?

7

At the morgue Jack stared at the face of the girl on the slab until he knew he could pick her out of a thousand other women were she still alive. The day had shown him two of the most beautiful faces he had ever seen. It made him ill to think that one was dead, and the other . . .

"Want me to strip the sheet off the broad?" the white-coated morgue attendant asked him.

"No thanks," Jack said. "I've seen all I need to see."

"Pretty luscious stuff even after the doc cut her up some."

"Put her away!" This leering young bastard would never know how close he had just come to getting brained.

He was still seething when he reached the coroner's office and found the medical examiner who had done the post on the girl's body. The M.E. was a considerate guy named Harding Jack had worked with once before, not at all like some of the experts Jack had to deal with who felt they had to mystify a helpless layman with their professional jargon.

"We figure her for twenty-five, give or take a year," the M.E. said. "Measurements? Give me a second while I make a couple of interpolations and I'll let you have them in inches and pounds

instead of metrics. You'd rather have it that way, wouldn't you?" Jack nodded and the man pulled a plastic-coated chart toward the report he was reading from. "Five-eight and a half, one hundred sixteen pounds. Ummh, let's see. Yeah. Thirty-six, twenty-three, thirty-four. All her own teeth and in pretty good repair. She had some extensive—and expensive—orthodontic work as a young adult, not the usual teenage braces. If it was done in Albuquerque we could have made her by now. It was sophisticated work, heavy cosmetic stuff, and three of the four guys in town who could have done it have already said she wasn't their patient. The fourth is on vacation down in Mazatlán, so we'll have to wait on him, but we're not holding our breath. He's only been practicing here a year. We think this work was done longer ago than that." The M.E. read to himself for a bit, then went on. "No pathology of any significance other than the tiny chemistry disturbances that linger from childhood diseases. One thing. She had an accident or took a beating about two years ago. Badly crushed cheekbone that took a long time healing. She broke a tibia in her left leg when she was six or seven. Good recovery on that; no shrinkage or misalignment to speak of. Oh, she had an appendectomy at maybe twelve years of age.

"No evidence of drug use. Trace alcohol in the blood. She probably had a beer or a glass of wine an hour before death. Liver doesn't say she was a boozer. Hadn't eaten since late afternoon. Looked like a chicken salad sandwich."

"Cause of death?" Jack asked, feeling a little foolish. Well, hell. You never knew. He had one client who had tried to kill someone who was already dead from a heart attack.

"Thrust right under the sternum straight into the front left ventricle, angling about eight degrees upward, from a long thin blade, a kitchen butcher knife, maybe. Actually, there were four wounds but it was the first one that did the job. The last three were very close to the first. Took a steady hand. Time of death? Between nine thirty and ten thirty P.M., if the other times we were given—discovery of the body, time of transportation and so forth—were on the money." Harding stopped. He looked at Jack.

"Okay," Jack said. "Let's have the rest of it."

"All right," the M.E. said. "The so-called 'good stuff.' She wasn't a virgin, but while we can't be sure, it wouldn't appear she had intercourse for at least a day or so before death. No sign of semen, no tumescence or exacerbation of the vaginal tissues which might have told us something. Kind of rules out rape, at least rape in connection with her death. Rapists don't generally wear condoms, and since she used an IUD it's doubtful a regular sexual partner would have used one. Hey! Bad thinking there. With this AIDS business people use condoms for something besides birth control. But, anyway, no trace of estrogen medication so we guess she relied on the coil. Incidentally, that murderous little thing was going to cause her no end of trouble, and soon."

Tourists were milling around the Indian vendors selling turquoise and silver jewelry under the *portál* on the east side of Old Town Plaza as Jack walked up San Felipe to La Placita for dinner. The Zuni and other Pueblo craftwork still moved fairly well, but not at the clip of some years back. There had been a time in the early seventies when it seemed there were only two kinds of people living in Albuquerque: those who sold Indian jewelry and those who bought it.

The sun was slanting through the cottonwoods in the ancient plaza, lighting the white wooden gazebo at its center, throwing the front of two-hundred-fifty-year-old San Felipe de Neri with its twin bell towers into late-afternoon shadow.

He almost barged into a man and woman, huge people in bright shirts and matching hiking shorts, who were making a selection from the goods laid out on a blanket in front of a withered Indian lady. A little brown girl sitting beside the vendor woman was saying something in Tewa or one of the languages of the Pueblos of the upper Rio country, her light voice making a pleasant counterpoint to the soft Spanish of a young Hispanic selling tacos and burritos from a cart at curbside on the left of him. The big tourist woman straightened up, held gossamer-thin strands of silver *hishi* to the angled sunlight, and said *"Wunderbar"* to her even

bigger companion. The man had a Leica camera draped around a thick neck. The woman was your basic Brünnhilde: blond, broad of beam, and with eyes of pure Prussian blue.

Funny. Marty had never asked for any of her mother's good jewelry. Tucked away with Jane's things, gazed at fondly and no longer with the sharp pain of the first two years, was some *hishi* that could have come from the hands of this same artisan. Any and all of Jane's things were Marty's the moment she dropped a hint. Perhaps he should offer them. He shouldn't put it off as he had the partnership.

He moved around the German couple. The woman took her eyes from the necklace for a fraction of a second and glanced down at his canes. Did he see a flicker of sympathy in her pink face? He hoped not.

At the table in La Placita, when he had finished the last of his *chile rellenos,* he dug out the scrap of paper on which Orlando Esquibel had scribbled his home address when Jack, after leaving the morgue, had stopped by Orlando's grocery store on Fourth Street to make the date for this evening. It was a nice neighborhood store, well stocked, neat as a pin and clean as a hospital room, and with a delicatessen section Jack decided to visit again someday when all this was over.

The Esquibel home was on Mountain Road, just three blocks from where Jack sat. An easy walk, the way his legs had felt since Luis came into his life yesterday.

8

"May I have a look at Luis's room?" Jack said. "Or anyplace else in the house he used regularly. I particularly want to see the places the police spent time on."

The bedroom Graciela Esquibel led him to would have been luxurious only for a Trappist monk. It held less evidence of individuality than a room at Motel 6. There was a small desk with a study lamp, a bill from Exxon for $43.67 (current) and a check from W. T. & Jeanette Freelander, 2784 Charro Place NW, in the amount of $679.50 and made out to L. E. Services.

"Luis painted their house last week," Graciela said. She had begun weeping softly as they entered her son's room.

Some decent men's clothes hung in a closet: a suit and a sport coat, several pairs of slacks, and two ties. None of the clothes, not even the half dozen shirts hanging there (ironed as a labor of love by Graciela, Jack was sure) were the least bit garish. Luis Esquibel was a young man of sober tastes. Somehow he wasn't surprised.

With a tilt of his head that asked permission he opened the drawers in a handmade Spanish Colonial chest, thinking that daughter Marty would give the chance of a gigantic corporate

retainer to own it. Odd that Marty, so modern at the office, kept an apartment loaded with antiques. It was the other way around with him. His eyes found nothing more than the socks and underwear he knew by this time were all he was going to find. "Luis was a housepainter?" he asked. "Where did he keep his work clothes and tools and such?" He could have kicked himself for not thinking of it sooner.

"In the garage," Orlando said. "He changes out there when he comes home at night."

Whatever Jack hoped to find in the way of traces of his client's personality or character he didn't find there, either. The garage had a dirt floor with two deep ruts, the tracks of the pickup the police had impounded as evidence. Paint-splotched overalls, two suits of them, hung on a clothes tree in a corner. Partly filled cans of paint and a few unopened ones were stacked neatly in and under shelves, and brushes soaked in pans. Nothing. If he hadn't shaken hands with him earlier, Jack's client would be as abstract as his alleged victim. "I suppose," he said finally, "the police have seen everything I've seen."

"Yes," Orlando said. "They were here most of Sunday." Compared to this morning down at D, Orlando's look was assertive, almost arrogant.

"Did they take anything?"

"Luis's record book and work schedule."

Well, the APD packrats had to take *something*. Jack doubted if they had found anything useful in the book or schedule. He would have heard the detonations at headquarters this morning if they had.

He and Orlando started back toward the house, where Graciela, who hadn't gone with them to the garage, was waiting on the patio. She had been crying again.

Everything about the Esquibel home was middle-class and normal. The faded Reagan-Bush sticker he had seen on the bumper of a Buick Riviera when he pulled into the driveway seemed somehow in keeping with Orlando's by now completely evident machismo. To some local Hispanics Jimmy Carter's ac-

cent was never anything but Texan. That his son-in-law was a Democrat wouldn't have put Orlando off at all. He could vote happily for the Republicans on the national ticket without forgetting that here in the state things had to go the other way; a law of nature. Jack smiled. It would make straight-ticket partisan Marty vomit.

On the patio Jack turned to Orlando. "And you really don't know whether there was anything . . . going on . . . between Luis and this black girl?"

"Certainly not!" It was a cry of outrage. "*My* son and *una negra?* Never!"

What the hell did the man *think* Luis might have been up to with the victim? Did he suppose the two of them were wandering in the bosque at two A.M. on coincidental nature hikes and, chancing to meet, had struck up a conversation on riverbottom flora and fauna that ended with the stabbing to death of one of them?

It only took a few more questions for Jack to come to the conclusion that the Esquibels *didn't* know anything they didn't know they knew, not about the victim's identity, anyway. Luis never brought anyone answering the girl's description to the house. He had never spoken of her, or if he had the mention had gone unnoticed. They didn't even remember a strange name Jack could check, and they were as puzzled as Jack as to why the boy was being so secretive. Neither could think of a thing Luis might want to hide. Jack wasn't doing any better here than he had done in either of today's other visits, to the D center or the county morgue. But at least he could thank his stars that they hadn't made too much of his aiding Luis in not seeing them earlier today. He had felt uneasy as he dazzled them with lawyerly half-assurances, though.

"Mr. Lautrec," Graciela said then, "Luis didn't just paint houses, you know. He was an artist, a real artist." She said it in a strange, impassioned voice. It seemed to come from far more than just the understandable desire to elevate her son in his attorney's estimation; it was almost as if she sincerely believed that establishing Luis as an artist would somehow lift him from

commonness, somehow excuse him from anything the law said he had done.

Jack didn't need to kick himself this time. "He was an artist? Did he have a studio?"

"Yes, sir."

"Where? Here?"

"No. Not here, Mr. Lautrec. He uses the old cow barn at my cousin Ernesto's."

"Where is that?"

"Three houses down the street."

"Did the police see the studio?"

"No. They never asked."

"Can we go there now?"

"*Sí*. Yes."

The street Jack followed Orlando and Graciela down was shaded with old cottonwoods, and the evening sun seeping through the leaves was casting speckled shadows on the adobe homes they passed. It was like walking in some remote Iberian village. Hard to believe, when he looked at the rural calm of this stretch of Mountain Road, that Albuquerque was moving close to having half a million people in it. When he had been a boy a lot more of his city had looked like this. He harbored a few wistful regrets, but no great outrage, that his town had moved so resolutely toward the twenty-first century. He didn't view himself as quite that hidebound and resistant to change.

Orlando turned in through a gate in a chain-link fence half-hidden in shrubbery. "The barn is way at the back," he said.

The adobe shed Orlando called a barn wasn't locked. Canvases in various stages of completion were stacked on three sides of its lone room. When he took it all in Jack trembled with excitement. Here at long last (it seemed impossible that he had only had his client a single day) was Luis Esquibel . . . or *one* Luis Esquibel. That it might be the only Luis Esquibel he would ever get a grip on was beside the point.

Not entirely an ignoramus where art was concerned, Jack quickly became aware from the work he saw that Luis was pretty

good. On the walk down the street, perhaps swayed by the fact
that the boy painted houses for a living, Jack had prepared himself
for something like the proletarian-poster work of a bush-league
Diego Rivera. Luis's paintings were standard enough, represen-
tational, landscapes mostly, splashed with strong color, but with
nothing about them to set on edge the teeth of those who said
they "didn't understand" modern art, though in simple truth they
feared it. It didn't seem too farfetched to say that Luis stood in
the same relationship to oils and canvas as his brother-in-law did
to politics. His work sent messages but they were sensible signals,
not shouted threats.

What fascinated Jack most was that the old barn hadn't been
turned into just a studio. It was Luis's home away from home
and explained the spartan plainness of his room at the Esquibels.
Framed photographs decked the walls—relatives, Jack supposed;
children and adults, the latter much older than the boy in D,
family snapshots from another time. One was of Heck with Luis's
sister. He looked in vain for a picture of the girl now lying in the
morgue. Books littered every surface that didn't hold painting
gear. The lawyer was surprised at his client's catholic taste in
literature: Cervantes, Conrad, Dickens, the only moderns Saul
Bellow and John Cheever. No Gabriel Márquez or Fuentes or
Octavio Paz? Perhaps there were no activists in *la familia Es-
quibel.* There was a stack of books and art magazines on a low
table by a cot. Luis must have slept there with some frequency.
Jack wondered if the black girl had. The barn was far enough
from Orlando's cousin's house that the cousin might not have
known, but it would pay to ask.

Orlando and Graciela led him through Luis's paintings. "This
is Graciela's *padre*," Orlando said when they reached a portrait
of an old Hispanic with a face wrinkled like the dried chilis on
a *ristra.* "Luis and *el abuelo* were very close. He did this from
memory but it is old Santiago, all right."

One corner held a drafting table. Jack hadn't seen it when they
entered, hidden as it was by an enormous easel in the center of
the studio with a half-finished canvas of the fountain in the Civic

Plaza resting on it. "Luis thought for a while of becoming an architect," Orlando said.

The wide drawer beneath the flat top of the drafting table seemed the only enclosed space in the entire room. When Jack hobbled over and tried it he found it locked. "Let's open this, Orlando." Somehow, the idea of Luis Esquibel and locked drawers seemed wrong. The young man he had talked to in the morning relied on stouter locks than manufactured ones. With a snap the drawer finally yielded to Orlando's prying at it with the heavy metal ruler he had found on the workbench next to the drafting table. Jack reached up and pulled the cord on the fluorescent lamp that hung above the table. He slid the drawer open.

Jane Doe in charcoal looked up at him. It was a nude, torso and head. Jack marveled at the technique, a quantum leap above what he had looked at in the paintings. The highlights, even in this dull, often lifeless medium, made the black skin shine. He couldn't keep himself from touching it. His thick finger gently traced the line from her sternum, where the "long, thin blade" had entered, to her navel. It didn't smudge. The drawing must have been sprayed with fixative. It was meant to last.

Four more sketches, different poses, were stacked beneath the first. Three were of the entire figure. In only one, a study of her head, was her hair done up in the cornrow braids Jack had seen on the body on the slab. In all the others it was puffed out in a black-cloud Afro. Jack's throat tightened until he couldn't swallow. This was surely one of the most lyric female bodies he had ever seen—a woman a man killed *for*, not a woman he would murder. Except . . . except that he suddenly knew with a sinking feeling that, shown these sketches, the most senile, jaded, sexless jury he could ever get would know at once that the man who made them was passionately involved with the woman he had looked at while he worked . . . in love with her beyond redemption. And the woman who looked at the working artist? Her studied indifference in two of the drawings, her gaze of amused friendliness, nothing more, in the other three, completed the story. She hadn't loved him back.

Motive.

He heard Graciela gasp behind him, and he turned. It felt as if his eyes were being pulled from their sockets as they left the sketches. "Graciela . . . Orlando . . . ," he said. "Do you know her?"

"No, Mr. Lautrec," Graciela said. She crossed herself.

"Never saw her before in my life." Orlando's voice was hoarse. He must have been as taken aback as Jack was. Bigotry just went flying out the skylight, didn't it, friend Esquibel?

"With your permission," Jack said, "I'm going to take these drawings with me." He didn't look to see if they agreed; his eyes were back on the drawings he had spread across the table. "If the police ever ask about this studio . . . or these pictures . . . or anything," he said, "tell them. Tell them the truth. Hide nothing. Tell them I took them. But don't volunteer! Tell them only what they ask to know."

Jack considered what he had just done. In his time he had sliced a lot of corners off, but taking the drawings, while not an obstruction of justice or illegal in any way, could really rile Ben Scanlon if Jack didn't turn them over to the police, or at least tell them about them. He knew he wouldn't. Daughter Marty would scream her head off, and he couldn't rightly blame her. He couldn't worry about that now.

His last moments with the Esquibels were the horror he had known they would be. He knew his face must have told them the truth when they asked about Luis's chances and he let the statement limp out that they would all have to "wait and see." The only consolation, he knew, wasn't really one at all: they didn't beg him to talk Luis into seeing them, but that was probably due to the mortification they had already suffered by their son's rejection of them at D this morning.

He could hear Graciela's sobs as he left, could hear them until he went to sleep. And he could hear Orlando's parting words. *"Mi hijo! Luis y una negra.* Better if he had killed himself instead of her!"

9

When Jack, still in his old flannel bathrobe, went down to get the morning *Albuquerque Journal* from the stack in the entrance hall of his apartment building, the two-column headline hit his eyes like a banner.

BOSQUE MURDER SUSPECT

BROTHER-IN-LAW OF

CANDIDATE FOR CONGRESS

He would have read the story right there in the foyer, but old Adele Thompson whose third-floor apartment was straight above his was coming up the walk with her poodle. The poodle was yapping at him as if he were a break-in artist. Early as the day was, Adele was dressed as if for an afternoon garden party, her silver hair looking anything but slept-in. Jack hurried back through the inner door as fast as his legs could carry him. He went through the kitchenette, fixed his cup of instant, picked up the foil container holding the last wedge of Sara Lee coffee cake, and tucked the *Journal* under his arm. It burned like an electric

blanket with a faulty thermostat all the way out to the table on his balcony. He decided not to read it quite yet. His sympathy for Heck Velasquez's predicament needed no reinforcement.

He sipped his coffee and looked out over Albuquerque. The apartment stood a good four hundred feet above San Mateo and the office, nearly two miles away, and six hundred above the center of the city, two and a half miles farther into the valley. When he sold the old house on Nob Hill on the south and moved up here, he had been hard put to decide whether it was a view of the city he wanted or one of the Sandia Mountains soaring in back of him. In the end the memory of when the bad knees were sound had made his mind up. He didn't want to look at the mountains. When Jane was alive the two of them had hiked those high slopes behind him every summer Sunday morning when they weren't up at the cabin in the Arroyo Hondo north of Taos.

Besides, that unprepossessing-looking city that sprawled down there was his provider and his theater. Browning's vexed and vexatious Italian in "Up at a Villa—Down in the City" would have known exactly how he felt. He loved Albuquerque as another man might love an old flame, tenderly, not with the searing passion Luis Esquibel must have felt for the girl he killed.

Last night, to calm Orlando, Jack had wanted to suggest that the black girl might have been a prostitute, but it wouldn't have been anything close to the truth if he had; not that he could rule out entirely the possibility that the black girl *had* been a hooker. She could never have been only that to Luis.

From his balcony, Jack could look down the course of the Rio Grande—distant, but faintly visible even through the haze of early morning auto gunk—and follow it south to the dim green swatch of bosque where Luis had been found with the dead girl whose five charcoal likenesses were now propped on the couch in the living room Jack almost never used. Nearer, between him and the buildings of the downtown business district, the adobe and territorial-style lecture halls of the University of New Mexico were just catching the morning sun. Heck Velasquez, if he were teaching in the summer session, was probably parking that dusty

Pinto at Woodward Hall there right now, getting ready to meet an eight-o'clock class. If Jack remembered Marty's characterization of him correctly, a dozen stories like the one in the morning paper couldn't keep him from holding his scheduled classes.

Just north of the Civic Plaza whose fountain Luis had painted, indistinct under the smog stream which seemed a second, slightly elevated, river flowing over the deepest crease of the valley, was the detention center. There was no need to try to focus on it. He would see it close up too soon again as it was. He finished his coffee, reached for the paper, but decided once more he wouldn't read it for a bit.

On his way to a bath he stopped in front of the couch and looked at one of the three sketches, the one where the black girl wore the faint beginning of a Mona Lisa smile, but a smile revealing more disdain than La Gioconda's. It mocked him as it must, unconsciously at least, have mocked the artist. It mocked Jack nearly as much this morning as it had when he awakened in the night and stumbled from his bedroom to stare for fifteen minutes or more at the drawings, feeling, in those dark moments when his eyes followed every line of her face and figure, that she wasn't entirely unknown to him. He still had that feeling now, but without the troubling haunts of three A.M. Instincts he trusted told him this was one of those things you didn't dig for. If it were true that he indeed did know her from somewhere, the recollection would emerge when it was ready. Trying too hard now might push it deeper, perhaps make it irretrievable.

Aside from just being Luis's lawyer, he burned to know how the boy in D and the girl were linked. They both were (had been, in her case) uncommonly beautiful young people, but the thought of that innocent creature (innocent? funny thought) now in Gantry's custody being physically involved with this high-voltage female, whose sexuality even in the charcoals pulsed as if she were still alive, was nearly laughable. It would be like taking a beginning sailor from the tiller of a dinghy and putting him at the helm of a racing yawl in a heavy sea.

He pondered the pictures for five more minutes before he shook

himself from the trance he was settling into. He had better begin getting ready to see Luis Esquibel again. Armed with the memory of what the black girl looked like, more from the sketches than from his inspection of her in the morgue, he knew it would be time to take a hard line with the young man.

"I found your sketches of the girl, Luis."

Luis just looked at him. There was no surprise, no alarm.

"Come on, son. Don't you think you ought to level with me now? Who was she?" Again no answer, just that vacant look.

"Well, if you won't tell me, I would appreciate it if you wouldn't tell anyone else about the pictures." He sighed. The situation would have been comic if it hadn't been so dangerous. Jack realized then that he hadn't yet given his client "the lecture," a thing he usually did in the first five minutes with a client or a potential witness, where a lawyer, without actually coaching or putting words in his listener's mouth, subtly lets him or her know the things he *doesn't* want to know; no tearful confessions for instance, where a plea of not guilty is the right road to take. In Luis's case Jack was almost at the point that he was willing to take any road, no matter where it led, and hell's bells, he supposed he would in the end have no other choice than to plead him guilty.

Damned Three West! Today it seemed to smell even worse than usual. It was as if today's stench had been added to yesterday's . . . and to the stink of all the other yesterdays. Maybe it was only that, but something suddenly churned inside Jack Lautrec and spilled right out. "You young fool! Don't you know what you're up against? The gas chamber, that needle they're seriously considering in the general assembly, or . . . believe me, this could be even worse than either in your case . . . the absolute rest of your life doing hard time in max! You're young. That could make for a lot of thoroughly horrible years."

Not only was there no answer from the boy, there was no reaction, not a tremor. Jack wondered if Luis was totally without fear or just numb. If it were the latter he had better back off. He

had better back off, anyway. Some of the other prisoners drifting around the rec room were beginning to look at them. They might, until now and for whatever reasons, have granted Luis a wide berth, but this would be too entertaining for them to miss: a row between a dude and his lawyer, particularly when the lawyer was doing all the screaming. They would be on this boy like a blanket once Jack left.

"All right," Jack said, "let me lay it all out for you, Luis, as simply as I can. The grand jury will send down an indictment pretty shortly now. Within three weeks I expect. It could come faster. Then, too, the district attorney might file a criminal information and bypass the grand jury altogether. I wasn't at your first appearance in metro court, but I'll have to see you through this next one and the bond hearing I'll ask to go with it. We're going to have to enter a plea. Sure, it might have to be a guilty plea, but 'guilty' can wear different faces. We'll only plead guilty to something way less than murder in the first degree. The important thing is that you're going to have to trust me, give me something to feed the D.A. to make him doubt he could get a quick conviction on murder one. Our main object, before we even start thinking about your trial, is to keep the judge from setting a bail your folks can't meet if we decide to plead not guilty. Your father tells me he'll have to borrow on the house and get what he can from the bank on the grocery store."

Louis blanched. Was Jack getting through at last? "Tell him to forget about the bail," the boy said.

"*Forget about it?*" Jack bellowed, too upset now to care about other listeners. "Are you crazy? Do you like it in this dump? I want you out of here. It could be months before you come to trial. I hope it is. Gives us time. In the meantime, if we can't or don't make the judge's bond, you'd rot in here . . . or worse." Jack jerked his thumb over his shoulder in the direction of the Ping-Pong and pool players. "You think because you're a man you can't get raped, Luis? Maybe you think you could take that. Can you take AIDS?"

That bothered Luis a little. His pale, olive face turned a shade

paler. Just saying it had bothered Jack a lot. He bored in. "You
don't need to tell me the whole story. Not yet. I sure want it long
before trial date, though. But for Lord's sake, give me something
now that can make it look as if there were extenuating circum-
stances. I don't suppose we can deny that you killed her, but
maybe we can show the killing wasn't murder under the law.
Think! Was she blackmailing you? Did she threaten you, steal
from you? Talk, man, talk!"

Something, a look of satisfaction, of small triumph, maybe, had
come into Luis's face.

"Luis . . . ," Jack began again, "it all starts with her identity.
Who was she?"

Luis turned away and looked out the window. "Mr. Lautrec,"
he said without turning back, "I want you to let me plead guilty
and then get me off as lightly as you can." He might have been
telling a dentist to pull that aching tooth, that he couldn't be
bothered with spending the time and enduring the trouble needed
to save the thing.

"I *can't* get you off lightly, Luis," Jack said. He kept it soft this
time. "Unless we make a defense. Without something I can take
to the D.A. there isn't a lesser plea we can cop to."

Luis Esquibel kept on looking out the window.

10

Jack stared at the charcoal drawings now in front of his office bookcase, hoping they would tell him something they hadn't yet told him. Nothing. Even the momentary feeling of recognition that had come at breakfast (never mind the stronger one in the middle of the night) was gone. He *didn't* know the young black woman, had never seen her. It had been wishful thinking, something he couldn't sustain long enough to carry with him into an even more wishful interview with Luis.

Although it was still days, perhaps weeks away, a preliminary hearing in district court would be on him and his client before they knew it, and in this case the last thing he wanted was that speedy justice everyone yakked about, and did very little to bring about. He wouldn't sleep well until the arraignment had come and gone.

With this client he had another worry. If he did persuade him to plead not guilty to first degree murder as he had decided just five minutes ago—not *if*, Jack, *when*: there could be no *if*—would the boy stick to it? It would be devastating to have Luis struck by conscience in court and overrule his attorney. The press would

have a field day and it still wouldn't stop Ben Scanlon from going after the death penalty if he intended to. Perhaps Graciela could be of some help here, talk to Luis with him, if Luis would let Jack off the hook on his promise to keep the family away.

The phone rang and he punched the button that brought Fran up on the speaker. "Yeah, Fran?"

"Call for you Jack, on line three. Dr. Velasquez!" There was a flutter in her voice. Not surprising. From what he had heard, Heck had that effect on almost all the women he dealt with. He didn't feel any particular surprise that Heck should be calling him, either. According to Graciela, it was Heck who had recommended him to the Esquibels. He would have called the professor himself soon. Maybe—don't get excited, Jack, and expect too much—Luis might sometime have even told Heck about the dead girl.

"Lautrec," he said.

"Hello, Mr. Lautrec. This is Hector Velasquez, Luis's brother-in-law." Nice touch, introducing himself like that, as if he had to.

"It should be Jack and Heck, shouldn't it? We've met, Senator."

"That's right. The fund-raiser at the Hilton in February. Could you have lunch with me today, Jack?"

"Sure, Heck. Where and when? You name it."

There was a laugh with a touch of embarrassment. "Well . . . ," Velasquez said, "I've faced two classes full of inquisitive stares already this morning and I don't feel up to a public place right now. If it's all right with you, Jack, how about my office here in Ortega Hall? I'll send out for a bite and call the campus cops so you can park outside the door." Thoughtful, that.

"I understand, Heck," Jack said, "about avoiding the public." He looked at his watch. "I can be there in an hour."

As Velasquez said fine and good-bye and hung up, Marty entered the office. Her eyes went straight to the charcoal sketches. He still had the phone to his ear and Fran's voice cut through the buzzing to ask him if he wanted something.

"No, Fran . . . wait a second. Yeah. Hold my calls. I'm heading for lunch with Heck Velasquez and I don't have time to make a start on anything."

Marty's eyes flicked to him at the mention of Heck's name just as he had intended them to. It was a swift, curious glance but now those sharp eyes were back on the drawings and fixed there hard. "Where did you get these, Dad?" Her tone was all light innocence. "It's the dead girl, isn't it?" she said. Her voice was a mere rustle of feathers. It didn't fool him. She was getting set to crucify him.

"Found them in Luis Esquibel's studio," he said.

"Oh?"

"Place he keeps at his father's cousin's."

"They're good, awfully good." The pencil had been shoved behind her ear now. "Does Phil Gilman know about them? Or anyone in Ben Scanlon's office?"

"Beats me," Jack said. He could do the innocent bit, too. "I haven't told them. They could have found them as easily as I did . . . if they'd asked."

"But they didn't know *what* to ask, like my smart daddy, did they?"

"Guess not," Jack said. He shrugged so she wouldn't notice he was squirming a little. "I'm not about to try to teach them their business."

"Are you going to give them these pictures?"

"Nope."

She still hadn't looked at him. She took a step nearer the drawings and a pencil was at her teeth again. She was counting to ten with the taps before she let him have it and he picked up the count himself . . . eight . . . nine . . . ten! *"Dad!"*

By George, she was looking at him now. He didn't shrink from the look but he would have been just as happy had she turned back to the sketches.

"You've done some pretty stupid things in your time, Mr. Jack Smartass Lautrec," she said, *"but this takes the cake!"* She drew a breath after the outburst. He struggled to his feet during the

slight pause and pointed a cane at her. "Daughter!" he said, "I'd just love to stay here and fight this out with you but as I'm sure you heard I have a date for lunch . . . with one of your heroes." He brushed past her. "Close my office door when you leave, *please.*" He could still hear her sputtering and fuming as he went by Fran's desk. He winked at the secretary, who had clearly heard it all. What on earth was Fran looking so tragic for? He had meant it when he said he would love to stay here and fight this out, and Fran should know it. She'd seen the two of them through many another ruckus. He almost assured Fran that Marty could take all the whacks she wanted at him when he got back.

He didn't see that Marty had followed him into the lobby and that she watched him as he crossed the parking lot.

She sank into the couch facing Fran's desk.

"You saw the paper this morning, Marty?" Fran said. "Heck Velasquez doesn't need this kind of thing—nor does Ana."

"I don't need to be reminded of either one of the Velas-quezes! . . . Forgive me, Fran. I didn't mean to sound so sharp."

"Nothing to forgive." Fran looked thoughtful. "Jack doesn't know about you and Heck, does he?"

"No. At the time it was going on Mom was still alive. She knew. I guess I wasn't yet in the habit of sharing confidences with Dad. When I got the habit, Heck was already in the past."

"Did you tell him you asked Heck to call him?"

"No, and I cautioned Heck not to tell him, either."

"I heard some heated conversation when you were in his office, Marty. What's he got in there that put you in such a snit?"

"Come on in and see for yourself."

Marty led the way.

Fran Crowley looked at the drawings and gasped.

11

"Hope you don't mind a Big Mac and fries, Jack," Hector Velas-quez said as he motioned the lawyer into a chair beside his desk. He pushed the stacks of papers and spiral notebooks to one side. "Stuff I've got to read and grade," he said. The poor guy was stunting around, postponing getting down to cases as long as possible. Jack couldn't blame him.

"I could have gotten us a couple of enchiladas from the union," Heck said, "but I've had so much Mexican food at my rallies lately I couldn't stomach another pinto bean."

"Looks fine," Jack said. They ate the hamburgers in awkward silence. Heck looked fit and athletic, as he did in the TV campaign commercial where he was playing good tennis. He—or some shrewd adviser—must have figured he was well enough en-trenched with the blue-collar and ethnic minority voters to make a play now for the carriage trade. The rich liked their candidates to look rich, too, as if *they* owned stocks and bonds that needed protection.

On the drive to the campus from the office, Jack had noticed a dozen campaign posters he hadn't paid particular attention to

before. Charisma? Heck had it. Jack had reflected that Heck, Luis, and the dead girl were all splendid-looking creatures. It seemed it wasn't always an unmixed blessing. He could almost be grateful for his old leather purse of a face and the rat's-nest beard he suspected Marty still thought an affectation. It wasn't. Women had no knowledge of what a two-handed job shaving was and how tough it had gotten to stand there on those morning knees while he scraped his chin clean.

"All right, counselor," Heck said. "What do you want to know?"

Jack smiled. "You called *me*, Senator, remember? What have you got to tell *me*?" Careful, Jack. It almost sounded as if you had the man on the witness stand. Bad habit.

"Well, for openers," Velasquez said, "how is Luis? He won't see anyone. Can you get us in?"

"No, Heck. Sorry about that, but I have to abide by my client's wishes."

"I know that, Jack."

"He's fine, as far as I can tell. Physically." He would hate having to go on and admit failure to actually reach his client.

"Jack, I can't believe this boy could kill anyone," Heck said. It wasn't what he meant. It almost never was what anyone meant. He just didn't *want* to believe it. But he did believe it and it was ripping him apart. Jack wanted to tell him that we can all kill— and when we're honest with ourselves, we know it. Heck was going on: "Jack, I think I'd love that kid even if he weren't a relative. I actually vomited when Graciela and Orlando called me about his arrest." He still looked a little ill as he said it. "Something like this," he said, "is incomprehensible to me no matter what provocation Luis had . . . or thought he had. I've known him for seven years, since I started dating Ana, and I've never seen anything but gentleness. Not that he's a weakling, mind you."

"Ana is his sister?"

Velasquez nodded. "She's four years older than Luis." He smiled. "I can see the question in your face, Jack. She was seventeen when I married her. I was thirty-two and, yes, I did feel

like a cradle robber. There are times I still feel she's closer to her brother than to me. I swear if one of them is cut the other bleeds. She's bleeding now."

"You have children, don't you?"

"Two. Luis is godfather to them both. Little Luis is six; Elena, the baby, is half past two." The sheepishness, the sadness, still played in Heck's face, but were diminishing. Jack had questions he wanted to ask, but it seemed wiser to postpone them. Answers given to unasked questions might be worth more. As it had been with the Esquibels and the unearthing of Luis's studio and the pictures of the girl, Jack was after the things Heck might know but didn't know he knew. Let him talk. "You said he was fine physically, Jack. How is he holding up in other ways?"

"Wish I knew. He doesn't exactly confide in me. About the only thing I've gotten from him is that he wants me to plead him guilty. From a tactical point of view that would be disaster. I won't hide from you the fact that it may be disaster, anyway. He *seems* to understand what it will mean if we cave in, but then there are times I'm afraid he doesn't. I have to find something to change the charge from first-degree murder, but he hasn't given me a bit of help so far."

"He's told you who the girl was, hasn't he?"

"No."

"Jack," Heck said. "Can you talk him into seeing me? *Just me?*" The sheepishness was gone. Velasquez was once again the determined man of his public life. Still, there was worry showing in his face. Not surprising. This was big trouble for him, big trouble for any man.

"I'm not sure," Jack said. "Luis said no visitors at all and I gave my word. Let me see if I can get his confidence first."

Velasquez's face darkened with disappointment. "I want to help, Jack. He's got to see me, he's just got to."

"Give me a day or so," Jack said. "To tell the truth I'd *like* him to see you. Maybe you could persuade him to let it all hang out with me." This wasn't going at all the way Jack had thought it would. He had the feeling Heck was finding out more than he

was, and yet . . . "What do you want to see Luis about, Heck? Can I take a message for you? Ask him anything?"

"No, Jack." Velasquez was shaking his head. "I guess I just want to buck him up." Again that look of trouble . . . and the determination to do something about it. This man didn't duck.

"I'd like that," Jack said. "I'll pass along your concern for him." They were going around in circles. Jack figured he might as well forget waiting for whatever tidbits of information Heck could, or would, accidentally provide, and plunge right in.

"Do *you* know who the girl they found Luis with was, Heck?"

Velasquez opened his mouth, closed it, and shook his head.

"What are you telling me, Heck?" Jack said. "That you don't know who she is? . . . Or that you don't *know* if you know?"

"I suppose I *could* know her. But it would be entirely apart from Luis. What does . . . what did she look like?"

Right. Heck wouldn't have seen the pictures Gilman was sending around. Neither the *Journal* nor the *Tribune* had printed (nor were apt to print) any shots the cops had taken in the morgue. He realized he should have run the risk and brought one of the sketches with him. All he could do now was describe J. Doe as best he remembered her. He felt he did it pretty well.

"She sounds like any of two dozen women on the campus," Heck said, "three of them in classes I teach." He smiled then. "Something just occurred to me. If I did know who she was I might not be able to tell you."

"Oh? Why not?"

"It's clear that Luis doesn't want you to know who she was. I might have to respect his wishes even if you are his attorney."

"Fair enough," Jack said, "for now. If the girl's identity somehow becomes a means of saving Luis from the gas chamber . . ."

"Of course I'd tell you then. But only if it turns out I know."

More circles. Jack made up his mind to bring the sketches to Heck the first chance he got. This talk should have left him as frustrated as those with Luis, but it hadn't. Nothing had become any clearer, but somehow Heck's deep feeling for his wife's brother held something in the way of hope. "What are you going

to do about this mess, Heck?" Jack asked. "I mean as far as your campaign is concerned. Before you answer, let me go on record that I feel you're entitled to worry about yourself. You'd never get my vote if you weren't realistic."

Heck smiled. "I take it I do have your vote, then, Jack? Thanks . . . if that's so." He was thinking hard about something now. "The only thing I can see to do about it is to meet it head-on. I won't hold Luis at arm's length. I'll help every way I can. If he'll see me I'll drop everything. I was hoping you could tell me more than you have and I'll admit, too, that I wanted something to get me off the hook with the voters." The smile became sheepish again. "I didn't tell you but I've a couple more meetings like this today. I'm to see Phil Gilman and Ben Scanlon—at my request—this afternoon, and at five I'm taping a press conference for the six-o'clock news. I hope the police and the district attorney can tell me enough to keep me from looking stupid when the media crowd bears down on me. I had hoped *you* could."

While Heck was talking, a young woman, twenty maybe—Luis's age—and a young man perhaps a year or two older, entered the office. Jack hadn't heard a knock. Velasquez must have an open-door policy with his students, as Jack had heard he had with his constituents.

The girl was a fresh blond beauty who put him in mind of Marty when she was in college. She didn't look at Jack but the young man did: a short, swarthy, muscular Hispanic wearing a Che Guevara Cuban cap and the Chinese hairs mustache of the dead guerrilla leader. This youngster wouldn't bridle at the tag "Chicano." He studied Jack through black eyes heavy-lidded with suspicion, but suspicion of the general, all-inclusive variety, the kind Jack was sure the boy reserved for every Anglo he didn't know and probably a lot of those he did. Jack could also see why the girl wasn't looking at him, hadn't even noticed him. It would be impossible for this young woman to enter a room that held Hector Velasquez and see anyone else for a while.

"Will you be able to make the rally to Bataan Park tonight, Heck?" the girl said.

"Sure, Bonnie," Velasquez said. "Did you think I wouldn't?"

Now the girl did see Jack and threw a worried, nervous glance in his direction. "Well, we thought that with this other thing . . ." The boy in the Cuban cap shifted his gaze from Jack to the girl as she spoke and the lawyer saw something else. The boy looked at her in much the same way she looked at Heck.

"Bonnie," Heck said, "I could run . . . but I couldn't hide."

The girl stopped looking at Jack and looked back at Heck. Jack had now disappeared as far as she was concerned. That wasn't true for the young Hispanic, though. He had returned to monitoring Jack as intently and with the same undisguised hostility as before.

"There's bound to be a bunch of Henderson's people there to heckle you after the story in the morning paper," Bonnie was saying. "With all the beer flowing there could be some of that trouble you're always warning us about."

"Might be sensible to cancel the beer, Bonnie," Heck said. "As for the heckling, I'll just have to face it." He turned to the boy. "Can you keep *los vatos* in check, Emiliano?"

"Sure, man. No sweat." Emiliano's voice was flat, surface gray, but Jack thought he heard a note of disappointment in it. Emiliano liked trouble, thrived on it. Jack saw the same knowledge in the tight look on Heck's face.

"I *mean* it, Emiliano." Velasquez's voice lacked any great force but the effect on the young man was magic. He nodded at Heck as if he were taking a solemn vow.

Without another word (nor another look at Jack) the two young people faced about and left the office.

"Takes all kinds," Heck said when they were gone.

"I know."

"Actually—and this may surprise you—Emiliano's really a pussycat. Bonnie on the other hand is an extremely volatile young woman. I worry about her. I think she's a little too dedicated to

what I blushingly call 'the cause.' She'd run right off the track
if I let her."

"It does surprise me, Heck. I would have thought it the other
way around." He still did.

Strange situation, but not unusual. The girl was off her rocker
for Hector Velasquez and he didn't see it. The boy did, but even
smitten as he was by the girl he didn't hold it against Velasquez.
Something else smoldered in Emiliano. One thing: he was a
damned sight more tiger than pussycat.

"Jack," Heck said. "How is Marty?"

"Just fine."

"Give her my . . . best."

"I'll do that."

Funny. That last was said perhaps as earnestly as anything
Jack had heard from Velasquez.

But none of it was solving the problem of Luis Esquibel and
none of it was helping Jack get a make on the Jane Doe. There
were no answers here for the moment. "I've got to push along,
Heck," he said. "Got a lot of legwork to do. Thanks for the lunch.
And good luck with Phil and Ben and your show-and-tell with
the fourth estate."

"Jack," Velasquez said, "don't let that boy get destroyed."

"I won't if I can help it."

"Get me in to see him, Jack. *Please!*"

═══ **12** ═══

Marty was sitting behind her desk, bubbling, but not, Jack was surprised to find, like the cauldron of righteous anger he expected.

"We've got her!" Marty said. "Fran and I know who your black Jane Doe was." She was grinning, and he would have speculated on it, except that her statement was so overpowering.

"The police called? Or Ben's office?" he asked. No. Couldn't be. They wouldn't *keep* the news from him but they certainly wouldn't call and volunteer it.

"Of course not!" Marty scoffed. "This was plain, old-fashioned sleuthing."

"All right," Jack said. "Spill it."

He held his breath. He needed to know, but he wasn't entirely sure he would be happy with Marty's answer. The identity of the victim might be the one thing that by its very nature might allow of no other charge but murder one and the one thing that might, collaterally, convict his client. And, too, in spite of Marty's glee that it was she and Fran who had made the black girl, it was only prudent to assume the cops had done the same.

"The girl . . . ," Marty said slowly, savoring the moment pretty

much the way he would have done himself, "was—until about a year and a half ago—a high-fashion model in New York—a fairly famous lady named Akidha."

"Spell it," he said.

"A-k-i-d-h-a."

"How did you run her down?"

"Go on in your office. Fran and I have it all laid out for you."

A drift of open magazines covered the top of his desk: *Harper's Bazaar, Vogue, L'Elégance;* others he had never seen before nor heard of.

From their glossy pages the girl in the morgue or a slimmer twin looked at him. Fashion model? Hell, she was a good deal more of an advertisement for herself than for the stitchery she wore, whether it was Dior or Saint Laurent. Strange. There was far less mystery in the dead face he had looked at when the morgue attendant peeled back the sheet than in the ones he saw in the photographs. With a shade less flesh, the high cheekbones were even more pronounced and the slit eyes hid more in some uncanny way than did the closed ones he had looked at yesterday. He was looking now at a creature who had possessed a high order of intelligence and sophistication to go along with that formidable sexuality. How was an innocent (that word again) like Luis connected with this high-powered woman? . . . and why had he felt it necessary to end her life?

Marty was leaning across the magazines as he looked at them. He motioned her to the chair in front of his desk. The grin had become a smile of satisfaction. He couldn't be sure, but perhaps that outburst he had expected, looked forward to, in fact, wasn't coming. "The whole story," he said. "Everything. How do you know it's the same girl and not just a look-alike?"

"To begin with," Marty said, "I'm taking entirely too much credit. It was Fran who fingered her."

"Fran?"

"Yep. When you left here I looked at Luis's drawings for a bit. I got the funny notion I'd seen her somewhere, but I couldn't for the life of me decide just where. I brought Fran in here to see

the drawings, and she recognized her immediately. Didn't have a second's doubt."

The thought crossed his mind that he, too, had gotten the feeling he knew the girl from somewhere, but it surely wasn't fashion magazines. It was followed at once by the reminder that he had dismissed the idea, too.

Marty did go on. "Well, in spite of the fact that Fran hides her figure under J. C. Penney shirtwaists, she reads high-fashion magazines the way kids read comic books. She knew this Akidha at a glance. She went home while I covered the phone for her, and brought these back. They're all fairly old. Akidha hasn't been featured for almost a year. Well, one look convinced me that the victim and Akidha were the same girl, although she seems to have put on a few pounds—not bad pounds, either—since New York, if Luis's sketches are at all faithful."

"They are," Jack said, remembering the outlines of the body under the sheet in the morgue. "I don't see the name Akidha under any of these pictures."

"That isn't done. We called the advertisers and got the numbers of their ad agencies. The art director of the first agency we called gave us the names of the places they take their top models from. More calls turned up our girl's personal agent. Man named Feldman—our first setback. He wasn't going to tell us a thing unless we told him why we wanted to know. Poor guy. He was only trying to protect her. We didn't tell him she was dead."

"Protect her?" Jack's heart began a somersault. "Protect her from what . . . or whom?"

"Be patient. We finally persuaded Feldman we didn't mean her any harm, but I don't think he really believed me when I said Fran and I were just fans who wanted to write to her. Then . . . well, my guess is that he's been dying to talk to somebody about her. Akidha seems to have been more than just a commodity to Feldman. Talked about her as if she were his daughter."

"You said he wanted to protect her. Get to that part *now!*" Jack said. Be patient, hell!

"Okay." Marty began again. "In the first place . . . Akidha, as you've probably guessed, wasn't her real name. She was born Cecilia Jackson twenty-four years ago this coming December tenth in Harlem. Her family called her Cissy. Her father Ralph was a small wheel in the numbers-running game until nine years ago when he underwent a conversion and took his family into something called the Scimitars of Black Islam, one of the splinter offshoots of the Muslim movement that sprang up after Malcolm X was assassinated. From what Feldman says this outfit makes the Muslims look like Boy Scouts. Cissy was a dutiful daughter of the faith until she was almost nineteen. Then she got rebellious. She got sick and tired of those dowdy white shrouds the Scimitars dress their women in, but what really got to her was that like all fanatic puritans they didn't believe in educating women. She was a fine student, but college was out. They had her under what amounted to house arrest for about six months before she ran away from home. Somehow she got into modeling and worked shows and conventions for the next couple of years. Then Sol Feldman found her, and it was straight to the top after that. Big bucks, jet-set parties, millionaire boyfriends, trips abroad, the works." Marty stopped for breath.

Jack's mind was racing and questions were forming, but he didn't interrupt. No wonder Marty was a good lawyer. Maybe she took notes when she was on the phone, but she didn't use or need any now. What a great defense attorney she would make.

Cut that short, Jack . . . and listen.

"As you might expect," she said, gaining speed, "the more success she had the more she was in the public eye. *People* magazine did a piece on her and the Scimitars saw it. They found her and beat her half to death. Feldman apparently stayed with her night and day until she was out of danger. That was almost two years ago."

That accounted for the broken cheekbone the medical examiner had reported.

Marty had a little more. "She didn't wait for her release from the hospital. Grabbed her clothes in the middle of the night and

left. Feldman hasn't heard from her since. He's tried to find her and he sure doesn't sound like any dummy, so I imagine she was pretty slick at hiding. Dad, when the time comes, I want you to break it to him."

Jack nodded. "Okay," he said. "That tells me who she was in New York. Who was she here?"

"Don't know. I doubt if she was Akidha or Cissy Jackson, since she hid even from Feldman. I've done the obvious things: checked the phone book and the city directory on both names. She *could* have been living with someone, but you'd guess by now they would have reported her missing. My hunch is that she buried herself in the South Broadway district, but the renting agents have no record of her. I still bet she lived there somewhere."

"If that's so," Jack said, "it means Gilman's men can turn her before I can."

"Oh . . . I called the model agencies. Not a black model answering her description registered with any of them. I suppose she stayed clear of that line of work. Have *you* got any ideas?"

"One. It means hitting the streets again and frankly I'm just too beat to do it today." He could have ripped his tongue out by the roots when he heard himself. What on earth had gone wrong with him, admitting he was tired? She was still wearing the eager look she had worn when he walked into her office, but a dark shadow was moving into it. She stared at him for half a dozen breaths, started to say something, shook her head, finally got it going again.

"Dad," she said, "even with finding out who she was this case will go badly, won't it?"

"I'm afraid so, but how can you tell? I haven't bled all over the place."

"The hell you haven't. I've got eyes."

"Still think I'm wrong to be handling Luis?"

"Yes," she said. "Not just Luis."

"Will you tell me why? Have you got some aversion to defending people who find themselves on the wrong side of the law?"

"Of course not!" Her eyes blazed for an instant, but then the fire subsided. "I just think you've done more than your share. I'm tired of seeing you torture yourself for the people you defend." Was this the turn to softness on her part he had half-jokingly thought he feared? Well, he was close to welcoming it.

"Maybe this will be the last, Marty." He scarcely recognized the anguished voice he heard as his own. She got to her feet and started to leave the office. At the door she put her hand on the knob then drew it back as if it had burned her. She stood motionless, her back to him. The damned Muzak from the dentist's office swelled with some saccharine melody for strings he should have recognized but didn't. Finally, Marty turned to him.

"Did you mean that, Dad?" she said.

"Hell, I can't promise, Marty . . . but yes . . . I think I did."

He could almost hear the gears meshing in her blond head as she walked back to his desk. She looked down at him. "Dad," she said, "how would you like my help on this one?"

He knew he had better pretend to think this over. He took several breaths, deep ones, before he even tried to answer. He wondered if she could hear the blood throbbing in his temples. *He* sure could. "I think . . . ," he said. This was no time to be arch; he had better level with her. "I think I would like that as much as anything in all my life, Marty." He watched her sink back into the chair facing him. For a few moments they just looked at each other. He couldn't remember her looking lovelier. Then he began, keeping his voice soft, filling her in on everything that had happened and everything he had thought since the Esquibels had sat, two days ago, where she sat now. He kept nothing back. All of the agony and frustration he had known in the face of his young client's obstinacy poured across his desk. Once he glanced at the sketch of the black girl—Akidha . . . Cecilia . . . Cissy, remember? no more Jane Doe—the one with the faint beginning of a smile. Had it curved a bit more? He sighed, but he sighed with a smile on his own lips. "Had you planned on helping me before just now?" he asked. "Is that why

you picked up the ball and ran with it?" He nodded toward the picture.

"No. Not really. I was still pretty ticked off with you when you left." She laughed. "It was curiosity that got this cat. Then Fran's excitement got me excited, too. I'll admit that halfway through those calls I began to wonder why the hell I was doing it."

"Well," he said, "whatever your reasons were, it was one hell of a job."

"Hey!" she said, her eyes suddenly riveted on him, "if I sign on with you for this defense, do I retain the right to argue with you?"

"You bet you do, counselor."

"All right, then," she said. She was eager again, and he discovered he was no longer tired. She went on, "What's the one idea you said you had before we started all this mush?"

"*You* gave me the idea," he said.

"I did? When?"

"First when you talked about Akidha there gaining weight and then when you said you called the model agencies. I agree with you that she wouldn't have looked for anything in her regular line of work here. She was on the run and too well known . . . and don't those fashion models have to be a lot skinnier than the girl in those drawings? Incidentally, I don't think you're right about her living around South Broadway. There are Muslimlike sects down there, and maybe even these Scimitars, although I've never heard of them. As far as I know, Gilman hasn't had any luck showing her mug shot around the district, either, and believe me, Ida Talley would have been on the phone to me if he had." No, he wasn't tired now. He was going fine, chugging along on all twelve leaky cylinders. "But about my one idea. I think she might have looked for work *something* like what she was used to doing in New York. Now, when I found Luis's sketches of her I assumed he had just made drawings of a girlfriend . . . but don't *artists'* models carry a little more heft than fashion models?"

"They sure do!"

"Good. Would you check the art school at UNM for me? And don't forget the private ones. They might have a name and a phone number and maybe an address if they used her regularly in . . . what's it called? . . . a life class? Call the Esquibels. Find out if Luis studied with anyone."

Her head had started going up and down as he talked. "I'll start right now. I'll call the Esquibels first, then check with Bill Davison at Popejoy Hall, and I'll have Fran find out about the private schools."

"Don't let them know why we're asking. And don't get your hopes too high. By the way, what about your own work load?"

"Sweet of you to ask!" Well, he could hardly blame her if there was still a tiny bit of acid left. Strong stuff, but it must have eaten itself away by the time she went on, "All I have for tomorrow is taking a deposition in the Melton thing. Rudy will do it for me if I get too tied up on this." The Melton thing? He didn't dare ask and betray how much distance he had put between himself and the other cases in the office. It wasn't just Luis, either. Orville and a whole string of criminal matters had occupied him for months. He was lucky Marty didn't bring it up; it was no time to go into his delinquencies at the risk of losing her as fast as he had gained her.

"Dad . . . ," she said. "How did it go with Heck?"

"He doesn't seem to know any more than his in-laws do."

She shrugged—or had it been a shudder?

"If I turn something up," she said next, "what's the next move?" It was as if the question about Velasquez had been asked an hour ago and forgotten now.

He grinned. "If you turn something up I'll sock that young sphinx down in D right between those pretty stone eyes with it. He might just start to talk when he realizes that his lawyer—his lawyers—aren't exactly stupid." Oh, how he had enjoyed saying the plural "lawyers." He watched Marty as she gathered up the magazines and went to the wall for the charcoal sketches. She was a beauty, all right. One thing was sure: partner as she now may be in this defense, she wasn't going to be making any visits

down to D, not if Jack Lautrec had anything to say about it. He shuddered at the thought of Marty walking through that gauntlet of thugs, junkies, and two-way rapists. "I'd better stagger out and thank Fran," he said.

"Too late, Dad. She's gone for the day."

"Good Lord! What time is it?"

"Ten to six."

"Does Fran still keep that little black-and-white Sony in the console behind her desk?" he asked.

"I think so. Why?"

"I want to watch the six-o'clock news."

"You think the cops might have made another statement?"

"Something like that." He felt uneasy, not coming across with her right now, but what the hell . . . he wasn't sure of what had just hit him yet.

"I'll bring it in for you," she said.

"I'll get it myself. You're to help me with Luis, not play nurse-maid. Okay?"

"Okay."

"Take off then, Marty. I'll lock up. And, Marty . . . thanks again."

He fiddled with the knobs of the little television set and got the contrast adjusted to his liking just as the opening commercial of Channel 13's newscast finished.

Settling back in his chair he watched the clearing away of a three-car pileup. He was relieved when the on-the-spot announcer reported that injuries had been minor.

Why, he wondered, hadn't he told Marty about Heck's press conference now that she had declared herself fully at his side? She, bless her, had shown no reservations. There was no time to frame an answer.

The tiny screen was revealing a meeting room at the university with Heck seated in front of a pair of microphones. No aides flanked him; he was going to face this by himself. He looked at ease. Jack could see the jowly face of George Jones of the *Journal*

in the front row of questioners. He was sitting next to Jeanne
Wayland of Channel 13's staff. Jeanne, who ran the station's
public affairs program, "Forum 13," could turn out to be the most
penetrating of Heck's interrogators, for all her fundamental de-
cency. Yes, she could . . . if the *Tribune*'s hotshot, Sally Bentley
there, let her get a word in edgewise.

Jack heard Heck say he was going to read a statement and
then take questions. He picked up a sheet of paper and looked
the camera squarely in the eye. The camera was friendly to him
and clearly Heck knew it. He played this game like a pro.

The TV switched from candidate to audience while Heck read.
Jack didn't take in too much of the prepared statement. It seemed
to contain a predictable set of remarks. He did see the girl Bonnie
and the boy Emiliano sitting in the back of the conference room.
The camera lingered a bit on the girl's pretty face. She seemed
troubled. Understandable. This could be a moment of high risk
for the "cause." Then, just as Heck finished, the vertical hold on
the set went wild and the audio broke down to a series of manic
squeaks. It was as if the whole press conference had been in-
sanely speeded up and then, by some quantum leap of Jack's
imagination, as if the whole tragic time machine in which poor
Luis was being processed had suddenly raced on out of kilter.

Frantic without knowing why, Jack twisted and turned the
control knobs, trying to pull the picture and sound together again,
but by the time things were back in working order an Oil of Olay
commercial was appearing. A handsome black woman in diving
décolletage filled the screen. Of course she wasn't Akidha, but
she almost could have been . . . almost. He stared at her, feeling
something close to recognition.

He knew then that he had been absolutely right in those dark
hours of Wednesday morning. He had seen the dead girl before.

And now he knew where . . . and very nearly when.

13

"Jack! Good to see you," Jeanne Wayland said. "It's been far too long. What brings you to the studio? Want air time on my show again?"

"Not right now Jeanne, but I do want a favor."

"Name it. If I can do it you know I will."

He liked Jeanne. She handed out a good deal less baloney than most media people he knew and she cut straight to the heart of things on her weekly show. Jeanne was no longer dewy youthful but behind the glasses that gave her a slightly academic look a pair of sharp eyes sparkled. "Do you think," Jack said, "that I could get a peek at the tapes of Channel 13's evening news for say the last year, perhaps a bit more?"

"How come you're not asking the news director?" She wrinkled her nose as she studied him over the tops of her glasses. Bright lady; she knew he was up to something.

"You know how paranoid they get in the news department. I'd probably have to subpoena them. That would take days, days I haven't got."

Jeanne laughed. He hadn't fooled her but then he hadn't ex-pected to. "And besides . . . ," she said, "you don't want anybody,

anybody in the D.A.'s office, for instance, to know that you're looking at them. Right?"

"Something like that. Can you get them for me?"

"What are you looking for, you old pirate? Anything to do with that Esquibel kid they picked up with the body in the bosque?"

"Rather not tell you, Jeanne. Not now. Let's just say I'll owe you."

Her brow puckered as she thought it over. "Okay," she said at last, "on one condition. I get to watch you while you watch *them*. Maybe I can read a little something in that poker face of yours."

"Deal."

She led him into a viewing room with a monitor screen tucked into a wall of shelves, seated him at a table, and excused herself. Alone, he wondered what had made him say, "days I haven't got." He and Luis were only facing the arraignment in district court, and that wasn't the end of the line for them by any means. There would still be the months before the trial and a lot of things, not necessarily all bad, could happen. The arraignment itself wasn't even imminent, not if Ben Scanlon was going to the grand jury for an indictment, as Jack was pretty sure he was, but he had awakened this morning with the fag end of a bad dream still fresh in his mind. In the dream Luis and he had been standing in the top bell of a giant hourglass, both of them shrinking in size as the sands ran out beneath their feet. He knew in the dream that when they reached the orifice they would have been reduced to absolute nothingness, swept on through and lost forever. With some unexplainable effort he had jolted himself to wakefulness in the instant before it happened.

There had been any number of times in the past when things were turning so sour for a client that he had felt he, too, would go down with them, but never to the extent he felt it now.

Why? He had been whipped by impossible cases before, where the evidence against his defendant was so clear, so utterly conclusive, that it would have been fantasy to expect an acquittal from even the most forgiving jury, but even then Jack hadn't foundered. He had been drawn to clients before, too . . . had

known affection for them, and, in a case or two, something akin
to love (never mind mere sympathy or pity . . . always present)
without feeling quite this vulnerable. With Luis, it was different.
He had sensed it from the start, had known how he was risking
wounds. Maybe, just maybe, it had something to do with that
remark he made last night to Marty.

"Maybe this will be the last one . . ."

Had he really meant it?

At any rate, to this moment in Jeanne Wayland's viewing room,
he had been unable to shake the feeling of lurking disaster that
had dogged him with such determination ever since his solitary
breakfast yesterday and his near collision with Adele Thompson
and her poodle.

He forced himself to think things through from another angle.
Get tough, he told himself. Appealing as Luis Esquibel might be,
he certainly had done little to earn his attorney's loyalty. The
blind young fool wanted to go to prison, perhaps die. Why not
let him? Why not plead him guilty without a qualm and have
done with it? No one could criticize Jack Lautrec for doing exactly
what his client wanted.

It won't wash. Don't kid yourself. There was one particular
critic who would pillory him if he rolled over for Luis Esquibel,
the one whose bearded face was reflected in the sleeping TV
monitor screen in front of him.

"Here we are, Jack," Jeanne Wayland said from in back of him.
He hadn't heard her when she entered the room trailing a young,
T-shirted technician. "Cliff here will start the tapes for
you . . . and I'll be watching."

He had to watch a lot of stale news in the next three hours.
Cliff disappeared after showing Jack how to use the remote con-
trol to speed up tapes or freeze them, and how to load a fresh
one. Jeanne left him twice to powder her nose or something, but
by and large she showed staying power.

Little of it was pleasant viewing. Between the coverage of
OPEC meetings, the continuing crisis in El Salvador, the whole
nightly chronicled parade of misery and suffering, he watched

the tennis victory of still another tantrum-prone teenage Croesus and the year's second round of floods in the Middle West. Then he saw a whole series of tapes on the state's big story of recent years, a waking nightmare that settled once and for all not only why the feeling of impending doom had visited his dreams and stayed on to haunt him through the morning, but settled, too, the question of whether or not he would fight for Luis Esquibel. The tapes were of the two weeks when Channel 13 covered the riots at the penitentiary and their aftermath.

They had been bad enough taken piecemeal, night by night, back when he was still learning the Grand Guignol stories behind these scenes of blood and death and wreckage where two of the men he had defended were hacked to pieces by their fellow cons. Now, in one gagging dose, and with Jack knowing everything about the riot that he knew now, but hadn't known when it happened (things more horrible by far than the prison administration and the for-once too stricken media dared inflict on dinner-hour viewers), the sights were far more sickening. He shook his head as he felt again the unbelievable, mad power of the rioters, saw the jagged indentations in toilet bowls that looked as if they had been bitten into by some Jurassic monster, the charred, excrement-smeared walls, and the blood, streams of it. The small screen flickered as if it were trying to blink away these images, but couldn't. Jack couldn't, either . . . nor could he blot from memory the things he had heard about and seen when he visited the prison with the families of some of the men inside, two days after the riot: the check forger who had arrived at emergency at Saint Vincent's Hospital in Santa Fe with the metal coat-hanger driven right through his head from ear to ear; the slop bucket brimming with the grisly products of the castration of a dozen men who, if any lived, must now envy their merely decapitated comrades. There was no way Channel 13 could have shown any of that.

In one important way, the worst thing he watched as the tapes played was the look on the faces of the inmates unhoused

by the fires the rioters had set, cons blanket-wrapped against
the cold, huddled by the penitentiary's chain-link outer fence.
They had to go back inside those walls; the dead, at least,
didn't.

Luis Esquibel in that charnel house? Jack shuddered, and saw
that Jeanne had caught the shudder from across the table. "Are
you all right, Jack?" she asked.

"Fine."

Then the screen showed shots of Jack himself, with Orville, at
Blakely's trial. Orville had been lucky in one respect; he hadn't
taken Gantry's van up the interstate until long after the riots were
over.

There was a shot, too, of Betty Blount, the girlfriend Orville
had casually picked up during the publicity blitz accompanying
the trial. Poor, pathetic Betty. She had begun writing mash notes
to Orville while he was housed in D, and the Texan had cynically
made a gofer of her, and an emotional slave to boot. The Channel
13 interviewer had taken pity on her and let her sit in the court-
house hall for their talk, but the camera had played mercilessly
over her enormous bulk, all three hundred and God knew how
many pounds of it, showing elephantine, scab-covered legs.
"Don't care what he's done, he's my honey," Betty was telling
the TV man, her warty face wreathed in smiles, although her
eyes were still puffy from the torrent of tears that had spilled
down her balloon cheeks after the jury brought in its verdict.
Jack was sure no one could have told Betty that, had he been
out of stir, Orville, while no prize himself, wouldn't have tossed
her a glance. Jack had known a dozen pitiful creatures like Betty
pretty well: deprived women who were sure they had now found
in their convict boyfriends the purest shining love known to hu-
mankind. A few of them would have killed for their men without
a moment's hesitation. During the trial and appeals Betty had
made a dozen trips to the office on Orville's behalf, and a major
fraction of a thousand phone calls. Jack probably hadn't heard
the last from her.

Well, Orville was up at the penitentiary now, with hundreds of other pathological types, all waiting for Luis Esquibel, or some other "fresh young meat" just like him.

Jack grimaced. Jeanne caught that, too. "Have you seen what you came to see?" she said.

He nodded. "Some of it," he said. It wasn't quite the truth. In a perverse way all the horrors he had seen had been of use, but they weren't what had brought him down here. That should be coming next. Although he was glad he hadn't, he could have skipped everything he had watched so far. Looking at it had been a red herring of sorts to keep Jeanne from guessing what *he* was guessing. Then, interrupted by a scandal in the highway department, the NBA play-offs, and Prince Charles's visit to the city, the more recent newscasts he had really come to see rolled across the screen. They told him where he had seen the victim before and in what connection. They told him more than he had expected to be told. They told him far more than Luis Esquibel wanted him to know.

"You didn't give much away except during the riot clips," Jeanne said when the little screen went black. "Jack . . . whatever it is, can I have it first when you decide to let it out?"

"Promise."

"I'll hold you to it, Jack. Then you won't owe me."

On the drive back to the office he avoided the interstate.

A mile west of San Mateo, Central Avenue was a warren of porno shops, topless joints, and "adult" movie arcades. Drunks slouched against the sun-blasted brick walls on the north side of the street or walked the littered sidewalks (some like spastics, some rigid in comic efforts to mask their condition), lone, lost, desperate men in a world that had no use for them. Here and there Jack could spot the afternoon hookers looking for early tricks to cash in on before their watchful pimps were up and on the prowl.

Was this the corrupt and corrupting world he wanted to keep Luis out of prison *for*? In some ways it was little better than the pen.

Yes, damn it! Luis could *choose* this corruption if he wanted it . . . and that made all the difference. What Luis no longer had any choice in was what he was going to tell his attorney: the truth . . .

. . . or something close enough to the truth for Jack to go to work on.

≡≡14≡≡

Marty Lautrec's spirits were soaring as she burst through the double doors, but they stayed aloft only until she saw Fran Crowley's face. Fran, bless her, had never learned the flash-on smile affected by other receptionists. Not the least part of Marty's affection for her sprang from the fact that with Frances Crowley, smiles were heartfelt or nonexistent. What Marty was getting now was worry and concern, but not the general, exasperated worry and concern that signaled, for instance, that Carol, who ran the firm's Apple III, was late with a promised brief or a motion to be filed in tomorrow's session of district court, or that gentle Rudolfo Garcia had one of those depressions brought on by the few judges who made little secret of their contempt for Hispanic lawyers. This was the intense, specialized worry and concern Fran always reserved for Jack Lautrec, and Jack Lautrec alone, when he was troubled about a case. For a moment, Marty flared inwardly. The singular thickheadedness of men escaped her understanding.

"Is he in his office, Fran?"

"Yes, Marty. He asked for you when he came in."

"Alone?"

"Yes. I peeked in once. He looked asleep, but I really wasn't sure." That wasn't quite the truth. Fran would know whether Jack Lautrec was asleep or awake. "Well, if he's napping . . . ," Marty said, "I've got stuff that will bring him out of it faster than a bugle call. Hey, did he ever get around to thanking you for spotting Akidha from those drawings?"

"Yes, he did," Fran said. "He blushed."

"Did Rudy take that Melton deposition for me, Fran?"

"Yes. And he went over that Sperling divorce settlement Jack didn't have time to look at." It was as close as Fran would ever get to criticizing either of them. Rudolfo wasn't any tougher. Well, two nasty tempers were probably enough for this small office, anyway. Carol's infrequent pout about the work load she actually couldn't live without didn't count, and Tim Whipple, the paralegal, was about as mean as Mickey Mouse. At times like these Marty tended to blush a little herself. No matter what she had told Jack—and she chuckled at the thought that by rights she should have gotten an Oscar for her performance three weeks ago—she wouldn't have left this office for Santorini & Gill for two hundred grand a year. "I'm going in to see him, Fran," she said. "You'd better hold our calls."

"Now that you're joining this defense, are you going to tell Jack about your *personal* stake in it?"

"I don't know yet."

"Dad, wake up!"

"Wasn't asleep, Marty."

"You look like hell."

"Thanks."

Well, there was nothing wrong with the young woman standing in front of him. Her eyes were sparkling.

"Let's have it," he said.

"You were right all the way down the line. Her name here in the city was Lupe Sanchez. She posed in the buff two or three days a week at a studio school run by that old gay Timothy Merryman over in Corrales. She must have still had money left

from her big days in New York City; she sure didn't get enough bread from that old skinflint to rent the house she did."

"Where was that?"

"In the Los Griegos barrio. Accounts for the Spanish name she took. Probably figured it would bury her a little deeper."

"You went by the place?"

"You bet. The door was locked and I couldn't see much through the windows. But I asked a neighbor lady, Julia Perez, if she knew who owned the place. Akidha's landlord was Tony Cisneros."

"Antonio?" This was a break, maybe. Jack had squared a pot charge against one of old Cisneros's granddaughters the year before.

"I didn't call him yet, Dad," Marty said. "Thought *you* might want to do that."

"Did the neighbor remark about Akidha's . . . Lupe Sanchez's . . . not showing since last Saturday?"

"Nope. I'm sure she didn't make any connection. I said I was a bill collector. The house sits way back from the street with big cottonwoods and a tangle of bushes hiding the front of it. The neighbor is the only one on the block who could even see the driveway."

Jack put his fingertips together. Marty was circling the diamond so fast he hesitated to check her before she scored, but it was important she touch every base. "Let's go back a bit," he said. "*Was* Luis a student of Merryman's?"

"Yes. Luis did the one drawing I took with me at the school."

"Nothing funny between *them?*" He was pretty sure of the answer, but he had to ask.

"Good Lord, no! Luis is straight enough. He even dated a couple of the female students before Akidha came along. Then the two of them became a genuine thing, but only for a month or so. Something happened and he quit going with her. Quit Merryman at the same time."

"How long ago was this?"

"Ten months. Last fall sometime."

"Do you think Merryman will report your questioning?"

"No. I'm sure the old tightwad works off the books. He doesn't want attention."

"Could she have posed in other classes?"

"If she did I didn't find them."

"You checked with the Esquibels?"

"They didn't even know Luis was studying art. Graciela thought he was doing his thing all on his own. He kept everything in that studio of his."

"Has Gilman found out about the studio?"

"Apparently not."

She had been standing. Now she sat down, beaming. She had every right to be proud of herself; it was good, thorough work. Then he realized something was missing. "How did she get across the river to Corrales?" he said. "Did she drive? And what kind of car did she own?"

"Didn't own one. A number of different people called for her. Julia Perez couldn't identify the cars very well beyond color, and she was at a complete loss as far as describing the drivers. Incidentally, none of the cars she saw was Luis's pickup. I've got a list here of some she thinks she saw in recent months." She pushed a sheet torn from a legal pad across the desk at him. "The two I checked were her only nighttime visitors. There's nothing for Saturday, though. Julia and her husband were at Bluewater Lake over the weekend on a fishing trip." He looked at the list she had given him, his eyes going first to the checked cars. He was pretty sure the first one was Orlando Esquibel's Riviera. It figured. Luis must have borrowed it for his dates with Akidha, or Cissy Jackson, or Lupe Sanchez as he probably knew her. A romantically inclined boy didn't take a girl to dinner in a beat-up pickup. But the other car . . .

If he knew it, as he was sure he did, it tied in with everything he had seen on Jeanne Wayland's tapes. There was only one place to go for more answers at the moment. This time he had a fighting chance of getting them. A shiver ran up his spine and his scalp tingled.

Marty's voice broke into his thoughts. "You're going to call Cisneros?"

"What? Yeah . . . sure."

"You don't seem too excited by the prospect. I thought sure you'd want to call him right now, get a key, and we could go down there."

"That can *wait*," he said.

She stared at him. "Dad . . . ," she said, "that house in Los Griegos is where the murd . . . *killing* took place. I'm sure of it."

"So am I." He stood up.

"Well?"

"I'll see you in the morning," he said. Something struck him. "Come to think of it, I won't. I'll probably be going right from home to see Ben Scanlon."

"Let's have dinner together. I want to know why you're not hot to trot about the house in Griegos."

"Can't, Marty. I'm heading right from here to see Luis."

"At this hour?"

"This *can't* wait."

"But why tonight?"

"Marty," he said, "I don't mean to hold anything back or keep you in the dark. I need to make sure of something, though. If I'm right, I'll call you at home if it's not too late. If I'm wrong . . . well, I don't want anybody to know exactly what I'm thinking."

"I thought we were partners, Dad."

"We are. But not to the extent that I want anyone innocent getting hurt. Trust me for a little while." He hoped he hadn't tipped his hand that she was one of the innocents.

She sat at his desk for a full five minutes after he left. He had tried manfully to look hopeful, but Jack Lautrec was a troubled man and the trouble was contagious, if unknown. Her head began to ache, and she finally did what she always did. She went to Fran. "I'm worried, Fran," she said.

"Me too. I don't think I've ever seen him quite like this. He

went through here without even saying good night to me. That's not like him." Obviously, Fran wasn't going to be able to help. They looked at each other. Fran shook her head. "Marty, I want to change the subject."

"Sure, Fran. Good idea."

"I know it's none of my business . . . but is it really all over between you and Heck Velasquez? You looked a bit strange after you called him the other day."

"It was all over the second he walked out on me. I'm a big girl, Fran." Was she as sure as she tried to sound? "Well, maybe it took a little longer than a second, but I did manage to campaign for him, you know."

Luis was finishing his dinner at a table in the mess hall . . . alone, naturally.

"Come with me, Luis," Jack said. "I want a word with you."

He led the way to an interview room the accommodating Brooks found him a key for, ushered Luis in, and locked the door behind them. For once it didn't bother him that the room might well be bugged. He rather hoped it was.

"Sit down, Luis." The boy stared at him. *He knows something quite different is in the air this time,* Jack thought. "*Sit down!*" Yes, he had meant to sound that rough. He hoped the "game face" he had worked up on the ride to Three West in the elevator looked every bit as threatening as he meant it to. Luis sat down. He folded his hands on the table in front of him.

"All right, Luis," Jack said. "Let's have no more of the big silence act, okay? You and I know you *didn't kill* that black girl Lupe, don't we?" He held his breath. Luis's reaction would tell him what he wanted to know, he was sure of it.

Luis dropped his head on his hands. It looked as if he were praying. Bingo! "And . . . ," Jack said, more gently. "We both know who did . . .

"It was Hector Velasquez, wasn't it?"

═ 15 ═

Jack watched Ben Scanlon run his well-cared-for hand across his smooth, tanned cheek as he checked the shave he had no doubt gotten from a barber on the way to work. He's the same age as I am, within two months, Jack thought, but if it weren't for that touch of gray at the temples he wouldn't look fifty.

And Ben couldn't weigh five pounds more than the 175 he had carried when he played tailback in Jumbo Bannerman's horse-and-buggy single wing, back when Jack, a journeyman pulling guard, ran interference for him. Squash, Jack had heard. Nothing as mundane as tennis or golf for old Ben. Scanlon still wore the all-conference ring from that senior year when the team finished second. Jack didn't own one. He felt no resentment. Ben, with the born ability of a good running back to use his blockers well, had made Jack look better than he was.

"Sure, I'm here to bargain, Flash," Jack said in answer to Scanlon's question. "But not on the plea. That's going to be 'not guilty' to the bitter end." Ben sometimes pretended he didn't like the old nickname. Jack knew better.

"The way things stack up it's damned well likely to *be* the bitter end, Jack," the district attorney said. "Are you trying to tell me

Esquibel didn't kill that girl? Come *on!*" Ben smiled. It wasn't the merciless smile he sometimes wore. That one didn't come until you crossed him.

"Yes, I'm trying to tell you Luis didn't kill her. He's innocent all the way, and that's not just a position I'm taking in order to bargain. What I want, Ben, is for you to restrain yourself on bail. You could help by making it an open charge, too, not first-degree. I want my client free until the trial." He decided to go for broke. "If this thing *comes* to trial . . . which I doubt."

"Oh?" Scanlon's eyes went wide. Jack was pleased. He must have presented a look of confidence he by no means felt. "Come on, Jack," Scanlon went on. "Have you got something I don't know about?"

"Maybe. I don't *know* what you know." That was weak . . . and mildly dangerous, too. "No, Flash. Not yet. I'm looking, though."

Scanlon smiled. It was still the disarming smile, praise be. "Good," he said. "I wouldn't like to think you're asking favors while you're holding out on me."

"Not a chance, Ben." Perhaps he had better give the appearance he *was* leveling. "I'm on to something, but disclosure now might hurt someone unnecessarily. So far it's just conjecture."

"I'll accept that . . . for now, Jack. I can't expect you to tell me what you're guessing, but any physical evidence, no matter how inconsequential *you* think it is, had better be on the table. Agreed?"

"Sure."

"Okay. Now what specifically do you want from me?"

"I want you to go to the judge with me to talk about the bail."

"Can't. I'm booked solid. But you can go on over by yourself, Jack. I won't raise any objection."

It was too good to be true. As affable as Ben was being today, there must be a catch somewhere. "Thanks, Ben. Who's handling things?"

"Val Cordoba." Scanlon's smile broadened.

No wonder Ben was being so generous. No member of the bar association save Ben dared call District Judge Valentino Cordoba

by his first name, never mind "Val." Jack snuck in a "Valentino" on purely social occasions just to test his nerve; but he didn't take liberties with the old judge, who tended to O.D. on dignity. Scanlon went on, "I'll check with Val tomorrow if he doesn't call me first. Right now you'd better give me some damned good reasons why I shouldn't buck you on the low-bail request."

"Well, for one thing, you're not standing for reelection this fall, Ben, so you can pretty well shrug off any criticism you might run into. Second, what you have so far, while I'll admit it's sensational—finding my client with the dead girl—isn't by any means conclusive and you know it." Probably Ben didn't *know* any such thing, but Jack's saying he did might just make him wonder. "And Luis hasn't made a confession . . . or even given you a statement." Ben's face hardened a little. It must be a sore point around here and at the department. Ben had in all likelihood had Gilman on this plush carpet for it already. "Let's not kid each other, Flash. If you felt one-hundred-percent sure, you would have filed an information instead of shipping it over to the grand jury."

"I still can. It hasn't gone yet."

That was a surprise and a minor disappointment. It had to go to the grand jury if Jack were to get all the time he wanted and, after last night with Luis, felt he needed. "No," Scanlon was saying, "MacReady is sending it over this afternoon." Jack tried to suppress his sigh of relief. He had better play his last two cards and play them fast.

"Ben," he said, "I know that with public feelings about crime today you've got to play the law-and-order stuff to the hilt, but I also know you've got a conscience. If this kid is found innocent, you'd never forgive yourself if something happened to him down at D." It was true. Rigid enough, Scanlon was no unfeeling monster. That was card one; now for number two. "One thing more. If Luis *should* come to trial, I'd like *you* to prosecute. We haven't faced each other in a murder trial in too damned long. Might be fun."

That card had been the ace of trumps. The grin lighting the face of the man behind the mahogany desk told Jack he had stroked that giant ego almost to where it purred. "All right, Jack. Go and see Val," Scanlon said. "I'll go easy on the charge and on the bail, but in return I want more in the way of disclosure from you than the law says you have to give me. No surprises at the arraignment. Fair?"

"Fair," Jack said. He stood up to go.

The phone on Scanlon's desk began to ring. "Don't run away," Ben said, the faint hard look gone. "Let me brush this off." He picked up the phone. "I thought I said no calls while Mr. Lautrec was with me, Nancy." There was a pause. "Oh? Well, I guess you better put him on." As Scanlon listened to his caller he motioned Jack back into his seat with that beautifully manicured hand. While he waited for the district attorney to finish, Jack let his eyes wander around the office. No one liked being stared at while they talked with someone else. For one small, sneaky moment Jack couldn't help thinking of what it might have been like to spend a little of his career in these surroundings. Idle thought. Even when he had made that close losing run for it he had wondered if he could ever really prosecute. He was a defense attorney . . . period! Things did have a way of working out.

It was more than a minute before Scanlon said good-bye and hung the phone up. Jack couldn't remember that the D.A. had said a word himself. "Jack, can you spend another ten or fifteen minutes here with me?" Scanlon said then. Was there something a touch ominous in his voice now? "Someone's dropping by to tell me something. Maybe you ought to listen, too." The hard look was back. It was absolutely adamantine now. Jack nodded. He could feel moisture beading on his forehead. Maybe Ben wouldn't notice. "Why don't you wait in Nancy's office?" Scanlon said. "If you play your cards right maybe she'll fix you a cup of coffee."

Jack moved out into the secretary's office as if he were walking in his sleep. He didn't ask her for a cup of coffee. He knew he

would sweat like a pig at the first sip. He picked up a copy of the *Harvard Law Review* from the table next to the couch he almost collapsed in, and leafed through it only for Nancy's benefit. He wished he didn't have to wait to find out what disaster had overtaken him. Might as well face it right away.

But he did have to wait. Making small talk with Nancy was out of the question. He could slip, let something out, if only an attitude. Ben trained his people well. She might sniff out the fear in him if he talked; might have sniffed it out already. He didn't want Luis on his mind in case it showed, but that he couldn't help.

Jack hadn't left the detention center the night before with everything he wanted, but there had been gains. Luis had finally admitted that he had found the girl already dead in her rented house, and he had admitted seeing someone else leave just before he got there, but he had repeated the impassioned lie over and over that he didn't know who that someone was.

"It was Hector, wasn't it, Luis?" The boy had shaken his head with such violence Jack feared he would break his neck. He knew he would have to forget the question for a while. Maybe, when Luis gave sober thought to what was facing him . . . yes, and maybe not. "Did you touch anything in the room except the girl?"

"*No!*" It was just too much of a protest. He watched Luis reverse himself. "Yes. I picked up the knife."

"Did you take it with you?" Perhaps the weapon was in the river after all, or still undiscovered in the bosque. Hope was playing tricks with common sense.

"No, sir. I . . . dropped it. I left it there."

Something wild occurred to Jack Lautrec then and he knew fear as he hadn't known it in a long, long time. No, Jack. Don't be tempted. Don't even think about it. "You introduced Hector to Lupe, didn't you, Luis? And he took her away from you." Perhaps he could stir enough remembered anger and jealousy in the boy to get the truth from him.

It hadn't worked. Jack knew why. No hatred of Heck—if there were such hatred—could overbalance the love the boy felt for

his sister and her children. They were the ones he was protecting with his silence, not Heck Velasquez.

Jack hadn't told Luis how he had doped all this out. There were still one or two shaky things about the premise . . . until the look on Luis's face told him he was right. The seduction of Akidha by Heck Velasquez (or, as seemed likely, the other way around) had taken place almost in public. Jack had seen it unfold on the TV monitor in the Channel 13 viewing room while Jeanne in turn watched him. The press conference he had caught on Fran's Sony the night before, despite the malfunctioning of the little set, had triggered his memory again. He *had* seen the dead girl before and Heck's appearance in front of the camera had reminded him of where. The sight of the black woman in the Oil of Olay commercial had cemented it.

As the newscasts rolled by, Jack had spotted Akidha at every political rally of Heck's the cameras recorded. In the first several she sat well to the back of the crowd, eyes glistening. There was no mystery about why he hadn't paid particular attention to her when he had first seen her as he watched the evening news during the year. Something glistened in *every* eye in *every* crowd, and none of those eyes were on Akidha, not even those of the attractive blonde he saw at one of the early rallies . . . Marty. Her eyes shone for Hector Velasquez, too. That was why he hadn't told her of his suspicions last night before he went down to D . . . and why he trembled now, knowing he would *have* to tell her.

As the tapes played, it was fascinating to watch the changing positions of Akidha. In the first ones she sat or stood far toward the back. As rally succeeded rally she moved closer to the front. A pawn advancing in the early shots; by the night of the primary victory celebration at the Hilton she was a powerful queen. When Heck raised one hand to salute his campaign workers he took it from his wife Ana's grasp. The other held Akidha's.

Where was Marty that she hadn't remembered this? Jack hadn't seen her after that one very early tape.

He hadn't told Luis any of this. The boy knew it all, anyway.

And he didn't tell him about what, for Jack, became the clincher. The one car that came at night to the house in Griegos that Julia Perez could genuinely describe was, according to Marty's notes, a "little red two-door."

Yes, Jack had left the D Center with gains. He wondered if they were big enough to offset the losses. The only way he had gotten Luis to agree to plead not guilty at the second arraignment in district court was by promising that Jack wouldn't bring Heck's name into the proceedings. It would have to be someone he didn't know whom Luis had seen leaving the murder scene. It was something, but it sure wasn't much.

He was jolted from these thoughts by someone entering Nancy Gates's anteroom.

"Mr. Scanlon is expecting me, Nancy," the big man in uniform said to the secretary. He turned to Jack, eyes like agates. "Hello, Mr. Lautrec."

"Hello, Captain," Jack said. Phil Gilman. Sure. It was Phil who had called Ben. Jack hadn't seen him since he had read the report at the department the morning after he met with the Esquibels in his office.

"Go right in, Captain Gilman," Nancy said. "Mr. Lautrec, you're to go in, too." Jack saw that Gilman wasn't happy about the inclusion of the lawyer for a defendant in a conference with his boss.

"Phil," Scanlon said, "tell me again what you told me over the phone."

"In front of *him*?" Gilman said, tipping his head toward Jack.

"Sure. We've got to give counsel for the defense the package sooner or later. Might as well start now."

"*You* have to. I don't. I'm just a cop." Gilman was a tough, tough hombre. Not many people took that stern tone with Ben Scanlon and kept on working for him.

"Well, Phil . . . ," Ben said, "I can ask you nicely, or . . ."

". . . Give me an order?"

"That's the bottom line." Ben was smiling the wicked smile at last, but at Jack, not Gilman. "You see Phil, Mr. Lautrec and I have a little deal working. Total honesty. No secrets."

The police captain stirred uneasily. He cleared his throat. "Okay, Mr. Scanlon," he said. "This letter came in the mail this morning." He reached inside his tunic and brought out a glassine folder. "It's one of those things with the words cut from a newspaper and pasted up. Told us where we could find Jane Doe's house. It's in Los Griegos."

Jack kept his eyes on Gilman. He could feel Ben's on him. Gilman was going on, "It was where the homicide took place, all right. The lab will have a report to you within an hour. There was a lot of blood we can match with the victim's, and we found what we're pretty sure is the murder weapon, a knife with a clear set of prints they're checking against the suspect's now."

"You said something about a photograph that came with the letter, Phil."

"Yes, sir." Gilman reached inside the tunic again and came up with another glassine folder. He handed it to Scanlon, who gave it a quick glance before pushing it across his desk at Jack. Through the sheen of the folder Jack saw what appeared to be a picnic in the mountains, Sulphur Springs Canyon he guessed, with several young people seated at a rustic table. He knew two of them. Luis had his arm around Lupe Sanchez (as Jack had finally decided to call the girl from here on out) and he looked happy. Lupe's exotic face held the faint smile of the one charcoal sketch.

"Well, now . . . ," Scanlon said to Jack, "I think we've got a bit more than when you and I talked earlier, Jack . . . scene, weapon, victim's identity. We *have* made the girl, haven't we, Phil?"

"Yes, sir. Name was Lupe Sanchez."

"And . . . ," Scanlon went on, enjoying every second of this, clearly in no frame of mind to rush matters, "it appears we have a hint of motive. What do you think, Jack?" Scanlon obviously didn't expect an answer; he got none. "Your turn, Jack," the

district attorney said next. "That's pretty much what the prosecution's package will look like. Any old thing you want to tell *me*?" Something puzzled Jack. Ben was pissed with him, but why? He should only be gloating now, expansive, what with the goodies his big cop had brought him. "Phil." Scanlon had turned to Gilman again. "There was something else we touched on when you called me. Did the neighbors in Los Griegos report any strangers nosing around the house where the murder happened?"

"Yes, sir. One."

"Could they make an identification?"

Hope fluttered in Jack's chest. Heck Velasquez. Let it be Heck. He could force the prosecution to bring Heck's name up at the hearing, and he wouldn't have to break his word to Luis. Even as he thought it he knew how wrong he was.

"We're going down there this afternoon with pictures to make sure," Gilman said, "but the description fits a lady lawyer named Martine Lautrec."

Scanlon's smile was merciless now. "Jack," he said, "somehow I get the feeling you *weren't* going to tell me everything you knew. Tell me I'm wrong, old buddy."

Lautrec shrugged. Nothing he could say would help matters now. He stood up.

"Sit down, Jack," Scanlon said. "I can't for the life of me understand why you're constantly trying to deprive me of your company today. I still have a couple of things to say." The bastard. His voice was unctuous now. "First, Jack—and I'm sure this won't surprise you—we're going for murder one, and we'll ask that the defendant be held without bail. Second, I won't prosecute this case myself. Seems fairly simple. I'll let Curt handle it. The kid should be able to cut his teeth on your Luis Esquibel." Jack felt as if a ten-pound hammer had been swung into his solar plexus. Curt was Curtis Santorini, son of old enemy Joe Santorini, who had once suborned a witness in one of Jack's civil cases in a way Jack couldn't prove. Angry with Jack once, Marty had threatened to join the firm of Santorini & Gill, knowing nothing

in the world could so get his dander up, even when he knew she could never be serious about such a move. The boy hadn't prosecuted a capital case since Joe talked Ben into taking him on for experience before he ultimately joined his father's firm.

Somehow Jack found his voice. "See you or your stand-in in court, Ben. Good-bye."

"Good-bye, Jack," Ben said. "Oh . . . we *will* file a criminal information. No need for the grand jury now."

16

When he told Marty what he thought, it was as if he had struck her.

"I don't believe it, Dad! If there's a man incapable of murder it's Heck Velasquez." She had subsided some, but there was still a molten flow around her from her first eruption. Velasquez apparently could inspire something like blind loyalty even in an otherwise realistic political animal like Jack's daughter. He wished he could reinforce his new idea with the news that Luis had admitted everything, but the boy had refused all of Jack's attempts to get at what he now felt to be the truth. His glacial silence hadn't been totally unexpected. He had set out to protect his brother-in-law and he was damned well going to do it.

"Marty," Jack said quietly, "no man is incapable of murder."

"That remark is just another reason why I sometimes get sick of the kind of law you practice," she said. "It's warped your view of people."

He could argue that, but not now. Defense hadn't warped him; it had made him realistic. "You want out of our new partnership?" he said.

"*No!* My half of it just got bigger," she said. "Something like this is why I retained the right to argue with you when I signed on."

"Fine. I'm glad you're still with me . . . on any basis. But Marty, you're going to have to be a lawyer about this . . . not a groupie for a politician."

"Groupie? Why you . . ." She stopped, and squared her shoulders. "May I point out that you're going to have to be a lawyer, too, and not a reckless crusader?"

"Don't you *see* how everything points to Heck?"

"No, I don't. Aren't you forgetting the possibility that Luis isn't lying? That he really and truly doesn't know who it was he saw leaving Lupe's house that night? Aren't you also forgetting that now he may *be* lying? That he did kill her? It's what Gilman and Scanlon think. Theirs is the only hard evidence. You may be riding those famous 'instincts' of yours to a nasty fall."

"I always consider that." He bristled, his beard actually stiffening a little. She had put a doubting emphasis on "instincts." His pointing the finger at Heck had been more than instinct . . . hadn't it? "I'm right," he said, "I know I am." It was hard to keep his voice low. He wanted to rage—not at Marty exactly . . . at anyone. "It wasn't just the stuff I saw at the TV station or Julia Perez making what is probably Heck's Pinto. There was your hero's insistence on getting in to see Luis."

"For crying out loud, that's perfectly *natural!* You're twisting your view of his behavior after the fact. You couldn't praise him enough after you met with him."

"I'm not twisting it," he said, "I'm merely reassessing his remarks in the light of new circumstances. I feel in my guts that Heck wanted to know if Luis saw him in Griegos that night."

"You feel it in your guts? Oh, sure. And if *I* say something like that, you'll accuse me of relying on some nonexistent woman's intuition, right?"

Maybe she *was* right, but it would be foolhardy to admit it now. He shrugged and began again. "It's probably just as well you

don't agree with me. If I can prove my suspicions to *you* . . . I should be able to prove them to Ben and Phil or the court."

"How do you propose to go about it?"

"We—since you've assured me it's still 'we,' " he said, "can start a little investigation of our own. It's doubtful we can get Gilman and Scanlon to do it." He waited, hoping for another confirmation of the "we," saw a slight nod, and decided he had gotten it. "I called Cisneros. He'll give us a key to the house. APD has the place off limits to the press and everybody else, but I can get us in. There might be something there the cops missed because they were thinking Luis Esquibel, not Heck Velasquez." Her mouth opened to say something, but he held his hand up. "Damn it! Be objective."

"Okay," she said, "I'll be objective . . . but you'd better be objective, too. I'll make you a deal. When we're down there I'll conscientiously look for things that might hang Heck, if you'll be as open to something that points to precious Luis. It won't be easy for you. I know how blind you get when you're defending."

He checked his tongue just in time. He had been about to point out to her that in her first outburst it had been *she* who was defending. "I'll be fair," he said.

"You'll try," Marty sniffed, "I'll give you that much. All right. We check the house. We find something or we don't. What then?"

"We talk to the people around Heck, the ones who might remember Lupe."

"Hang on now! We only do that if we can do it without you opening your big yap about your suspicions . . . or arousing any in the people we talk to. Because if you're as wrong as I think you are, I'll never forgive you if this quixotic chase damages that man."

There was more here than mere regard for an attractive politician. He couldn't figure it. Maybe he was attaching false motives to everyone. "Fair enough," he said. "We'll talk with Heck first then before we tackle anyone else." He put a little stress on the *we*. He thought it would please her. She wrinkled her forehead.

"Well . . . ," she said, "I'm not sure *I* should actually sit in on any talk with Heck."

Another surprise. He thought she would jump at the chance. "Afraid?" he said. "Of what you might come to think?"

"No, damn your eyes!" Hers blazed. "You couldn't keep me out of it now. And I'm going to talk to Luis, too. Unless *you're* afraid."

That tore it. If he balked, he could never make her believe why he didn't want her going down to D. He had better try to duck on this one. "That's important? Now?"

"You bet it is. When can we see him?"

"Tomorrow . . . or the day after." He would think of something. Sure he would.

"Okay," she said, "but no longer." She stood up. "Get the key from Cisneros, then. I'll call Heck right now. We'll take him first."

She turned to leave, turned back.

"Dad . . . ," she said, "can any defendants be worth what you put yourself through for them? Do you *realize* the lengths you go to? And if you do . . . why? I want you to tell me. No kidding."

They weren't questions he hadn't asked himself often enough over the years. "Marty . . . ," he began. Good Lord, he was squirming, and he knew from the look on her face she had caught him in a blush. "Oh, hell! It sounds too self-righteous and puffed-up and crappy when I try to put it into words . . . and you've heard it all before, anyway."

"Since I'm in this with you now, maybe I'd better hear it again."

He leaned back in his chair and stared at the ceiling. She knew everything he could tell her, had breathed it in all her life. Men— or women—caught in a criminal prosecution had no one else but him or someone like him. All the power of the state was ranged against them: huge police forces with every technical advantage and tough, skilled cops like Phil Gilman to lean on the accused and whatever witnesses he or she might have; batteries of damned good lawyers to prosecute them; and a revenge-bent public urging them on.

"You've never had to face Ben Scanlon in court, have you?

He's damned near brilliant . . . and he isn't paid to be merciful to a defendant."

Careful . . . don't enjoy this too much. "As you know, Marty, just to be *accused* of a crime is tantamount to guilt in a lot of eyes. It isn't fair, but that's the way it is. The law doesn't *mean* to be unfair, but it can't help itself. Oh, things have gotten a *mite* more fair in recent years, with Miranda, the exclusionary rule, and a few other little things, but the deck is still stacked against the lone defendant. That's where I . . . *we* come in. All I ask is a fair chance for my clients. I don't mind taking a few risks along the way to see they get it." He stopped. "End of lecture," he said. "I warned you." He lowered his eyes from the ceiling and looked at her.

"But, Dad . . . ," Marty said, "haven't you won acquittals for clients you *know* are guilty?"

"Yes. Not often. Three times, I think. There may even have been a few guilty ones I *thought* innocent, too."

"As an officer of the court, doesn't that ever bother you?"

"Sure it bothers me. But I don't grieve about it, and I sure as hell won't apologize. It bothers me that with all their advantages the police and prosecution sometimes do a sloppy job. As a citizen and taxpayer I damned well resent it. And it bothers me that an occasional criminal is too clever for the law, too clever for his own attorney. But in defending that kind of client I also keep in shape for the ones who really need me. Remember, too, that there are a lot of successful defenses that don't end in acquittal. Generally, I'm not sorry, either."

"Not sorry?"

"No. A lot of my clients *belong* in jail. Orville Blakely's one of them. The biggest part of my work as a defense counsel is to see that for any number of reasons, the political climate of the moment, bad laws—and you know there are plenty of those—other things like public sentiment about a popular victim, say a U.S. president or a rock star, my client isn't punished *beyond* what's right and proper." He smiled at her before going on. "There's one more reason I do what I do, Marty. I don't enjoy saying this, but

since we're 'partners' I guess I should. I'm not really a good 'lawyer' anymore."

"Come *on*."

"I mean it. I've forgotten nine-tenths of what I learned in law school, and I haven't done more than just glance at the advance sheets and supplements in years. You and Rudy know far more law than I do now. I wouldn't have a chance of passing the bar today, and the young hotshots just hanging out shingles would take me apart in minutes if I tangled with them on a case that really turned on 'law.' I'm a defender. I'm a *hell* of a defender. It's what I do . . . and I mean to go out doing it." She was smiling at him now. Damned if she didn't look as if she'd gotten a touch proud of him in these past few minutes. Then he had to risk spoiling it. "I'd feel the same way if it was Heck sitting down in D instead of Luis." If his office held a more combustible gas than the kind he had just filled it with, the sparks in her eyes would have set it off and blown it to kingdom come.

He didn't cross-examine Hector Velasquez after all. With Marty sitting at Heck's elbow he suddenly felt it would be like cross-examining her. He *told* Heck everything he knew and guessed. By the time he finished, the man was a different man from the one Jack had eaten with in Ortega Hall. He hadn't gone to pieces; he had hardened. When Jack finally asked him, "You killed her, Heck, didn't you?" a totally disinterested party could have read either guilt or innocence in his face. Jack wondered how *interested* party Martine Lautrec was reading it. For the moment he didn't dare look. "You're not going to deny you *knew* Lupe Sanchez?" Jack said. "I can subpoena those TV tapes." He was bluffing; Luis, by forcing that ridiculous promise from him, wouldn't let him.

"No," Velasquez said, "I won't deny it. I knew her. I knew who the murdered girl was from the time Orlando called me and told me they had arrested Luis."

"You mean you knew it when you *killed* her."

"I didn't kill her, Jack." The politician turned to Marty then

and Jack got the feeling that he was no longer going to be able to reach Heck, not today. "I didn't kill her, Marty," he said. There was something subtly more beseeching in his tone with her than in the one he had used with Jack. He was going on, "I think you know I could never kill."

Jack broke in, "Will you also deny it was *you* Luis saw leaving the house on Wallace?"

Heck looked back at Jack but didn't answer. He turned to Marty again.

"Heck," Jack said, "I'm curious about something. Luis's sister hasn't been to D trying to see him. Can you tell me why?"

This seemed to startle Velasquez. "I've asked her to," he said, "but she can't bring herself to see him while he's in that place. If you knew her, you'd understand." Again he looked at Marty. "I don't think I should say another word today." When he looked back at Jack it was as if a mask had dropped; the genial politician was nowhere to be seen. Had Marty noticed?

"I'm going to get you, Heck," Jack said.

Heck stood up. "You're going to have hell's own time doing that, counselor." Deadly. A man who could kill stood in front of the two Lautrecs. He left the office. Jack decided to wait before he looked at his daughter. Let her tell him what she was thinking when she was ready.

The first sound from Marty was a muffled sob.

"Hey!" he said. "I'm sorry, I really am."

"Don't, Dad. Don't say a word. Just leave me alone!" She shook her head as if she were trying to fling away tears before they came. She bolted from her chair and through the door.

It couldn't be much fun to have your hero torn to shreds in front of you. Jack, of course, hadn't *torn* Heck, he had only clawed at him, and without much effect at that, but in Marty's eyes it must have amounted to much the same sorry thing. Still, her reaction had bordered on panic. What was he missing here?

To his utter surprise, he had scarcely finished telling himself what a heel he was before she was back. She had composed

herself and looked as keen and determined as if she were just heading into court on a big settlement she was sure of winning. "All right," she said, "let's get the keys and go down and look at the house in Griegos."

≡≡ 17 ≡≡

Checking the house in Griegos turned out to be more easily said than done.

There had been no problem getting the keys from Cisneros, and a call to Gilman had brought permission, but when they reached the place they found the police had installed a padlock. They had to drive three blocks to a phone booth, call Gilman again, and have him send someone down. The captain didn't question their right to take a look at the scene, but he clearly relished delaying them. "Deliberate," Jack said. "He knew about the lock. He could have said something, but I think he wants to keep that edge Ben feels he has on us."

During the wait for Gilman's man, the two of them sat at opposite ends of the top porch step, feeling the same awkward strain as they'd experienced on the drive down. Neither of them had said a word in the car, nor did they in the twenty-five minutes it took the black-and-white and the young cop with the key to pull up in front of the house. "Captain Gilman says to remind you you're not to take anything out of here," the cop said as he swung the door open for them. He walked back to the curb and got into his patrol car. He didn't start it, but reached instead for

the mike of his two-way radio. His boss must have told him to hang around until they left.

Jack stood to one side and let Marty enter first, and then followed her across the threshold. Their mutual silence went with them through the door.

The police had set wooden standards with ropes looped between them around the couch in the living room. The setup made it seem to Jack as if he and Marty were gawking at exhibits in a museum. Blood stained the couch, and on the carpeted floor a chalk-marked rectangle showed where they had found the knife.

As they moved through the house he couldn't shake the museum idea from his head. It was as if Lupe Sanchez—or Akidha or Cissy Jackson, however she thought of herself in those last moments—had lived and died in another time. He came to this house without any real thoughts on what the young woman had been like; he knew now he would leave with none. It was as if, used to hiding from what had driven her from New York, she had gone right on hiding within these bare walls, fearful that any hint of personality or character she might reveal would be broadcast well beyond them.

They found little in the way of furnishings, no pictures, no bills, no correspondence of any kind. Tubes and jars of makeup stocked the cabinet in the one bathroom, but there was none of the evidence Jack would expect to find if a man used it regularly. He watched as Marty riffled through the clothing in the closet of the bedroom. The few outfits on the padded hangers looked expensive, not that he was knowledgeable about women's clothes. Hell, he hadn't even known what a shirtwaist was until Marty mentioned that Fran was wearing one the other day. Finished with the closet, Marty walked to the bed. She stood looking down at it for half a minute, then shook her head. When she left the bedroom he went to it himself. If she had seen something there it eluded him.

The only tiny thing they did discover they discovered in the kitchen. Akidha—Lupe—had been a health-food freak. Marty found enough wheat germ and other vitamin-packed natural

foodstuffs in the cabinets to feed a commune. Even this did nothing to bring to resoultion the blurred, grainy picture he had of Lupe Sanchez.

He thought of Luis's monklike quarters in his parents' home. The boy's room had been kept bare to hide his personality from his intimates; hers seemed purposely bereft of ornament to hide hers from the world. His room was ascetic. Hers was merely empty . . . lonely. He caught himself up short. In the past he had worked hard to *distance* himself from any victim. Sympathy for a victim, even when his client was as innocent as Luis Esquibel, posed dangers to a rigorous defense. When this case was over with, then, and only then, could he permit himself to feel a little grief for this murdered girl.

On the way out, Marty stopped in front of the roped-off couch. Then she moved quickly to the door and through it. The young policeman watched from his patrol car until Jack snapped the padlock in the hasp, then he smiled, waved, and drove away. Marty had taken a seat on the same top step and Jack eased himself down next to her, almost touching her. She didn't move away. They seemed to Jack to be huddled together in defeat, not at all the way they had been as they waited to get inside.

"All right, Dad," Marty said. "You win. It was Heck who killed her." She sounded sick.

His mouth fell open. He had *won*? Funny, he felt no sense of triumph . . . none at all. "Did you see something in there that escaped me, Marty?" he said.

"Not a thing. This excursion was largely a waste of time."

He decided it would be prudent to wait a moment before he asked her anything more. "Well, *daughter* . . . ," he said at last, hoping that the reliable old taunt might bring her around, "would you mind telling me exactly what brought you one hundred eighty degrees around to this conclusion?" She turned to look at him. His ploy hadn't worked.

"Before I do, there's something else I have to tell you first. I should have told you the moment we began working this together,

but I was afraid you might think it was the *reason* I asked if you wanted help. You'll have to take my word for it that it had nothing whatever to do with my decision. My *stated* reasons were the real ones. Will you believe me?"

"No reason not to. You never lied to me about anything important in your life."

"All right," she said. "Brace yourself." She turned from him and looked straight ahead. "I've known Luis Esquibel a long time, Dad. I met him through his sister, Ana—and Hector Velasquez."

"You got involved with them in politics?"

"No, Dad. Eight years ago, before he married Ana, I got to know Heck as well as I've ever known a man." There was a quaver in her voice. She drew a deep breath. "We were lovers. It didn't end well, and I came close to hating him for a while, but until today I never could have pictured Heck as a murderer." The last hadn't quavered.

Had she told him "Brace yourself?" He could no more have braced himself for this than he could have stood against an avalanche. Damn it, she was breaking the rules! Daughters didn't tell their fathers things like this. It wasn't that fathers were necessarily prudes, or stupid, or out of touch with (or opposed to) today's morality. Had he ever allowed himself to think about it, which he hadn't, he would have admitted—intellectually—that, yes, Marty, like almost any other healthy young professional woman who had postponed marriage, had probably known a small number of men that way. There was still a convention that had to be maintained. *Daughters didn't tell their fathers.* Oh, hell! It really didn't matter.

Wait a second. Yes, it did matter. He tried twice before he got it out. "I can understand why you're telling me this now, Marty, but . . ."—he would have to say the next words very, very tenderly—"why didn't you tell me then?"

Good Lord, her shoulders were trembling. There was no sound, but she was shivering with tiny sobs.

She lifted her head when the tremors stopped. "I had Mom

back then, Dad. I took all my stuff to her. I could tell her anything. Remember how she was? . . ." (*Oh, yes, Marty, I remember! Jane was the deep, loving center of our family, she was the only one who . . . but he better not miss a word this daughter of his was saying*) ". . . I had just joined the firm, and you were the great lawyer to me, not just my father. You had more important things to think about than my love affair, or so it seemed to me. Maybe telling you about Heck just now will help explain what made me change my mind. It happened when you asked him why Ana hadn't tried to see her brother."

"Oh?"

"That did it in spades. I know Ana. I made it a point to *get* to know her when he left me for her eight years ago." She turned and looked at him. "This isn't easy."

"I don't suppose it is, but why did my question make the difference?" Lord, but it was hard to force his mind back to the case of Luis Esquibel.

"The Ana I got to know would have been crazy mad to see her brother," Marty said, "and I can't believe she's changed. The only thing that would have kept her away is if Heck *told* her to stay away. It's actually the only flaw I ever found in him; his secret attitude toward women, not the public one. Ana is his perfect little helpmeet wife. He trained her. I think it didn't work out for us because I simply couldn't *be* an Ana. That's part of the story I still don't want to tell anyone. The bottom line is that if Heck kept her away from Luis, it was because he was hiding something, something he didn't want her to know. He knew Luis would tell Ana the truth. And Luis played right into Heck's hands because *he* knew Ana would get the truth out of him. That's why he refused to see his family."

Jack refrained from pointing out to her that, except for the part about Ana, these were the things he had tried to tell her earlier. Perhaps if she hadn't been in so much pain now . . .

From where they were sitting, he could see Sandia Crest looming through the cottonwoods. *Thanks, Jane. You still send me gifts.*

"Dad," Marty said now, "tell me exactly what Heck had to say in your meeting in Ortega Hall."

"I might slant it, Marty . . . without meaning to." Funny, how you sometimes backed away a step or two from a fixed position when people started to agree with you.

"I'll make allowances," Marty said.

He repeated the conversation in Heck's office almost word for word.

"Interesting," Marty said. "Particularly where you described Akidha, and Heck said it could be a woman on the campus or in one of his classes. There are a number of good-looking black girls who drift in and out of his campaign headquarters. Odd that he didn't mention *them*."

"I don't know," he said. "You didn't remember them either when you were trying to think of where you'd seen her." Good grief! Was he suddenly beginning to build a brief for *Heck*? Apparently she didn't catch that. She was fiddling with the hair covering her right ear, feeling for the pencil to tap her teeth, and not finding it she looked a little at sea.

"We can't go to the police or Scanlon with this, can we?" she said. "No proof."

He nodded. "And they'd never believe us."

"But . . . we can build a little fire under Dr. Hector Velasquez. Maybe he'll panic . . . make a mistake."

"It fizzled out when I tried today," Jack said.

"Let me take a crack at it. I'll make some calls when we get back to the office. I just might know people who know more than we do."

"Who?"

"I'll tell you tomorrow." In a lightning switch she smiled at him. "Right after you've taken me down to D to see our client."

He not only didn't feel inclined to argue with her, he had the sudden realization that now he wanted Luis and Marty to see each other. Someone closer to the boy's age might persuade him to let them go after Heck. It wasn't very much to hope for but for now it was their *only* hope.

"I think I see things pretty clearly," Marty said. "And I think you ought to call Orlando and tell him to get Ana down to see her brother. No, I'll do it. You made those promises to Luis, darn it."

What she didn't see, nor did Jack, was the Cadillac with the New York plates parked halfway to the stop sign at the cross street, nor the driver, a black man dressed in a dark wool suit, with a ribbon-thin black tie knotted tight against a starched white collar. Dark glasses hid his eyes.

As their two cars pulled away from the curb the Cadillac followed, but at a distance.

18

Jack Lautrec's city, seen by him from his balcony at night, was as alive as it was sometimes dreary in the daytime, and he never went to bed without spending a few minutes out here looking at it.

It hadn't quite gotten as cool as it would but it was deliciously cool after the heat of the day. The scene in front of him was a sparkling sight, as if someone had taken a giant brush, dipped it deep into the Milky Way, and laid a coat of stars on the valley floor. Through the clear night air he could follow the big eighteen-wheelers braking their way down Nine Mile Hill on Interstate 40 across the Rio Grande. His phone rang. He was tempted to let it go unanswered.

"Dad? Marty. I made my calls. I've seen some people."

"And . . . ?"

"Good news and bad." She gave "good" and "bad" equal weight.

"Bad first," he said.

"Can't. The bad news comes out of the good. You'll see."

"Okay. Good first then. Shoot."

"Remember the girl in Heck's office?"

"Bonnie?"

"Right. Bonnie McCabe. The girl who organized Students for Velasquez."

"That's her, I guess."

"Well, the good news is I'm sure if we can get her under oath we could force her to testify that Akidha and Heck were lovers."

"Great!"

"There's more. Akidha . . . or Lupe . . . did leave Luis for Heck, not that Luis ever really had her from what Bonnie says. Nobody knows when it happened, but nobody knew about Lupe at all until the night of the celebration at the Hilton. She wasn't any part of Heck's campaign in the primaries. That's why I didn't remember her. I would have known her from the Hilton victory shindig, but I was stuck in my precinct until three A.M., waiting for the Election Board to get a voting machine unglued. That was the only time she and Heck were within ten feet of each other . . . in public. She began showing up at headquarters after the runoff campaign got under way. Now I'll confess I sure as hell would have noticed any woman Heck was getting close to, even though we weren't together any longer, but I took a rest from politics after the primaries." There was a long pause. "Back to business. Apparently Lupe was content to stay in the shadows . . . until the victory party. When Heck won so big she suddenly wanted in on it. Got pretty damned insistent. Started coming to Heck's headquarters *then*. Made some low-key scenes. Now get this . . . according to Bonnie, Heck was going to make a break with Lupe when she solved the problem for him by getting herself stabbed to death."

It all sounded just *too* good. "Marty," Jack said, "Bonnie wasn't just *waiting* for the chance to spill this. The girl I saw in Heck's office would go through fire for him."

Marty laughed. "Dad! I'm going to have to teach you a few things about women. Look, I know Bonnie McCabe would hop in the sack with Heck if he crooked a finger, but jealousy has its own peculiar logic. I just planted a few dirty reminders in Bonnie's mind and I couldn't shut her up. She got pretty wild about poor Lupe even if she is dead."

"She knew our Jane Doe was Lupe? How? It hasn't made the news yet."

"Seems Heck told the people close to him after he saw us this morning. Wanted to warn them you might go on the attack. Anyway, she rattled on until she suddenly realized she was playing right into my hands. You're right that she doesn't *want* to hurt Heck . . . and that's where the bad news comes in. When she realized she might be implicating Heck, she tried to take it back. Now she says she's going to Scanlon to tell him she heard Luis threaten to kill Lupe after they broke up—and she'll even bring along a corroborating witness."

"The boy who was with her . . . Emiliano?"

"Right."

Jack felt as if *he* had been stabbed. As Bonnie would protect Heck, so Emiliano would lie on the witness stand like a trooper for the girl. *He* looked too tough to shake. "Luis didn't make such a threat. Stake my life on it," he said.

"Well, we can ask him when we go to D tomorrow." Damn! He couldn't get out of that awkward chore now. "One thing, Marty," he said. "Even this news isn't all bad. If Bonnie makes such a statement on the stand, she might speculate on *why* Luis said what she says he said. If she mentions Heck, I'll go after him in cross. I only promised Luis I wouldn't bring his name up myself."

There was silence on the line again before Marty said, "Something I want to point out. Except for the fact that Julia Perez saw the Pinto, I would swear Heck wasn't meeting Lupe at the Griegos house. I didn't see any signs a man would leave."

"How would you know the signs a man would leave?"

"Come *on*, Dad." There was a peal of strong laughter from the other end. "I'd know the signs of *this* man . . . in Timbuktu. Heck shaves twice a day. There wasn't one solitary item of men's toiletries in that bathroom cabinet." When she said good night he almost slammed the phone into its cradle.

He went out to the balcony again. Yes, if Ben (or his stand-in Curt Santorini) got Bonnie to tell her story (contrived or not) on

the stand, Jack wouldn't have to subpoena her, and from the seesaw she had ridden in her talk with Marty, she would probably fall apart under cross-examination. She, not Jack, would bring to light the affair between Heck and Lupe. A good judge would probably sustain objections on Jack's cross, but the jury would have heard the questions, and with any kind of luck the answers. But this would only prove useful at a trial, not at the arraignment coming up. Forget it for now, Jack. And if he was going to sleep tonight he had better forget more than just Bonnie McCabe and settle down. He went back to watching over his city.

The phone rang. Marty again? Much as he needed more information he hoped not. He needed rest more at the moment. Wrong number maybe. For once he hoped so. It wasn't Marty. "Mr. Lautrec?" It was a woman's voice, an old brittle voice. "This is your neighbor Adele Thompson . . . up above you. No need to answer. I'm so hard of hearing over the telephone I wouldn't understand you anyway. I'm calling to ask a favor. Could you take Marie-Louise out for me tonight? My sciatica is acting up. I've already called the two other people in the building whose names I know, and they're not home." Who the hell, Jack wondered, is Marie-Louise? "Please, Mr. Lautrec. I'm counting on you. I'll have Marie-Louise on her leash when you ring my door."

For Pete's sake . . . that insufferable little dog!

He was trapped. He couldn't even tell her no. Hard of hearing or not, she hadn't waited for an answer. He boiled. It meant getting out of his robe and into slacks, shirt, and shoes. Then there would be the struggle up a flight of stairs (for the first time he wished the apartment building had an elevator), down two flights to ground level, up two and down one again. All that Sisyphean agony for a mewling little mutt.

Adele did have Marie-Louise all ready when he reached her door. "Oh, thank you, Mr. Lautrec! You're a good neighbor. Marie-Louise likes that grassy slope just this side of the parking lot." She clucked and cooed to the poodle until Jack feared he might vomit. Adele was pressing something in his hand. "And,"

she said, "Marie-Louise gets a little reward when she's done her business nicely."

Shame overcame his irritation. The old lady did look as if she were experiencing a lot of pain. He knew a little about that, but he didn't feel too damned sympathetic after he had stood for ten minutes on the juniper-ringed lawn near the parking lot, waiting for the fussy little animal to find a spot that suited her. Marie-Louise, a thorough if not expert sniffer, wandered back and forth, in and out between his legs and the two canes. The lawn was still damp from the sprinklers he had seen running when he got back from dinner, and he couldn't rest much weight on the canes for fear of them sinking into the soft sod. The knees were complaining, and the biscuit Adele had handed him was getting sticky. "Come on, you bush-league, lilliputian Lassie," he snarled, "squat and get it over with. We haven't got all night." Nothing. The leash was shortening as the tiny dog wound its way around the canes.

Then Marie-Louise stopped her sniffing.

She faced the junipers screening the parking lot with her weasel-slim body suddenly as tight and rigid as if she were made of stone. She gave a throaty growl that sounded as if it might have come from a much larger dog.

"Get on with it!" Jack said. "There's probably a coyote in there ready to make a meal of you."

The poodle was quivering now.

Then, yapping like a harpie, Marie-Louise shot toward the trees. The leash tightened on the canes, jerking them away. As he fell in a heap on the wet grass, Jack heard the whine of the bullet passing through the space where his head had been. The report of the shot was an echoing afterthought.

There was the noise of running feet. He picked up the figure of the runner as he reached the floodlit parking lot. A man. Just before the man disappeared in the rows of parked cars, he turned and looked back toward the grassy slope. He was carrying a rifle with a scope. The light came from behind him, and Jack couldn't

make out a thing about him. Then he was gone, and Jack heard the door slam on a car he couldn't see . . . gravel screaming through the air . . . the car roaring off. It needed a muffler.

"Here she is, Mrs. Thompson. All safe and sound and satisfied."
 "Thank you, Mr. Lautrec. You're a dear."
 "Fine little lady you've got there, Mrs. Thompson. Intelligent."
He meant it. He could have added "brave" . . . oh, yes.
 "What, Mr. Lautrec? I'm sorry. As I told you, I don't hear too well."
He didn't have the heart to tell her he didn't know whether Marie-Louise had found her spot or not. He hoped there wouldn't be an accident on that cream-colored, high-pile carpeting.

He turned out the lights in the apartment and closed the door to the balcony. Whoever it had been must now be halfway across the city, but he could, Jack supposed, come back. The way he had fled from the junipers into the parking lot he must have known he had missed. And he must have been an amateur. A pro would have waited a second or two after the shot and then, hearing and seeing no commotion in the building or on the grounds, would have stepped onto the grassy slope and calmly killed Jack properly. This gunman had panicked. He had probably known as much fear in that instant in the darkness as Jack had— and that was plenty.

After he had delivered Marie-Louise Jack had come down to his own apartment and picked up the phone to call the police. He put it down. What would the cops find? As well as he could guess at the line of fire, the bullet had passed across the front of the apartment building without striking anything. It wouldn't be found in a hundred years. There were no witnesses. The lack of any sign of disturbance probably meant that if anyone—certainly not deaf old Adele—had heard the shot, they most likely had thought it the backfiring of a car, something confirmed by the gunman's noisy exit.

But the main reason for not reporting it was that when the

news of what Jack claimed to have happened reached Gilman, and, through Phil, Scanlon, they would laugh it off as just another ploy of "old Jack Low Trick," a story concocted to cloud the issues surrounding his defense of Luis. Who could blame them?

He wouldn't tell Marty, either. Not now, anyway. She would be terrified for him. But he was positive that the attempt on him was connected with Luis's case. There had been threats against his life before, but with the possible exception of the halfhearted gunslinging of old Abe Hackett, they hadn't come to much. Still, maybe he was wrong. Maybe the man was a pro after all. If so . . . who had hired him? Hector Velasquez? Somehow he couldn't picture the candidate paying to have him killed, and inviting the man into his confidence. No, a man who could plunge a knife into a helpless girl would do his killing himself.

However . . . he could buy Heck as the *instigator* according to one plausible scenario. Some messianic young activists in his following would do anything for him. Heck could have ordered Jack's killing in much the same offhand manner Henry II got rid of Becket when he said to no one assassin in particular, "Will no knight about me rid me of this troublesome priest?"

Maybe Marty had stirred this up with her questions. Bonnie? . . . Emiliano? It hadn't been many hours since Marty had talked to the girl, but news like Marty's and the fury it could provoke would travel with the speed of light.

My God! Marty! If the would-be assassin hadn't tried for her yet, it didn't mean he wouldn't. Reason told Jack that *he* was the only one whoever had sent the assailant would figure it would pay to get, but reason wasn't always enough. He grabbed the phone.

"Hello?" There was the sound of a muffled yawn. She must have been asleep.

"Marty?" What would he say now?

"Something up, Dad?"

"Is there any chance we could be wrong about Heck Velasquez?"

"I'd like to think so, but no, not a chance."

"Marty, take care of yourself. No telling what a man who feels things closing in on him might take it into his mind to do. Lock yourself in."

There was a gale of laughter. "I always do. I've lived alone since before you sold the old house, remember?" There was a pause. "Hey!" she said. "You know what I almost said? I almost said Heck isn't the type to kill anyone." Another pause. "Funny . . . in what *you* just meant, I guess I still feel that way."

He was in bed and almost asleep before the shakes came.

Fear . . . he had met and known it often enough in Korea, but this was different. When he had been in firefights at Inchon and later, the fear had been a generalized thing. This was sharp-focused, intense. He knew he wouldn't become unsprung, but it bothered him.

He must have been silhouetted on the balcony when the gunman arrived. First Marty, then Adele Thompson, had called him to the phone. Marty might have saved his life with the first call, and that good little dog had probably saved it twice. It might be a long time before he could sit out there on a summer evening again and enjoy his city.

⚞ 19 ⚟

"You'll see in a second why I'm so worried about Luis being in
this cesspool," Jack said to Marty as they rode the elevator. "I
don't want him turned into a piece of meat. Stick close to me
when we get inside the gate to the rec room. No wandering off."

"Dad! I've been up here before. It's a little cruder and smellier,
but it's fundamentally no different from a singles bar." Jack
winced. Singles bar? Don't tell me. He wouldn't ask, either. He
was learning.

Gus Gantry didn't speak as they passed his office, although he
did give Marty a suggestive leer. He was clipping his nails with
one of those little gadgets. Funny, the surly lieutenant hadn't
passed up a chance to needle Jack for years. Maybe Scanlon had
ordered him to stay laid back with Luis Esquibel's lawyer. It
figured.

There was nothing funny in the look on the face of Brooks
when the guard opened the barred gate for them. Something was
peculiar, but not funny. Oh, hell, Jack thought. You're getting
paranoid because of last night. Knock it off. "Esquibel please,
Brooks," Jack said. Brooks flinched a little at the name Esquibel.

"Yes, sir," Brooks said. "I just left him in the mess hall." Why would Brooks *be* with Luis in the mess hall?

"Would you mind taking us to him?" Jack said. It wasn't his usual habit, but perhaps with Brooks as escort the ganging-up of the other inmates wouldn't be as heavy or as time-consuming.

"No, sir," Brooks said. He looked away. Had the dudes gotten to him in these few short days? Brooks turned then and began to lead the way. The men in blue suits didn't even try to hedge them in as Jack had expected. Maybe they were used to Jack now, and maybe asking Brooks to take them to Luis had done the trick. But still, whistles and catcalls directed at Marty sounded as the three of them crossed the rec room. Jack glanced at her. For all the nonchalance she had displayed in the elevator and her flip remark when they left it, she was now looking straight ahead of her, wearing that "no-see-'em" look he had noticed in recent years on strollers in the seedier blocks of the old downtown Route 66 district, the zombie masks walkers on Central Avenue affected to keep from making eye contact with the creeps who loitered in doorways and puked in the alley entrances.

At the door to the mess hall Brooks stopped suddenly. Jack saw him square his shoulders with an effort. He turned around and faced them. The nice black face had turned a sickly gray. "Mr. Lautrec," Brooks said, "no matter what I've been told, I can't just let you walk in there and look at Esquibel without getting you ready for what you'll see."

Jack's stomach suddenly turned as sick as Brooks's face looked. "What's gone wrong, Brooks?" He didn't wait for the guard's answer. He burst through the doors of the mess hall.

Luis was sitting alone at a table in the huge, empty room, his head down on his folded arms.

"Luis!" Jack shouted.

The boy raised his head, looked at Jack and Marty, and turned away. He tried to hold his head up, but it fell to his arms again. In that brief second Jack heard a strangled cry from Marty. His own nausea, the gagging in his throat, kept him from uttering a sound.

"I reported this, Mr. Lautrec," Brooks said. "I swear I did."
The contusions and swelling on the boy's face weren't the result of the fistfights Jack knew punctuated the monotony of D every hour on the hour. This was something more, something deadly. Luis had been worked over thoroughly, deliberately, and by some-one—or several someones much more likely—who knew every crippling trick. Dudes? Guards? Dudes most likely, but it didn't matter. Around eyes so puffed the brows and cheeks had split, across the flattened, misshapen nose, Jack saw purples, greens, yellows, an agony of hues.

He saw one other color . . . red.

"Gantry!"
"Yeah?" The man looked bored.
"Have you been *out* there? Have you *seen* my client?"
"Sure. I took a look. This ain't no kindergarten. What did you expect . . . the way he's acted? Somebody roughed him up is all. Shit man, you know it happens here all the time."
"What do you mean 'roughed him up is all'? That kid was beaten near to death. Who did it? I want names and numbers!"
Foolish. He wouldn't get them, particularly if it were the guards who had done it. And if it were the inmates, Gantry might not know. Even decent Brooks wouldn't tell him if *he* knew. Luis *surely* wouldn't, no more than he had told Jack and Marty in the mess hall. Innocent as he well may be, he was a con while he was in this hell hole and he would at last have learned the rules that might keep him alive until Jack worked some miracle and got him out of here.

Gantry just looked sullen.
"Have you called a doctor, Gantry?"
"A paramedic looked at him right after morning check-off."
"You bastard! That's not good enough and you goddamned well know it!"
"All I can do."
"No, it's *not!* I want that kid over at the Bernalillo County Medical Center and I want him there within the hour." He

pointed a cane at the phone on Gantry's desk. "Pick that up and call an ambulance."

Gantry didn't stir. "Suppose I refuse?" he said.

"If you do you'll be the sorriest screw in the history of this sorry dump."

Gantry's face wore an open sneer now. "You'll try to get my job, huh?"

Jack shook his head. He took a slow step closer to the desk. Then he shot a big hand toward Gantry, and the cane it had held clattered to the floor. His hand closed on Gantry's uniform tie and he jerked the guard lieutenant toward him over the top of the desk and held him with their two faces no more than an inch apart. "No, Gantry. I won't try to get your job." The first hot rage had left him now. His voice was low. "And I won't even try to get this on your miserable record. I won't do one *official* thing about it, not even if that boy dies. This will be strictly between you and me. A personal matter, Gantry. You'll pay. I give you my word of honor." He released Gantry then and the prison officer sagged back into his chair, his face white. "Now pick up that phone while you still can and make all the calls you have to make to get my client to BCMC. Call, Gantry! Or *you* won't even need an ambulance."

He scared himself. How much of this threatened violence truly resided in him? He recalled his own words to Marty: *"No man is incapable of murder, Marty."*

He waited at the back entrance of the detention center for the ambulance to arrive. He was shaking. Fear for Luis and rage at Gantry had chased away some of the memory of the gunshot of the night before, the uneasy memory that had plagued him during the ride down to D with Marty, even when she had been getting on his back about his driving. He had to admit he had been pretty erratic behind the wheel. Now, in light of what he had just found on Three West, he knew he would have to put off thinking about the attempt last night.

A blush began and died. It was the delayed embarrassment he

hadn't felt while in his mixed sickness and anger he had asked Luis—in front of *Marty*—if his attackers had sexually molested him. His stomach had knotted as he asked. The pain and marks of the beating would probably fade in time; the trauma of the other never would. And there was that other thing, too. The boy had shaken his head, not much; they had left Luis's neck and head too battered for much motion of any kind. Jack's relief was short-lived. Of course Luis wouldn't admit to being raped. It was the D center version of that idiotic Sicilian stuff, *omerta,* the code of silence. He got Brooks to one side and asked him what *he* thought. "Don't think so, Mr. Lautrec," Brooks said. "At least he was fully dressed when Clint Rafferty found him in the can this morning. Hardly seems likely they would take the time to put his clothes back on, and he sure couldn't have gotten dressed himself. And there wasn't the blood on his pants you usually find after a gang job."

Jack would have to satisfy himself with that.

Marty had started to the back of D with him to await the ambulance, but when she remembered she had left her purse in a locker in the hall near Ron Chavez's reception desk, she had returned to the lobby, telling Jack she would wait in the car. He knew she really didn't want to look at Luis again right now. He couldn't blame her.

When he had returned to the mess hall after the row with Gantry, Marty had been seated at the table with her arm around Luis. It didn't look as if the boy was even aware of her. Brooks stood beside the two of them, his face drawn, an aching look in his eyes. The guard was wearing well with Jack. It amazed him not that the system could harbor bad ones like Gantry, but that it was also home to so many J. J. Brookses and Ron Chavezes. No regulation had made Brooks come with them; it had taken guts, particularly when he knew what had already happened to Luis.

The rear door of the detention center opened.

Brooks had found a wheelchair somewhere, and Luis was

crumpled in it. He nodded a feeble nod to Jack and started to say something just as the ambulance from the county medical center rolled into the driveway.

When Luis was safely aboard, Jack stood at the open rear doors of the ambulance. "I'll be in to see you later, Luis," Jack said. The doors closed and the ambulance started off. Alone now, he turned and looked up at the windowless rear wall of D.

"Luis," he said, "I give you my word . . . I won't let them bring you back here . . . ever."

As he rounded the corner of the building, he saw Marty sitting in the Imperial. She had seated herself behind the wheel. It made sense. In his present state he might kill or maim them both or someone else were he to try to drive.

He saw something else.

A black man dressed in a dark wool suit that made Jack hot just to look at on a day like this was standing at the rear of the Imperial on Marty's blind side. He was staring at her.

Jack's first idle thought was, "Hell, even a cat can look at a queen," but the rigid set of the man's body, and the apparent intensity of the stare, made him think again. He couldn't actually *see* the stare; the man's dark glasses hid his eyes. It was just a feeling on Jack's part, but a feeling he knew he could trust. There was something about the way the man held himself, something high-voltage, as if he were readying some jolting discharge.

Marty, fishing for something in her purse, was oblivious to the attention she was getting. Jack had stopped dead. Then he thought of his assailant of the night before. He collected himself and moved.

The man, as if something had alerted him, turned toward Jack. Reflected sunlight flared in the dark glasses and Jack blinked. When he could see again he found the man crossing Tijeras Street, not hurrying, but moving rapidly enough that Jack knew he could never catch him.

The man got into a five- or six-year-old Cadillac parked on the other side, started the engine and took the long, black car out

into the stream of Tijeras traffic just as Jack reached the curb. Jack thanked his stars for once for his slight farsightedness. He got a good, clear reading on the Cadillac's New York license plates.

"Calls, Fran?" Jack asked as Marty and he pushed through the double doors.

"Mr. Scanlon, Jack. He was steaming! Wants you to call him right away."

Marty laughed. "That will be about you sending Luis to BCMC." It was good to hear her laughter. There hadn't been any of any kind on the ride back from D. Twice he had started to tell her about the black man and the would-be assassin of the night before, and twice he had put his apprehension down to an overactive imagination, at least as far as the man down at D was concerned.

"Mr. Scanlon can damned well wait," Jack said. "Fran, I'd like you to run a vehicle license for me." He pulled from his pocket the envelope on which he had scribbled the Cadillac's number. "That's a New York State registration. Call Jerry Reeves at Motor Vehicles. Tell him there'll be twenty bucks in it for him if he gets it for us within two days and keeps his mouth shut."

"Dad," Marty said, "what's this about?"

Stupid! He was getting careless. He should have waited and asked Fran on the sly. Knowing Fran, that probably wouldn't have kept it from Marty, anyway. "Tell you later, daughter," he said.

"All right. I'll wait this time, but you better make up your mind to let me in on everything." Her eyes widened. "How come you're having Fran go through Jerry Reeves? He's Phil Gilman's brother-in-law. No way he'll keep his mouth shut. He'll go right to the cops that you're tracking down a plate."

"Sure he will. Exactly what I want. They'll think we're trying to hide something by going through the DMV. Maybe they'll start doing some of the detective work they *should* be doing." It seemed

to satisfy her . . . or was she just lying in wait? She was still looking at him hard as he asked Fran if there were any other calls. He noticed then that *Fran* looked a little strange.

"No. No calls," Fran said. "But we had kind of a peculiar visitor while you two were gone."

"Oh?"

"A colored . . . I mean a *black* man. Wouldn't leave his name." Jack felt the hairs on the back of his neck rise. "Sure didn't look like any of the black people who live in Albuquerque, although I couldn't tell you why." Calm, steady Fran was agitated. "Made me tell him where you'd gone."

"Made you? How?"

"That's the funniest part. He didn't do or say anything, but he *made* me tell him. I can't explain it. I'm sorry, Jack."

"Forget it, Fran." As if he didn't have worries enough. He had Fran describe the man. It was the man he'd seen in Tijeras Street, all right, but Fran made him sound middle-aged, something Jack hadn't tumbled to down at D. "Did he say what he wanted?"

"No, just asked where you were."

Marty was still studying him. He started for his office. He tried to close the door behind him. Her foot was in it. "All right," she said when he was behind his desk, "let's have it . . . *all* of it."

Trying to keep his voice light, he told her about the man in the Cadillac and admitted that, yes, he seemed to have been Fran's caller. "I was just curious about him, that's all, Marty."

"Oh, *sure*," she said. She stood there. "Let's have the rest of it."

"The rest of what?"

"You were all bent out of shape long before we saw Luis or found out about this black man. What's up? Why do I get the feeling it's somehow tied up with that funny phone call you made to me last night? Don't you think you owe it to me to come clean?"

She was right. She wasn't a child any more. He couldn't protect her by keeping her in her room or by picking her up at school. She would have to protect herself. And to protect herself she would have to know what they were up against, what she might

be up against on her own. He hadn't been thinking straight . . . if at all. He should have told her no later than this morning about the attempt made on him. "Someone took a shot at your old man last night." Sure there was shock and sure there was fear, but by the time he finished telling her everything, the fearful look had vanished, replaced by one of steely determination.

"Was it Fran's black man?" she asked.

"I don't know. Today's man drove a Cadillac. The car last night was a hot rod, I'd bet my life on it."

She made a passable try for a smile. "Don't bet your life on *anything*."

Even knowing the boy was getting the best of care, and with the solemn word of the doctor that Luis, while still critical, should mend without complication, Jack was, if anything, more shaken at the sight of his client in the intensive care unit than he had been in the first sickening moments on Three West. Back there Jack had been able to act, take on Gus Gantry; here in the hospital he felt helpless and unnecessary.

Hooked up by a score of wires and filaments to exotic equipment, attached to I.V. bottles and the technical ugliness of the huge black console at the head of his bed, with his vital signs flashing and skittering in jagged green lines across a stygian screen, Luis looked at death's door. A resident called Jack into the corridor. "There's some slight blood trauma, Mr. Lautrec," the young medic said. "That's not the big worry at the moment. It's his breathing we're trying to normalize now. We have him on full machine respiration, and we'll keep him on it until his chest starts to function properly. Just about all his ribs show damage, from hairline cracks to one simple but nasty fracture. There's been deep shock, but he's rallying from that. A specialist will reshape his nose. What happened to him? Did he try to take on a trash compacter?"

"How long . . . ?" Jack asked.

"Oh, he'll be here for a while. When he can do most of his own breathing again we'll move him out of ICU. Three days, I'd say.

And as soon as we have him off the respirator we'll have him walking."

"He can't talk to me, Doctor, with that big tube in his mouth."

"That's the breather tube. It runs down into his lungs. Another day on that." The resident looked at his clipboard. "He's a lucky young man. He'll be out of danger soon and he'll make a complete recovery. But let me tell you . . . one more hour's delay in getting him here and . . . " He shrugged.

"That close?" Jack said. He looked to see if the uniformed guard leaning his chair against the wall of the intensive care unit was listening. He was. Good. Worried as he was about Luis, it warmed Jack's heart to know that this "medical bulletin" would reach Ben Scanlon within minutes of the guard's finishing his shift . . . sooner if the man could promote the use of the phone at the nurses' station.

"That close," the resident said.

Jack had to ask. "Can you tell if he was raped, doctor?"

"He wasn't."

But it was even closer than this bright young medic thought.

When he returned to the office he had Fran ring the Hector Velasquez home. A woman answered. It must be Luis's sister Ana. Her pleasant, lilting voice seemed, under the surface, somewhat the worse for wear.

"Dr. Velasquez, please," Jack said.

"Just a moment." She must have placed her hand over the mouthpiece, but he could still hear a muffled "I don't know, Hector. It's a man."

"Velasquez here." Heck sounded wary.

"Jack Lautrec, Heck." There was a second or two of silence on the line, during which the background phone noises sounded like rolling thunder.

"I don't want to talk to you, Jack."

"You don't have to talk," Jack said. "I don't want you to. Just listen." He told Heck about Luis. There was no reply.

"Heck," Jack said, "I promised Luis I would keep you and the rest of the family away from him while he was in jail. This is

different. If you still want to see him, get on over to BCMC. I'll leave word with the police guard that you're to go right in. Take the Esquibels and your wife, but you go in first. I want you to see him before they do so you can prepare them for what they're going to find. It's not pretty." He hung up.

With Luis under sedation, and with the breather tube preventing speech, Heck wouldn't be able to get out of Luis whatever it was he was so anxious to get. More to the point, those eyes of Luis's would look doubly accusing to the politician when they peered from that battered face.

In Marty's office he sank into her easy chair, wishing he would never have to leave it.

"You called Heck," Marty said. "Did Ana let you talk with him?"

"Yeah. He came right on the line, for all the good it may do us."

He studied her. No, she hadn't seemed troubled by saying Heck's name—or Ana's. "If I'm not being pushy, how did you get to know Heck's wife?"

Marty laughed. "It was easy. Tennis. Ana was offered a scholarship to the university, but she gave it up for Heck, I expect at his insistence. He sure made enough hints about me and *my* work before he walked. Anyway, until she got pregnant, she still played fairly regularly at the club. We were a pretty mean doubles team for a while. I liked her . . . and believe me that took some doing." She picked up a pencil and began to tap her teeth.

Something occurred to him. "Could you pick me up at McCutcheon's Texaco near me on Montgomery? My car needs a lube job. I'd like them to work on it first thing tomorrow."

"Sure, Dad. And why don't we have dinner together?"

"Why not? Although I don't know if I'm much up to eating after seeing Luis."

At the gas station he got into Marty's Z-280.

"You don't look good," Marty said. "Something *else* cross your mind?"

"This is one of the places Orville knocked off. I don't think Sam McCutcheon has forgiven me for defending him."

"I never asked. Exactly why did Orville fire you?"

"Didn't think I did right by him."

"Did you?"

"You bet I did." Yes, he had. It wasn't his fault that Orville was right where he belonged. He had held up two convenience stores and the Texaco in the same night, pistol-whipped two pretty girls, and shoved his Saturday-night special into the right eye of the kid at the gas station, putting it out forever. He had put a bullet in the lung of one of the two officers who collared him at a Central Avenue bar. The cops had come there on a phoned tip from a waitress Blakely was bragging to about his evening's mayhem. Orville had refused to let Jack plead him guilty. "They got the wrong guy, Lautrec," he said. He had been furious with Jack that he hadn't pressed his cross-examination of the four victims harder. "Particularly that second little broad, Lautrec. You should have blowed her clean away." But it sure hadn't been Jack's feeblest defense. He took no pride in it. Now Orville was there in the pen, waiting for someone just like Luis. Jack supposed he could expect more calls about him from Betty Blount. *She* hadn't fired him.

"Dinner just doesn't appeal to me, Marty," he said as she got under way. "Just drop me off at the apartment. If I get hungry later I'll fix a bite at home."

The entrance gate to his apartment complex opened on a circular drive holding a stand of Colorado spruce. As Marty pulled into it with another car right on her tail, Jack saw the Cadillac coming around the other side of the circle. The black man with the dark glasses looked at them, and then the Cadillac leaped ahead and through the gate the Z had vacated. It needed a new muffler badly. In the noise of the Tijeras traffic he hadn't heard how loud it was.

Marty's gasp told Jack she had seen it, too. With the third car so close behind them there was no chance for her to back up or turn around. She tramped down hard on the accelerator and with

the Z's tires screaming she took the circle in an almost continuous four-wheel drift, but by the time they had come around to the gate again the black car with the New York plates was out of sight. Marty braked to a stop.

"*Now* are you going to call the cops?" she said.

"No. Not until we get a line on who he is."

"Five will get you ten he's the one who took the shot at you . . . Heck or no Heck."

He had to admit that this might indeed be so.

"Will you come to my place or move into a motel tonight?"

He promised to think about it. If he didn't make some kind of promise, he knew she would never leave. And right now he wanted solitude even more than he wanted safety.

It was raining when he took Marie-Louise out for her walk. He hadn't waited for Adele to call him. He picked up the phone himself and made the offer. Marie-Louise didn't much care for rain. They weren't outside the vestibule for even sixty seconds.

20

"Mr. Scanlon called twice, Jack," Fran said in answer to his question.

"I'm still not in if he calls again, Fran," Jack said. "Any word yet on that New York license?"

"Not yet. I talked to Mr. Reeves a few minutes ago and he's expecting a call from New York any second."

"Marty in?"

"No, Jack." He felt a tiny shiver of fear. He was fifteen minutes late himself. The shiver stopped when Fran went on, "She called and said she had to drop some things at the cleaners." That's what he wanted, a nice dull world doing ordinary things like stopping at the cleaners. He knew there was mail on his desk from Saturday he hadn't opened. Good. That could occupy him for several minutes, perhaps until Marty got here. He wasn't ready to consider the sight of the man in the Cadillac yet nor to try to decide whether he had been the unseen assailant the first night Jack walked Marie-Louise. He hadn't even planted himself in his chair when Fran buzzed him. "Dr. Velasquez is here to see you, Jack."

It came as no bombshell, but Jack hadn't expected him this

soon. He must have skipped his early class. "Cool him for two minutes and then send him in, Fran."

"Something else, too," Fran said. "The criminal docket clerk called to say that Judge Cordoba has set the arraignment for Wednesday at nine o'clock." Valentino Cordoba. Jack hadn't decided whether Valentino would be good or bad for Luis. Spanish-surnamed judges could be tougher with a Lopez or Martinez as defendant than with a Smith or Jones, bending like pretzels to be as fair as possible. Cordoba, on his record, might be particularly obdurate in the matter of the bond. But at least he was a competent jurist . . . more than competent, accomplished.

And Wednesday. He would have to check with Luis's doctor. Maybe, unless Scanlon ran in his own medical team, Jack would have the option of going for a postponement or letting things proceed on Cordoba's schedule. He didn't yet know whether he wanted more or less time now.

His office door opened and Hector Velasquez stood in front of him. He hadn't knocked. He had, the last time. Apparently Fran hadn't been able to hold him for the two stalling minutes Jack wanted. She was looking over Heck's shoulder and stayed there until Jack nodded. "Sit down, Heck," Jack said. "Have you finally got things you want to tell me?" He made his voice as gentle as he could. If he was going to hear anything like a confession, he wanted to make it easy for the confessor. But he wouldn't play games with this man.

"Good morning, Jack. You guessed right. Seeing Luis on Saturday brought me in to see you," Heck said. He sank into the chair in front of Jack's desk as if it were the end of a long day, not the start of one. None of the hostility Jack had heard on Saturday afternoon hardened his voice. There was edginess, certainly, but no open enmity. "Yes, I have things to tell you, Jack, some of which you've already guessed. But only if you'll give me your word there's no recording device of any kind in here."

"You've got it, Heck. I never did go much for that kind of stuff."

"And I don't want Marty in on this," Velasquez said. "Or anyone."

"Deal." Jack fought the excitement rising in him. Confession or not, he was going to get somewhere at last. He picked up the phone. "Fran. I'm not to be disturbed while Dr. Velasquez is with me. I don't care if the Russians bomb the city. Nobody . . . repeat, *nobody* comes in here." The next might hurt. It would bother Fran at least. "That goes for Marty, too."

"Thanks, Jack," Heck said. He did look genuinely grateful—and appealing.

For a second he forgot that the man in front of him was out to destroy his client, or had been until now. Let him *earn* pity.

"To begin with . . . ," Hector Velasquez said, "I didn't kill Lupe Sanchez." So much for the outright confession. Jack found it easy to freeze his face. He made no comment, and Heck went on. "Luis killed her, Jack, as the police say and all the evidence indicates. But that isn't to say I'm not to blame. He did it to protect me . . . and Ana. As you've made clear, you guessed I *was* Lupe's lover. I have no excuses. I knew how wrong it was, not only morally but from a practical point of view. It didn't stop me. I love Ana . . . but Lupe was something new and different in my life. For a long time it looked as if I could not only get away with it, but that it would go on forever. Lupe was so cool about the whole thing . . . laid back . . . *detached* is the right word I guess. She made no demands. I could see her or not as I pleased. I had the best of a couple of worlds."

Oh, yes, Heck. How well Jack remembered those shots of the victory party. It was *three* worlds you had. "Then things changed, right?" Jack said. "What happened? Did Ana find out about her?"

Velasquez shook his head. "No. She never suspected anything. You know, until Lupe, I was every bit as straight arrow as Ana thought I was . . . *thinks* I am. Lupe and I were careful. But you're right. Things did change. It started a couple of weeks before the primary. I went downstate to speak in Las Cruces. Lupe came along, but she stayed in a different motel. When I got to her room that night after the rally, I found her on the phone. She didn't have one in the house in Griegos. Said she hated phones. Anyway, this turned out to be a fairly lengthy call,

and although I tried not to listen, I got the general drift of the conversation, not that she said all that much. Can't tell you why I thought so, but I got the idea the party on the other end was speaking from New York. Lupe had always been quiet, contemplative, with a haunting sadness about her that wasn't the least part of her appeal for me. On the phone that night, and later, she was freer and more elated than I had ever seen her. It was the best time we ever had together . . . and the last good one."

Heck stopped talking. He dropped his head, lifted it, went on. "Lupe had always been circumspect, particularly when we met 'accidentally' in public, always kept her distance from me. She knew I was deeply committed to my marriage, and she seemed to accept it, to be willing to take the fraction of me she was getting without complaint. Then when I saw her next, alone that is, the night of the victory party after Ana had gone home by herself, she asked me to leave Ana. It was so at odds with the way things had been I thought she was joking, and I said, 'Sure, I'll tell my wife tomorrow and we can go to Acapulco and wait out the divorce.' I must have sounded pretty flip. Lupe was furious. Actually flew at me. After that she began coming to headquarters. I suppose some of the people on my staff might have wondered a little, but there was still nothing to make them suspect the truth."

It was amazing how an otherwise intelligent, perceptive man, a *politician*, for Lord's sake, could be so stupid. "Heck," Jack said, "what makes you think this affair was such a secret? How careful were you?"

"Well, of course we met out of town a lot, as in the trip to Las Cruces. That part was easy. Local people usually set those things up for me, and almost none of my workers here in the city went along. Here we did use her house in Griegos. I understand you've been there. Most often I would park three blocks away, sometimes in a borrowed car. I don't think I parked my Pinto there five times, and nobody's up late at night in that neighborhood. As for Ana, she's grown used to my keeping pretty funny hours."

"Tell me all your movements the night Lupe was killed," Jack

said. What's gone wrong with you, Jack? Why didn't you say "the night you killed her"? Are you beginning to buy this man's story?

No, damn it. What he was looking for was an attempt on Heck's part to try to establish an alibi; one he could put holes in. That *was* it, wasn't it?

"My movements? Let's see," Heck said. "I had dinner with the Independents for Velasquez Committee at the Sheraton Old Town. I got out of there at eight thirty or shortly after. From there I went to campaign headquarters to pick up some new literature that had just come over from the printer's. I gabbed with some of the kids there for a few minutes, and then I started for home. Must have been close to ten by then." He paused. His eyebrows were edging toward each other under the strain of heavy concentration. It would come now . . . the alibi . . . Ana.

"Of course . . . ," Heck said, "I *didn't* go right home. I went straight to Lupe's. This time I parked right in front. I knew I had to tell her it was over between us."

Jack was numb. Something had gone wrong. "How did she take it, Heck?" Lord, but his voice sounded anything but that of a confident attorney.

"I didn't get to tell her, Jack. She was dead." They looked at each other. The dentist across the alley had turned on his Muzak again. It was one of those whining versions of "Smoke Gets in Your Eyes."

"Do you realize what you've just told me, Heck?"

"Yes. The truth."

"Who did you think had killed her?"

"At first I *didn't* think. I ran. It took me a while to get to sleep, and while I tried to get to sleep I *did* think. It crossed my mind that it had something to do with that phone call I walked in on that night in Cruces."

"When did you decide it was Luis?"

"When Orlando called me—it must have been five A.M.—and told me Luis had been caught in the bosque burying her. It made sense in a terrible, sick way. He must have known more about Lupe and me than I suspected. I guess he must have stayed in

her confidence even after they stopped seeing each other regularly. That explained things. With Lupe threatening to bring things into the open, Luis must have figured he could protect Ana by protecting me. The only real way of protecting me was getting rid of Lupe. And then he got caught." Heck stopped. His eyes were red, burning with agony. "Jack . . . ," he began again, "there's one more thing that makes me sure it's Luis. When I got to Lupe's that night her door was open. She always kept it locked and bolted. She never would have opened it for anyone she didn't know. There was no one in this city she trusted except Luis . . . and me, of course." He looked hard at Jack. "What can I do to help Luis, Jack? I've asked you that before."

"You can repeat what you've just told me on the witness stand."

"My God, Jack! That wouldn't help the kid."

"Perhaps not, but I'd go after *you* like a ferret, Heck. I'd hang you out to dry."

"I see. Thanks for being honest with me."

"*Will* you testify, Heck? Will you tell a jury what you've just told me?"

"Let me think about it, Jack. If I think there's the remotest chance it will help him, I'll do it. But . . . I don't want fifteen years of damned hard work going down the tubes for nothing. Even taking that into consideration I'd still testify . . . if it weren't for one inescapable thing."

"What's that?"

"Luis killed her."

Heck stood up. "Do what you can for him, Jack. If anyone in this state can lighten his load . . . you can."

"Wait a second, Heck. There are a couple of other things." This would be chancy. "Do you, or any of the people close to you, own a firearm? A deer rifle, maybe?"

Heck shook his head. "I don't. My kids wouldn't tell me if they did. I don't make a lot of noise about it, not in this state, but I'm a gun-control man, remember?" If he was faking it, he was making a damned good job of it.

"Got any idea . . . ," Jack said then, "why a heavy-looking black

man driving a Cadillac with New York plates should be snooping around these parts?"

Velasquez just looked baffled.

"I guess that's all for now, Heck. I'll walk out with you."

Marty was standing by Fran's desk with a slip of paper in a hand that shook when she saw Heck, unless Jack was imagining it.

Fran wasn't exactly shaking; she was quivering. Her look said she had something in the way of news that shouldn't wait, and she was having difficulty holding it back until Heck left.

Heck nodded to Marty and pushed on through the double doors. She watched him until he disappeared behind a delivery truck in the parking lot, then she turned back to Jack. Her face betrayed nothing. Tough girl.

"What's up?" Jack asked.

Marty pointed to Fran. "Let Fran tell you."

"That New York Cadillac, Jack," Fran said. "It's registered to someone called Hassan Kareem in New York City. Marty's got the name and address on that memo."

Jack took the piece of paper and fixed the spelling of *Hassan Kareem* in his mind.

"Wonder what his name was before he joined the Scimitars?" he said. "Good work, Fran. Now start tracking him down here if you can. I doubt if you'll find him booked into a room under that Islamic name, but try it. Maybe some hotel or motel clerk will remember a black man in a New York car like that." Fran chuckled. Looking down, Jack saw the phone directory on her desk, open to the yellow pages. "Okay, so you're a jump ahead of me," he said. "Good going." He turned to Marty. The next few minutes were going to be interesting, but he wasn't looking forward to it. "Come in my office, Marty, would you please?"

"You *believed* him?"

"I'm not sure . . . but . . . maybe I do."

"Why? Can you tell me *why*? He's a politician . . . an actor. He snowed you."

"Maybe . . . but there was something in what he told me that really shook my certainty that he's our murderer."

"What was that?"

"Well, while it's not airtight, he's got the fair *makings* of an alibi. And he didn't even *try* to use it."

"He's still *my* suspect, Dad. Even if I don't want him to be."

"And you still could be right," Jack said. "Whether he is the killer or not, it won't help Luis if we can't get Heck on the stand. Not with the restrictions Luis has us working under. All Heck has to do is stay mum and he's as safe as if he was in God's pocket."

"Where does this leave us then?"

"Square one."

"What are you going to do?"

"Right now I'm going to return Ben Scanlon's calls and see if we can find out what he's going to throw at us."

"Mind if I listen?"

"Rather you did. Don't feel much like being alone right now."

As the phone rang in the office of the district attorney he watched Marty pick up the extension in his office. Nancy Gates told him Ben wasn't at his desk but that she would have him paged. While they waited Jack's and Marty's eyes met. Both of them were trying hard to smile; neither of them made it.

"Scanlon!" There had always been a challenge in Ben's voice when he answered a telephone, even back in college.

"Jack Lautrec, Ben." No "Flash" today.

"I've been trying to reach you all day. Sorry about what happened to your client. How's he doing?" The bastard. He was getting reports on Luis faster than Jack was. And *sorry?* Scanlon never apologized unless he was getting ready to lay something heavy on you.

"Fine, I guess," Jack said. "We'll forget about it."

"I won't. Somebody's going to pay."

Jack could believe that. Ben liked things to run smoothly; Gantry had let them get rough. Strangely enough, Jack hoped no one at D pointed the finger at Gus. If Jack couldn't make good on

the promise he had made to himself about Luis not going back to Three West, Gantry could really see that harm came the boy's way again.

"Your saying you're sorry is good enough for us," Jack said. "When does the defense get your package, Ben?"

"Should arrive at your office any second."

My, my, but aren't we being cooperative. If Ben was ready to swing on him, Jack had better step inside the swing and jab, but lightly. "Anything new since we talked the other day?" he said.

"Hell, Jack, you know there is! The McCabe girl's statement. Don't play games with me." There was a pause of such length that Jack thought for a moment Ben had hung up on him. "Jack, who's Hassan Kareem?"

"Don't know. Thought *you* might."

"Has he anything to do with the State versus Esquibel?"

"I honestly don't know." It was a violation of his rule never to let the other side know how much in the dark you were about anything, but no matter, Ben wouldn't believe he didn't know anyway.

"Because . . . ," Scanlon said, "if he has any connection to this case, I want it in the open before the bond hearing or the pre-liminary."

"You'll get it if he figures in it."

"With the shape young Esquibel is in do you want me to talk to Val Cordoba with you about a postponement on the Wednesday thing?"

"No postponement, Ben. We'll go on schedule. Wednesday." Jack saw Marty's eyes go wide.

"Suit yourself," Scanlon said. "How about talking plea *now*? I don't feel I should go for a reduction, but what the hell, maybe Val will go a little easier on the kid if the two of you don't fight us."

"Nothing doing, Ben. Not guilty. Are you still going to hit us hard on the amount of bail?"

"You bet. Sorry about that."

Again the apology; something more was coming.

"Jack," Ben said, "I understand there are some drawings floating around that Esquibel made of Lupe Sanchez. I've got a hunch you have them. Are you going to be a pal and send them over?"

"I'll look for them."

"Maybe I'd better subpoena them."

"Maybe you had better. Then, if I do find them, I'll know what to do with them." Might as well make him work for them. "Who told you there were drawings, Ben?"

"A little bird, Jack. As of now the name of the bird is privileged."

"It had better be in your package."

"Only if I decide to use the pictures."

As if on signal they both hung up, without the usual good-byes. Marty held the extension phone in the air as if she didn't know where to put it. "Dad," she said, "I thought you wanted time. Why didn't you go for the postponement?" She set the phone down, gently, as if she feared Ben might still be listening.

"I may have to yet. But if Luis's doctor doesn't object, I want our client in court Wednesday morning. I want Judge Cordoba to be looking at Luis's condition when he hears arguments on the bond. I fibbed to Ben about the plea, too. I'm going to have Luis stand mute, and we'll go for a preliminary hearing. Luis is good at standing mute, I've found. Maybe we can buy the time we need that way."

"Who do you suppose told Scanlon about the sketches?"

"I wish I knew."

"Dad?"

"Yes?"

"If you believe Heck, are you still convinced of Luis's innocence?"

"More than ever. Luis didn't do it."

"You had better tell me why you're so sure."

"I believe Heck told me the truth as far as it went. Whether he told me the whole truth remains to be seen. Suppose for a second he did tell me the whole truth. If Lupe *was* dead when he got there, *where was Luis?* In the house? Where was the pickup then? The police made casts of its tire tracks in the drive-

way. Once in, once out. Sure, it's possible Luis could have parked at the curb once—as Heck says *he* did—and the other time in the driveway, but that doesn't ring true. Did he come to the house on foot to kill her? It's two miles to the Esquibels' or the studio. Did he walk over, kill the girl, run home for the pickup, race back, pack her up, drive to the bosque, dig that Grand Canyon of a grave, and cover her up? All by the time the patrol car picked him up? That's stretching it pretty thin."

"So . . . if you got Heck on the stand . . ."

"Exactly. I don't think it would stop Valentino Cordoba from binding Luis over for trial, but I could work a *jury* with such doubt when we *got* to trial."

"And it might turn the cops toward Heck."

"Yes. He knows it, too. The only way I could get him to testify is if *he* were to come to the conclusion Luis is innocent."

"How can you persuade him?"

"*I* can't. I'm Luis's lawyer, and a little suspect myself in Heck's eyes. But maybe *Luis* can. If Luis were to accuse Heck, that might make Heck think things out."

"Well," Marty said, "we're in a bind. They both think the other did it. The worst part is that the law is after the one who won't *say* what he thinks. I bet he won't even say it to Heck. You know, if we got both of them telling their stories truthfully and in detail they would make a formidable pair of witnesses."

Jack's mouth fell open.

"Marty," he said, "I don't know if you know it, but you just pointed out to me that I've been going at this thing one hundred and eighty degrees wrong."

"How so?"

"Since day two I've been trying to persuade Luis to admit he knows his brother-in-law is a killer. Now, to have any hope of him opening up I'll have to show him Heck *didn't* do it. Won't be easy. He may think it's a trap."

"And you'll have to sell Heck on the idea that *Luis* is innocent. Dad, let me take a crack at that."

"Do you feel up to it?"

"Not really, but I'll do it. I still haven't abandoned the idea that he's our man . . . but somehow I'll soft-pedal that."

"All right, Marty. Go to it. And good luck."

Then fright gripped him. He believed Heck now . . . but if he were wrong again? What would he be setting Marty up for?

"On second thought, hold off for a bit, Marty."

"Why?"

"None of this will do us a bit of good at the arraignment or the hearing. This is a trial approach, something to tailor for a jury. What we've got to do now, if we assume they're both innocent, is find the real killer."

"Hassan Kareem? Was he the man who shot at you?"

"I'd sure like to think so, Marty, but once bitten, twice shy. I'm not jumping to any more conclusions for a while. Let's see if Fran has had any luck in tracking down Hassan Kareem."

She hadn't.

"Sorry," Fran said. "No Kareem—and no Cadillacs—among the twelve blacks or black families registered anywhere in town."

"I can remember when there was only one place in the city that would take them in at all," Jack said.

Fran spoke up again. "You had a call from Betty Blount, Jack."

"Orville's girlfriend?" It was the first he'd heard from her in a month. Well, he had more or less expected something from her about now. During the appeals process she had called or, worse, camped in the outer office, sometimes twice a week. "What did Betty want?"

"Orville wants you as his lawyer again. She says he's in an awful mood."

"No way! We've got all we can handle now. Would you, Fran . . . ?"

"Sure, Jack. I'll call her."

Jack turned to Marty. "What's in front of square one?"

21

The nurses had stripped the respirator tube from Luis's throat and lungs, and were now feeding him oxygen through thin plastic tubing taped to his upper lip. He could talk . . . if he wanted to.

Jack sat by his bed until Luis, who had been napping, opened his eyes, and then Jack told him of his new belief in Heck's innocence. The boy didn't speak. In the hope that all Luis needed was time to digest this new idea, Jack left the room promising to return, then found the boy's doctor, Saul Greenberg. "All right," Dr. Greenberg said when Jack told him about the arraignment. "But only if he won't be gone longer than two hours. He's to have a paramedic with him at every moment. He's no longer critical, but his condition is still serious."

"The D.A.'s office will see to his care and return on your terms, Doctor," Jack said. "The arraignment won't take long. The court will, however, want to schedule the preliminary hearing. That can be a lengthy affair. All of a long day at least."

"You can tell them three weeks . . . maybe . . ."

"I can't tell them. You'll have to tell them."

"I'll do that."

"Three weeks then? You'll stick to it?"

"I *said* three weeks, didn't I?" Greenberg seemed annoyed. Good. He looked tough enough to stand by his decisions, but to make sure Jack decided to goad him a little further.

"I don't think you appreciate how persuasive the district attorney is, Dr. Greenberg. He chews strong men up and spits them out. I wouldn't want you to get in trouble."

"Mr. Lautrec! I said three weeks, and I *meant* three weeks. Luis doesn't leave my care one day earlier . . . period!"

"Okay, Doctor," Jack said as meekly as he could, hoping he wouldn't smile and spoil it. He did smile as he walked back to Luis's room. He even smiled at the guard on duty at the door.

"Have you thought over what I said a few minutes ago, Luis?" Jack asked the boy. About the only things he could bear to look at in the bruised face were the eyes. Behind their glaze of pain they were even deeper and blacker than he remembered.

"Will you give me your word, Mr. Lautrec . . . ," Luis said, "that you really and truly believe Hector didn't kill Lupe?"

What a family! Heck and Luis didn't trust Jack enough to let him help them in the way he was best at helping people in trouble, but they were almost childlike in their willingness to take his "word" on matters of life and death. *Could* he give his word? His arguments to Marty notwithstanding, he wasn't sure. His fingers as he looked at Luis were itching to cross.

To his surprise, he suddenly decided that yes, he *could* give his word. Hector Velasquez, for Jack, had just ceased to be a murderer. It felt good to have it over with. "I give you my word, Luis," he said. "Without reservation."

"What makes you think he's innocent now, Mr. Lautrec? You were so sure he did it last time we talked," Luis said.

Good question. Strangely enough, to give his young listener what he now saw as the truth, Jack was going to have to go well *beyond* the truth. The real truth was just too unconvincingly simple. Jack believed Heck innocent purely because he *did* believe Heck, in the way Marty had started out believing. He would have to give Luis more than that. He would have to send the truth out with a "bodyguard of lies." "I know he's innocent, Luis,

because of something he *didn't* say." That might be paradoxical and cryptic enough for the moment to arouse the boy's interest . . . and eventual belief. "Your brother-in-law apparently hasn't figured out that he has an almost foolproof alibi." It was going to be the same scenario he had sketched out for Marty, but with the loopholes plugged. This time he was going to embroider it, stitch credibility into its fabric, and make Heck's threadbare story into a tapestry of whole, seamless cloth. Why not? Heck should have done it for himself. "According to the medical examiner, Lupe was killed between eight thirty and nine fifteen Saturday night. Heck left a dinner at the Sheraton Old Town about eight fifteen and was at his headquarters until after nine, and he could get people to say so. He would have had to move like Superman to reach Griegos by the time Lupe died." Well, hell . . . it was *almost* true. The M.E. had actually put the time of death half an hour to an hour later, but Heck *would* have had to be a rocket to have gotten there in time to wield that knife. Anyway, it wouldn't be until the preliminary hearing that Luis would learn that his attorney had shifted the times a little. "The real point is that I would still suspect Heck if he hadn't *talked* to me."

By God, it looked as if it might be doing the trick. Thirty years of taking depositions and coaxing testimony from reluctant witnesses told him that at last he was going to get a little of what he wanted, if he didn't look or act too expectant.

"If what you say is true," Luis said at last, "I could have walked right out of Lupe's house that night without doing anything at all." Oh, he wasn't entirely convinced, but that wasn't important. What was important was that he believe *Jack* convinced.

"Exactly, Luis." He waited. Then, "Heck stumbled on the killing . . . just as you did." Odd, the deeper he went, the more he knew it as the truth. Marty would see it, too.

"Who did kill her, then?"

Jack shook his head. "I don't know. There are some things I'll ask you a little later that might in time help us turn up a suspect, but right now I want to know everything *you* did that night. First,

why did you go there? It was all over between you and Lupe, wasn't it?"

"Yes, sir. There never really *was* anything. I just kept hoping someday there would be. I'd heard things from the kids around Hector . . . about how she was going to make trouble for him. I thought maybe I could talk her out of it."

"What time did you get there?"

"I don't really know. It must have been about ten . . . but Mr. Lautrec, I've told you all this before."

"Sure, but I want my memory refreshed.'" Now came the test. "We're about to get to something you *haven't* told me, aren't we?"

"Yes, sir. I lied to you before . . . about not knowing the car I saw. It was Hector's Pinto."

Go to the head of the class, Jack. "Then what did you do?"

"I pulled the pickup into the driveway. I sat there for a few minutes looking at the windows in the front of the house. That's when I first knew something was wrong."

"How so?"

"When I picked Lupe up, she would come to the window by the door and look out through the curtains. She did it when we were inside and she heard a car stop in front, too. She was afraid of something, but she never told me what."

"You asked her?"

"With Lupe you didn't ask, Mr. Lautrec. I can't explain that, but you just didn't."

"All right. You waited. Then you went in."

"Not right in. You had to knock at Lupe's even if she was expecting you. There wasn't any answer. The lights were on, but she *always* left them on. I remember once when we went out in the afternoon and she forgot them. When we got home that night she made me go in and turn on *every* light. She wouldn't come in from the porch until I looked in all the rooms, even the closets."

"And you never asked her what she was afraid of?"

"No, sir. Like I said, with Lupe . . ."

". . . You didn't ask. Go on."

"I knocked a second time that night. That was when I discov-

ered the door wasn't locked and bolted like she kept it even when we were inside, and it wasn't even on the catch. Right then I *knew* things weren't right. I pushed it open . . . and saw her."

The girl knew her killer. The front door had been unlocked when Velasquez arrived, and when the police got there, too. The *Journal* story had picked upon that, and when Jack and Marty had gone there, there was no sign the door had been forced; nothing in Gilman's report said the windows had been jimmied, either.

"Will this help me, Mr. Lautrec?"

"Only if you'll tell the court you saw Hector's Pinto . . . and he admits on the stand that he was there, too, and found her dead as you did . . . and *when* he found her." The next was going to hurt, but on the other hand it might make Luis angry enough to come out fighting. "You see, Luis . . . Hector still thinks *you* killed her. He doesn't want to wreck his future and come under suspicion himself if he can't *help* you. He doesn't think he can. But if I could get him on the witness stand . . ."

"*No!*"

Damn it! Nothing had changed. This idiotic loyalty was wearying.

"You wouldn't force him to testify, would you, Mr. Lautrec? I'd as soon plead guilty."

"No, Luis," Jack sighed. "I wouldn't force him." It was true. He didn't intend to put Heck on the stand until he changed his mind about Luis. "I'd *call* Hector if you let me, but with him thinking what he does, he'd be the worst witness we could have. Even if we turned him around a jury might think he was lying for you. We've got to find the real killer." He went back to the letter and photo the police had gotten. "Have you any enemies, Luis?"

"Not that I know of, sir."

"Do you know a Bonnie McCabe and an Emiliano?"

Luis nodded. "They work for Hector. Emiliano's last name is Padilla. It must have been one of them that took that picture. They were both there."

Jack told Luis then about Bonnie's claim that he had threatened Lupe's life. The swollen face couldn't show anything, of course, but the eyes shouted astonishment and hurt. If Jack could re-create this moment for a jury . . .

"Who knew you were going with Lupe?"

"The kids at Tim Merryman's. Hector's workers. Lupe had seen Hector on TV, and she wanted to meet him. I took her to campaign headquarters. That started her going to the rallies."

"Did you ever talk to Hector about Lupe after they started seeing each other? After all, he was cheating on your sister."

Luis's breathing was labored. "No, sir," he said. "At first I didn't believe the things I heard. There was always talk about Hector and women, but it never amounted to anything. It was only when Lupe threatened to make trouble that I got worried."

"Did you discuss it with your sister?"

"No. I *couldn't*. I sure wasn't scared she might hear about it. She sticks close to home, so the rumors never reached her."

From the look in the eyes above the puffed, discolored cheeks, Jack was afraid he might lose him if he went on with this. "Did Lupe ever talk about her life in New York?"

"No, sir. She talked about Europe and South America a lot, but she never mentioned New York that I remember."

"Did she ever mention something called the Scimitars of Black Islam . . . or a man called Hassan Kareem?"

"No, sir."

"All right, Luis. There's no chance *you* have an alibi before ten o'clock that night?"

"I guess not. I took some stuff to my studio and then just moped around trying to work myself up to go and see her."

"Did your father's cousin or anyone see you at the studio?"

"They weren't home."

The nurse entered. "I'm sorry, sir, but Mr. Esquibel gets a shot now, and then he'll want to rest."

Lupe Sanchez was no longer quite the abstraction she had been. A headstrong, sophisticated woman, on the run, she had taken

up with this inexperienced youngster out of the boredom that must have settled on her despite her fear. Luis took her mind off her terror . . . and she could trust him. Then, no more proof against Heck's charms than the other women around him, she found the man she wanted. That she must have been bright went without saying. Heck, for all the cracks in his character that had begun to show this past week, wasn't just out for a roll in the hay. He could have had all the oversexed young ninnies he wanted. Lupe must have captured him with her mind every bit as much as with her looks . . . even as she had captured this naïve boy. Two things about her screamed for attention: her fear, of course, and, more baffling, whatever *happened* to that fear. Why had she suddenly lusted to share the limelight with the politician-lover she had been content to "take a fraction of," a change in course that almost begged for discovery by her enemies?

Something had made her feel safe. Had the people from her past somehow lulled her into a false feeling of security? There was that phone call in Las Cruces, to New York if Heck was right. But there was also Hassan Kareem. Jack now felt sure some unseen thread stretched between dead Lupe and the black man.

Ben had said Jack could see Judge Valentino Cordoba alone, ex parte, but it came as no surprise when the judge's office told him no dice. Cordoba was far too fussily correct for that.

In or out of chambers, Judge Valentino Cordoba was an absolute doll, almost in the literal sense. He was only five-foot-two, and his cherubic pink and brown face looked younger than its seventy-three years even with his skullcap of snow-white hair. A South Valley lawyer for three decades before ascending to the district bench, and an authority on land grant law, he once in a while betrayed a strong distaste for criminal cases, but he never shrank from the tough rulings, either. Jack had never known him to raise his voice in court, but every attorney in the district walked gingerly around Valentino Cordoba. He hadn't had a case overturned by the appellate court in seven years.

Sitting next to Jack young Curt Santorini was smiling a complacent, wimpish smile. Jack, knowing the roadblocks Ben would put in his way through Santorini, had also abandoned the idea of talking to Cordoba about the amount of bail. But then the attack on Luis had presented an unwanted but useful opening. Worth a try. The only trouble was that this afternoon Valentino Cordoba was being an absolute little bastard. "It's a very nasty crime, Jack," he said.

Curt Santorini piped up, "It certainly is, Your Honor." He sounded like Stan Laurel agreeing with Oliver Hardy.

Jack tried to wither Curt with a look, but gave it up when he saw that the assistant D.A. was too self-importantly confident to be reached. He turned back to the little judge. "This lad isn't going to *run*, Judge Cordoba. I'm asking you to set a bond his parents can meet so he won't have to sit behind bars until his trial, if one comes." Jack could hear the pleading in his voice. He didn't care.

"But if he's guilty," Cordoba said, "and I'm sure you'll agree with me that Mr. Scanlon has presented impressive evidence"— the judge tapped the folder in front of him with a dainty index finger, while Curt nodded like a puppet—"it might constitute a serious threat to the public were he to be set free on *any* bond."

"He's not guilty, Your Honor . . . and we'll prove it. But that's beside the point. He's too badly injured to run . . . or to harm anyone. I don't want him to go through another day of incarceration. The risks I pointed out to the district attorney have already proved far too real. You know what can happen to a sensitive youngster who is institutionalized for any length of time. He can be subjected to physical and psychic trauma he can never shake. The physical one has already happened . . . once."

"I know. But the law must be served, Jack. May I point out that only Mr. Scanlon's request allowed this meeting to happen."

Jack wondered why Ben had called the judge after the show in front of Gilman. Probably to plant in Jack's mind the futility of his position. "I know, Valentino . . . ," Jack said, "and I'm grateful."

"I've listened. Don't ask for more now . . . *Mister* Lautrec."

What the hell was that "*Mister* Lautrec" for? Oh, my God! In his fears for Luis he had just called a judge by his first name. Unforgivable. You didn't even do this at bar association picnics. The stupidest One L *student* wouldn't. Just look at this little pouter pigeon. And look at Curt. Even he was smart enough never to make such an egregious error. Damned close thing Valentino's nickname, "Sweetpants," hadn't slipped out, too. Cordoba put his fingertips together. "I'll make my decision on the bond known on Wednesday when we hear your formal arguments, *Mister* Lautrec."

"Just as you say, Your Honor." The judge's sly, satisfied smile seemed to say that, yes, it would indeed be just as he had said. All right, just wait until you see my young client, Sweetpants! If that won't make you forget my slip, nothing will. But Jack had the foreboding nothing *would*. He stood up. Cordoba raised his soft hand.

"Give my regards to that bright attorney daughter of yours, will you, Jack?" The "Jack" seemed to say that all was forgiven . . . for the moment . . . but there would be no way of knowing until Wednesday.

"I will, Your Honor." Jack had seen a noticeable brightening of young Santorini's eyes at the mention of Marty. Sure, they had graduated from law school together. He couldn't blame the kid if he had a crush on her. Well, even after discovering the flaws in Velasquez, Jack would still prefer Heck or at least someone like him for Marty.

The judge smiled again, a more benign smile than the earlier one. "Your daughter seems to have rather a different class of clients than you have."

"Yes, sir. She's more interested in civil law than I am."

"Ah, yes. Civil law." Valentino beamed. There seemed nothing malicious in the beam, but Jack winced as the judge continued. "I've always maintained civil law is the only true test of the classic legal mind. Don't you agree, Jack?"

"Oh, it's a test, all right," Jack grumbled. Balls! The little weasel

is taunting me. Fair enough. Jack would give him a shot. "I'm sure Henry of Bracton would have agreed with you . . . *Your Honor.*" As long as the damage with the "Valentino" was done, he wished he'd had guts enough to risk just one "Sweetpants."

"Who?" The puzzlement in Cordoba's face was a tonic.

"Henry of Bracton. *A Tract on English Law and Customs.* Published in A.D. 1250 or thereabouts."

"Ah, yes. Bracton had momentarily slipped my mind."

Well, nobody's perfect, you sweet little fake, Jack thought. You'd have said that if I'd made good old Henry up. Santorini looked as puzzled as Cordoba did. Jack wished he could enjoy these little satisfactions more; they were the only ones he would get today.

He was going to have to give the probable bad news about the bail to Graciela and Orlando. No point in putting it off. The only bright part of the day had been that his promise to keep Luis out of D would hold for three more weeks, until the hearing . . . thanks more to Dr. Greenberg than to Jack.

22

"I wondered when you and I were going to get to talk to each other alone about this mess, Marty," Hector Velasquez said. He still had that smile, the one that looked as if he had just blinked away a tear. It had melted her to the marrow once. She hadn't sat in this office since law school, a year after she first went to bed with the man across the desk from her. He hadn't rushed her, she could still give him that much. It was six months after they met each other before he had made a move, and she wasn't sure now that she hadn't been the one who made the first one. Either way there had been no struggle. Eight years . . .

When she arrived at Ortega Hall today he had been in conference with a student, and she had waited for him in the old classroom, hearing him counsel his student in the office behind the open door, and wondering just how wise her coming here had been.

"Can I get you a Coke or something?" Heck was saying. She shook her head, remembering the soft drink machine that had taken a thousand undergraduate kicks a month when she was

here. Heck had made a gesture toward the door with his offer, and her eyes followed automatically.

He had closed the door behind them when he steered her in with that same old light pressure on her elbow. Closing the door was new. He had never closed a door in those days. A score of kids had walked in on some fairly hot embraces when she picked him up here. Funny . . . her body had no recall of those embraces; only her head . . . Well, maybe her heart, too . . . a little . . .

"Are we going to talk, or just look at each other, Martine?" Heck said. She wanted to answer, "Let me just look for a bit, Heck. I couldn't look at you the way I wanted to when we were with my father," but there would have been no *way* he would have heard it the way she meant it. Men never did. Martine? Had she called him Hector? It shocked her that for the life of her she couldn't remember now. She took a long look anyway . . . and let him wait.

If anything he was better-looking now. The gray in his hair and the small wrinkles at the corners of his eyes took away the slight look of callowness he had worn in the old days, the look she had recognized even while discounting it. No doubt about it, this was a "new, improved" Hector Velasquez. Don't be small, Marty. The guy *is* something else. No wonder Lupe Sanchez went overboard . . . had perhaps even walked the plank for him. "All right, Heck," she said at last. "You sold my father on your innocence. Sell me." My, aren't we tough? Would she get away with it?

He smiled. This smile was a work of art. "Surely he told you everything I told him," he said. "There's nothing else."

"Yes, he told me. I didn't listen, Heck. It's *you* I'll listen to."

"Marty . . . Marty . . . ," he said. His voice was a deliberate caress, but with gentle chiding in it. "Of all people, you must know I'm not a killer."

"That's not enough, Heck," she said. "I want to hear what you told my father. And then I want you to testify at Wednesday's hearing."

"Do you really want me to, Marty?" he said. "No one in the world knows my dreams like you do. Do you want me to give them up? You know how I've fought and struggled all these years." He paused, then: "Marty . . . Marty . . ." It was a reprise: the notes, the timbre, the persistent delicate rhythm . . . everything the same. She could sit here for an hour and get nothing solid. All he was going to give her was this: smiles and sly seduction. It was substance she had come for, and he was denying it to her, just as he had denied her worth by walking out eight years ago. To him she had been, she discovered, "just a woman," at best a "lady lawyer." This wasn't the contrite, decent sinner her father had described. This was a desperate man wreathing his desperation in secondhand campaign smiles. She stood up. "Heck," she said, "I guess there's nothing for us to talk about after all." She walked to the door, opened it, and turned back to face him.

He stared at her. He looked exposed. He didn't look like a murderer, though. He was innocent of that at least, and she had found it out the same way her father had. The anger and disappointment of a moment earlier were gone. She wasn't sure what had taken their place.

"Don't go, Marty," he said. "We've *got* to talk . . . please."

She shook her head. "Thanks, Heck," she said. "For everything. Some days a girl gets lucky . . . although sometimes it takes her years to realize it. You never could make commitments that run two ways, could you? You couldn't with me . . . and you couldn't with Lupe Sanchez."

"You saw him?" Fran asked.

"Yes."

"What did he say?"

"A lot less than I wanted him to; a lot more than he realized. I told Dad about Heck and how it ended when Dad and I went to the house in Los Griegos, but you know, I didn't really hear

what I said. I was right. He left me for Ana because he wanted
a pushover for a wife, and he knew I wouldn't be one. And then
I went right on adoring him for a while. I even worked in that
first campaign, hurting the whole damned time."

"Did Heck kill that girl?"

"No, Fran. I think Dad's right on that."

=＝23＝=

Esquibel's Fine Foods wasn't the same neat, orderly store Jack had visited the previous Tuesday afternoon, before going to the Esquibels. It looked as if it hadn't been swept out since he'd been here. Unopened cartons were pushed against the shelves and limp-looking lettuce heads rusted in the produce bins. Jack didn't see the clerk who had been at the register Tuesday, and there was no sign of the stock boy, either. Esquibel was waiting on a pair of neighborhood matrons, small, somber, brown women, and Jack found and picked up a jar of instant coffee he remembered needing. Some of the stock on the shelves hadn't yet been priced with the fancy, yellow E.F.F. label stuck on his coffee jar. Maybe business *was* down, although the kind of notoriety the Esquibels were getting generally worked the other way around. Of course in this small town within the larger city, Orlando's customers might be avoiding him to respect his privacy.

One section of shelving caught Jack's eye, since every item in it seemed to carry the yellow label. Must be old stock. He stepped closer, but as he did Orlando called to him.

Jack paid for his coffee. Orlando's hand trembled as he put it

in a sack. The man was in a bad way. A bigot he might well be, but Jack's heart went out to him.

"Have you seen Luis today, Mr. Lautrec?" Orlando said.

"Yes, Orlando. He's better."

"Graciela and I saw him Saturday and yesterday." He was whispering, even though they were quite alone. "He couldn't talk to us with that tube in him. It was very hard on Graciela."

"The tube came out this morning," Jack said. "He can talk now. More important . . . I think he'll want to. Take Graciela to see him." It might work. If Luis opened up to his father and mother as he had to Jack, perhaps *they* would work on Heck to testify. He wouldn't count on it.

Orlando tried to brighten. "Things are turning better, *sí?*"

"I wish I could say so, Orlando, but I can't." He told the grocer of his plan to have Luis stand mute at the arraignment, and how what hopes he and Marty had rested on finding a break in the case before the preliminary hearing. "About the bail, Orlando. It may be very high."

"I'll do all I can. I sold my Buick. Now I drive only my delivery van." Orlando said, "Graciela has already looked into selling the old furniture and her mother's jewelry. The bank will tell me tomorrow about a loan." There was bitterness in his eyes, although they didn't quite meet Jack's. He resents having to spend money on that battered boy. Don't let it upset you, counselor. "Don't borrow until we see how hard the judge hits us," Jack said. "We've got a little time. Luis will be in the hospital until the hearing, and that's three weeks off. It's the time between the hearing and the trial that concerns me. There is the real possibility that the judge will order Luis held *without* a bond."

"He would have to go back to jail?" Did Jack hear satisfaction? He got his heart back. He nodded. There was nothing more he could do here today. Orlando would have to sort out his feelings on his own and later with Graciela. Jack was glad he didn't have to see *her* at the moment. He mumbled a good-bye and turned to leave.

A young woman had entered the store during the last part of his talk with the proprietor.

It was Ana Velasquez. Jack recognized her from the pictures at the Esquibel house and in Luis's studio and from the Channel 13 tapes . . . but he would have known her anyway. She certainly *could* have been her brother's twin. Her face made Jack wish he could have met her under other circumstances. Lovely even in distress, there was only the suggestion in this face of the beauty it must usually possess. It must have undergone a psychological beating the equal of the physical one poor Luis's had taken. He wondered if Orlando would introduce them and how she would react to him. Had Heck told her of Jack's pursuit of him? If he had, there was every chance she now knew of her husband's infidelity. If not, Jack was still in all likelihood the enemy to her.

"Hello, Papa," she said to Orlando. "What do you hear about Luisito?"

Orlando held up his hand. It was a fatherly gesture, the kind made to a child who has interrupted adults, but the kind made with love. "He is better, Ana. Ana, this is Mr. Lautrec, Luis's lawyer."

She turned to Jack. "Hello, Mr. Lautrec," she said. She dropped her eyes. It was such a demure thing, such an endearing, ages-old, Spanish, *feminine* thing, that for a moment Jack imagined he had seen her curtsy. Marty's description of her as a "good little helpmeet wife" flashed through his mind, but without even a hint of the mild pejorative Marty had intended. Guarded as he still was, he had to resist the urge to put his arm around the shoulders of Hector Velasquez's wife.

"We spoke once on the telephone, Mrs. Velasquez," Jack said.

"I remember," she said. "Will you be able to get my brother free, Mr. Lautrec?"

"I should be able to free an innocent man, Mrs. Velasquez." It was clear from her look that she knew nothing of her husband's part in her brother's troubles. Jack realized something else in that instant, too. This woman in front of him was the most likely key to saving Luis. If all else failed Ana Velasquez could get Heck

to testify. No husband could refuse her. He knew, too, that he couldn't ask her, not if it meant that he had to be the one to tell her about Heck and Lupe. He was beginning to understand his client. It was a heavy feeling.

The weight of sadness and frustration still bent his spirits as he struggled from the Imperial in the office parking lot.

He didn't even see the car that tried to kill him until it passed him.

He heard the screech of tires as it hurtled away from him after he lurched backward, almost vaulting a space to the rear on his canes. The streaking car had missed him by no more than the width of a piece of tissue.

He heard the roar of its exhaust. It sounded like a rockslide. When he looked, he expected to see the Cadillac, but the car was an old Plymouth Duster with the rear springs reversed. Apparently there was a cutout on the exhaust to make that roar.

Through the rear window of the car as it ripped its way across the lot, he could see the Cuban cap the driver wore.

24

"That settles it, Dad!" Marty said. "You're moving out of the apartment until after the arraignment ... and maybe until the trial." He felt no inclination toward argument, but he did wonder what had made her so *monumentally* fierce. She had sported a chip on her shoulder even before he told her and Fran of the incident in the parking lot. Something had definitely gone wrong with her, but somehow, in spite of her genuine alarm at this new attempt on him, he felt it had little or nothing to do with him. "And," she went on, "you're not setting foot outside this office or going *anywhere* without me!" There was no stopping her now. He could only listen. "I'm plenty scared myself," she said. "Particularly since we can't expect any help from Gilman."

"You hollered cop?" Damn it! That was a bit much.

"I asked police protection for both of us."

"You didn't name names, I hope. It looked like Emiliano but I couldn't swear to it."

"Of *course* I didn't name names. Gilman was cute. He laughed. He said to dial nine-one-one and he'll be right over. If you say 'I told you so,' I'll spit."

"How do you plan to hide me ... us?"

"I'll book us into the Hilton. We can go from there to the arraignment."

"I have to see Luis," he said. "Give him the drill."

"No you don't. I've got Rudy lined up to do that. You and I are getting out of sight."

"I'll go stir crazy in a hotel room."

"Not a chance. I've got work lined up for both of us. You're not going to enjoy it."

He could guess what was coming next.

"You're going to practice a little law, a little real law," she said. "*If* you can remember anything from Contracts 101 back at Georgetown. It will free up Rudy."

He knew one thing for sure. He would perjure himself rather than let Judge Sweetpants Cordoba ever know about this.

"Now . . . ," Marty said, "could Emiliano Padilla be our killer?"

"Yes, he could . . . but we've got to get Heck to testify first so Gilman will start digging again."

"I've given up on Heck," she said. "I don't think we can get him to help us at the hearing, either. Rather not go into it right now. Let's get back to Emiliano."

Could he let that go? Perhaps he didn't have a choice. Maybe Heck was the chip she had been wearing on her shoulder. "I just don't know about Emiliano," he said. "There's a plausible case against him. If Henderson or the newspapers picked up the fact that we suspected Heck, it could tear Heck's campaign apart, and, sure, Emiliano could have murdered Lupe for the 'cause,' but he could have tried for me for the same reason *without* having killed her. He and Bonnie both knew what we were thinking. They didn't know we'd changed our minds. But if one or both of them did it, where does Hassan Kareem fit in . . . and, incidentally, has Fran had any luck?"

"Not a bit," Marty said. "She even checked places in Santa Fe, and she called Feldman in New York to see if he knew Kareem. No dice, but Feldman agrees with us that he's probably one of the Scimitars. Oh, you're off *one* hook. Fran bit the bullet and told him his Akidha is dead. It wrecked him."

Bless Fran. Telling Feldman was beyond any call of duty. "Something's bothering me about thinking of Kareem as our killer," he said. "If he did it, why is he still around? You'd think he'd make tracks fast. Unless . . ."

"Unless . . . ," Marty broke in, "unless he left a trail he can't cover or hasn't covered *yet!*"

"Exactly."

They looked at each other. "Dad," Marty said, "you know what that could mean."

"I guess your idea about the Hilton does make sense. Anything else?"

"Yes. Fran reached Betty Blount. Betty says she's terrified of the thought of telling Orville you won't take him as a client again."

"Sometime explain to me how women can fall in love with men like him."

"When I figure out why we so often pick the wrong men, I'll let you know." She fell silent. Suddenly he knew what had crossed her mind. What could he say? She was talking again. Good. It would save having to think about Heck right now. "Go on home and pack, Dad," she said. "I'll pick you up in forty-five minutes. We'll come back here to the office, ditch my car, and have a cab meet us in the alley."

"Come on, Marty. Let's not get paranoid!"

"A little paranoia now might lead to lots of longevity. There could be *two* assassins. Broad daylight didn't stop one of them." Then, and it did his heart good, she grinned an utterly wicked grin. "We're sure going to find out how good you are at contract law," she said. "Don't sweat it, though. I'll check your work, and so will Rudy."

At the meeting in Judge Cordoba's chambers before Luis's arraignment, Jack thought Assistant D.A. Curt Santorini was going to recite the criminal code in its entirety. Sweetpants Cordoba looked pained. He didn't take too kindly to being lectured on the law by any attorney; it must have been doubly galling when the lecturer had so recently passed the bar. It was fine with Jack that Curt was ticking the old judge off, but Valentino wouldn't let personal pique cloud his judgment in the matter of the bond, and his history in capital cases wasn't encouraging.

Still, you would have thought old Joe could have trained his nerd son better. If the kid wasn't a fast learner, he would find at the preliminary hearing that the little porcelain figure behind the massive desk was a force to be reckoned with. It would probably provide the only bright spot in Jack Lautrec's day.

Jack had entered chambers with Marty not through the door in the corridor, but from the courtroom. Joe Santorini, come to see his son perform, had already taken a seat in the spectators' section with his long, crocodile jaw resting on hands cupped on the top of a cane much like Jack's two. Jack nodded and Joe nodded back. Except in court on the rare occasions they faced

each other nowadays, they hadn't spoken in what was it now, nineteen years? With a father as smart as Joe, Jack wondered how Curt could be so dumb.

He heard Marty chuckle as he turned his back on Joe and walked toward the door to chambers. It made him shudder to think she had considered taking a position with Santorini & Gill. It must have been because of Ed Gill, a decent enough man. Jack never thought Ed belonged with Joe anyway.

The only new thing Jack and Marty learned in chambers was how Ben Scanlon had heard about the charcoal sketches. Timothy Merryman was on the prosecution's list of possible witnesses. The art teacher, who might be called to establish the relationship of Luis to the deceased, must have told Ben's people about the drawings. Jack wondered why Ben had never backed his demand for them with a subpoena. It was a small break; there was no way Jack wanted those drawings seen here or at the hearing, but as long as Ben didn't know that, fine.

The chambers palaver finally ended and Jack and Marty, the D.A.'s people, and the others who made up the inner circle of the judicial apparatus, filed back into the courtroom carrying enough briefcases, folders, and documents to make up a Pikes Peak of leather and paper. Even though the bond hearing was following immediately on the arraignment Jack knew only a twentieth of the stuff the parade was toting had any bearing on this matter. No wonder the public took such a dismal view of lawyers. Like Curt, we're all actors, he thought, and amateurs at that, unable to pick up a phone and say hello without a cue card. And why does there have to be such a legion of us?

That prompted another thought as he and Marty took their seats at the defendant's table to await the arrival of their client from BCMC.

Something had seemed wrong to him and now he knew what it was. Never before in his career had another lawyer sat beside him in a criminal defense. That it was Marty next to him instead of some other lawyer made him only marginally more comfortable. He had used other lawyers, but he had kept them out of

sight, hidden in the hall or seated in the audience, to be consulted only during recesses and breaks for lunch. He always wanted the defense to look the part of the underdog. Let the prosecution team fill the other table like an overstaffed praetorian guard.

There was no one in the jury box today, and he never felt quite right with an empty jury box either. Sometimes for affairs like this the sheriff's police put the defendant there. They wouldn't today with Luis being brought to court in a wheelchair (as Rudolfo reported Dr. Saul Greenberg said he assuredly would be) and with a cylinder of oxygen riding on the footrest.

In back of Marty and Jack, the hard, polished benches where Joe Santorini had camped were filling up. There were still more people up in front than where the audience would sit: newspaper and TV cameramen with their jungle gyms of equipment, reporters, the court stenographer, the bailiff and his gofers, cops, guards, and plain hangers-on. Jack checked his watch. Nothing would *hurry* Valentino, but he kept a tight schedule, starting on time and—even in the middle of riveting testimony—adjourning at his own appointed hour.

In back of Jack the trial buffs were taking their seats. Some of them knew court procedure as well as he did. Dull as a case promised to be, they, like dutiful if jaded drama critics, attended everything. He saluted two of the regulars he knew.

Would Heck show up? He doubted it. If he did he would probably delay his entrance until things were well under way up in front. A press-wise politician like Heck, unless he *wanted* attention (which Heck wouldn't want today), would wait until the eyes of a George Jones or a Sally Baxter were focused on the proceedings before he came through the door. He would make an early exit, too, before the media zeroed in on him.

Jack saw Jeanne Wayland in the third row. She was mouthing something at him and, although he couldn't really read her lips, he was damned sure of the words, "You owe me, Jack." He smiled at her. He hoped he could make the payoff soon.

The first arrivals with an intimate interest in today's business were Graciela and Orlando Esquibel and their daughter Ana. He

didn't want to look at them too long. Their faces were already
three tragic masks.

Then, in a gaggle of youngsters, he saw Bonnie McCabe and
Emiliano Padilla. He did want to look at *them,* particularly Em-
iliano. Bonnie was having trouble meeting Jack's eyes but the
boy was having no such difficulty. The insolence Jack had seen
in Ortega Hall seemed heightened and concentrated here, but
there was no suspicion in the young Chicano's look now, only
hostile certainty. Smart kid. He'd figured out that Jack either
wouldn't go to the cops about him . . . or couldn't.

Jack met Emiliano's stare with what he hoped was an equally
determined one of his own, holding his eyes on the boy until he
thought he detected something like grudging respect in the face
beneath the Cuban cap.

Jack was leaning toward Marty to say something when he heard
the gasp, a sick, breathy inhalation that seemed to be searing
every throat in the room. He knew they had wheeled Luis in. A
uniformed guard had stopped the chair just inside the front door
of the courtroom, and now bent over to take the cuffs off Luis.
The boy winced as the guard worked. His wrists must be as tender
as the rest of him. Rage blinded Jack. God damn it! Why did they
have to bring them in in cuffs? It had incensed him even more
back in the old days, when they would even bring in a handcuffed
prisoner right under the eyes of the jury. The Supreme Court,
thank God, had finally put a stop to that. Even without the jury
seeing it, it still burned Jack that a defendant could be cuffed as
far as the door. There were always photographers and TV crews
working the corridor and even if the jurors weren't supposed to
read newspaper accounts or see or hear transmissions of any part
of a trial, they did. Manacled, blinking against the strobes and
TV lights, hanging her head to escape the questions hurled at
her (the stupid questions the audio never seemed to catch), Little
Bo-Peep would look as guilty as Genghis Khan.

He knew the arguments made for cuffing a prisoner during
transportation, but they didn't wash with him. Was Luis there

going to wheel that chair onto the freeway and lead a high-speed chase into Arizona and out of jurisdiction?

Marty, as if she had read his mind, left the table, went to Luis, and nearly pushed the guard aside so she could take the wheelchair. She used only one hand to steer Luis to the defendant's table. The other rested on his shoulder. Jack was proud of her.

"Did Rudolfo explain everything that's going to happen, Luis?" Jack whispered to Luis when they reached the table.

"Yes, sir."

"The judge at some point will ask if you have anything to say. It's not necessary or advisable that you so much as open your mouth, but if there *is* anything you want to get off your chest, go ahead. Please tell *me* before you tell the judge, though."

"I'll let you run things your way, Mr. Lautrec."

Jack smiled his gratitude. It was a good resting place in a tortuous journey. He had never had much confidence Luis and he could get this far together. Then the call came. "All rise!"

As expected, as virtually demanded by Valentino Cordoba, the proceedings concluded in under fifteen minutes; from the clerk's opening announcement of the case, "the State vs. Esquibel," to Valentino's "let the record show the defendant Luis Esquibel is in court and is represented by his attorneys Jacques H. Lautrec and Martine J. Lautrec," through young Santorini's squeaky statement that the prosecution had come in with a charge of murder in the first degree, to Jack's gloomy avowal that his and Marty's client was standing mute.

Sweetpants smiled an indulgent, parental, pious smile, and Jack's heart fluttered with hope. Then the judge—with a certain amount of sadness, true—told the boy with the horribly bruised, misshapen face, that he would be "held without bond," and that he would be remanded to the county detention center as soon as he was released from the hospital, there to await a preliminary hearing on the state's case against him.

"Mr. Lautrec has requested a hearing on the matter of the lack of bond," Cordoba said. "The court will deal with it immediately."

Jack mumbled a pro forma argument, but his heart wasn't in it. Valentino Cordoba smiled. Curt Santorini smirked. The judge reaffirmed the arraignment ruling on the bond and, fixing Jack with an unyielding stare, said, "Don't protest, *Mister* Lautrec. Bond seems academic in this case for the moment. I understand your client will be in the hospital until the preliminary hearing."

Jack was glad he had tried to prepare Orlando and his son for this, but he knew he couldn't have prepared them well enough. Hell, he hadn't prepared himself well enough. Now he wondered just how hollow the vow was that he had hurled against the back wall of D: *"Luis . . . I give you my word I won't let them bring you back here . . . ever."*

Valentino Cordoba adjourned his court and left the bench.

Jack gripped Luis's shoulder. He kept his hand there, feeling the trembling, until the guard with the cuffs stepped forward, put them on, and took the chair. Then he turned and looked to the back of the courtroom.

Heck *had* come after all and was now leaving. He had apparently plucked Ana from his in-laws and was steering her through the door. The Esquibels looked even worse without her. Much as he wanted Heck in this thing, up to the hilt, Jack hoped the politician wouldn't be foolish enough to wait in the corridor to see Luis. He could do that better and more easily at the hospital.

Before adjournment, Cordoba had set the date for the preliminary hearing. Actually he had told both sides first back in chambers, citing Dr. Greenberg's report on Luis, but Jack, preoccupied, had missed the exact day. He would have to get the record from the clerk or check with Marty. He reached for the sleeve of Marty's dress but stopped before he touched it.

In the back row of the spectators' section, brushing past some of the audience who didn't seem in any hurry to leave, was a man in a black suit, a man with eyes hidden by nearly opaque dark glasses.

Hassan Kareem was heading for the rear door of the courtroom.

Jack had to clump his way through the cameras and light stands like a broken-field runner on slippery turf to reach the

nearest door. When he stepped at last into the corridor Hassan Kareem was nowhere to be seen.

Jack turned to go back, but Luis was being wheeled out. The boy tried to smile at him, his polychrome face made even more grotesque by the effort. Graciela and Orlando were waiting in the corridor for him.

Jack hurried toward Valentino's chambers. He would get the hearing date himself . . . now. It wasn't really important that he do so right this minute, but he knew he couldn't control himself if the guard refused to let the boy have a decent length of time with his parents. He saw Marty looking at him. She looked as pitiful as the Esquibels. Some tough lawyer!

26

"I can't stay here any longer," Jack said. "As big as this suite is it's giving me claustrophobia."

"I've located another place for us," Marty said.

"No soap. I'm going home. I want my own stuff."

"Suits me. These rooms are costing the firm two hundred twenty-eight dollars a day. But we ought to lie low until the hearing at least."

"That's three weeks!"

"Sure it is . . . but dead is a lot longer."

He didn't care much for the look of her. She had that impish grin she always wore when she was going to shock him or spring something on him that she knew damned well she could somehow talk him into. "All right, daughter!" he said. "Where do you want us to burrow now?"

Damn it! She was still grinning. Maybe "daughter" would never work again. It saddened him that he would probably have to search for another buzzword to get her goat. Old age, Jack. You no longer like to take the winners off the slot machines.

"We're moving to Fran's tomorrow," she said.

He wasn't sure he had heard her right. "Fran's?" he said. She nodded. *"Our* Fran's?"

"Yep. She's got all the room in the world in that big old place of hers on Girard, two empty bedrooms now that the kids are in college."

"No!"

"Why not?"

"It's an imposition."

"No, it isn't. Look, I didn't ask . . . Fran offered," Marty said. "She's plenty damned concerned about us. It would be more of an imposition to have her go on worrying. Besides, we'll pay her . . . if she'll take it."

He searched for a reason why they shouldn't do it, found none except, "It doesn't seem right, somehow . . . she's not used to having a dirty old man around the place."

"Oh, for God's sake, Dad! *Can* it!" The words had stormed out in her usual gutty tones, but she was grinning again now. "I'll be there to chaperone . . . unless, of course, you don't want me to."

"Marty!"

She turned serious. "All kidding aside, Dad. There's Luis to think about. What can you do for him if you're killed or hurt?" That turned the trick. He caved in. "It's settled, then," she said. And so it would have seemed, except that when they watched the CBS evening news, he noticed she didn't seem to have her mind on Dan Rather. She fidgeted. She glanced at him with a furtiveness he hadn't seen since the time she darn near totaled the Olds convertible. She left her chair and went to the window. He left his own chair, switched the set off, and turned and faced her. "Spill it, counselor," he said. "You've got something else up your sleeve."

Her eyes leaped to life, widening into two blue circles of innocence. "At Fran's," she said, "there's a bonus."

"Which you weren't going to tell me about."

"Well . . . I did kind of think it might be better if you found out for yourself . . . after we got there."

"Come clean, Marty. What's up."

"You'll never guess who's moving in next door to Fran."

"I wouldn't even try. Who?"

"Bonnie. Bonnie McCabe." She stopped, apparently to see how he took it. He gave her nothing and she went on. "She's going to house-sit for Stirling Ames while he's on sabbatical in Mexico City." Another stop. "Don't you see what this means, Dad? From next door we can maybe find out some things we don't yet know."

"Hell's bells, Marty. She'd be bound to spot us."

"Not if we're careful. Be interesting to see who comes and goes."

"Hell, I can already guess who. Emiliano."

"There might be others. Maybe Heck. Maybe even Hassan Kareem. That would spice things up, wouldn't it? He could even be working with the two of them."

She had seen Kareem in court too. "Bad hombre if I ever saw one," she had said when they talked the morning over. A good many more of her remarks, though, had been about Bonnie and Emiliano, particularly Bonnie. "Did you see her face, Dad, right after they brought Luis in?"

"No, I was busy watching you take over."

"Well, as I wheeled Luis to the table I got a good look at her. I've never seen anyone hit harder. What did Heck say she was? Volatile? Psycho's more like it. There's some pathology there, believe me."

"You're a *shrink* now? We've both gotten a lot of mileage out of our imaginations lately. In Heck's case it was all in the wrong direction."

"That still remains to be seen. At the risk of getting whacked with that 'woman's intuition' rap again, Bonnie McCabe was close to unhinged this morning. Nothing uptight about Emiliano, though."

Could she be on to something? The black man and the two kids from Heck's campaign? Or the girl—possibly a mental case as Marty was suggesting—could she have killed Lupe to protect her emotional turf? Or did she have Emiliano do it for her? "Did

you happen to see where Kareem was sitting? Was he near the other two?" he asked. "I missed him until he was up and moving."

"He was a row behind them and nearer the door. That doesn't mean anything. Heck wasn't sitting with his wife and the Esquibels, either."

"How did you know Bonnie was moving in next door to Fran?"

"Stirling Ames told Fran when he dropped off a key today for her to keep while he's away. Isn't it interesting that Fran will have a key to the place while Bonnie is living right under our—"

"*Marty!*" Damn it! She didn't look a bit ashamed. "I think maybe we won't move to Fran's after all."

She leveled her eyes on him . . . hard. "Then I'll go there by myself," she said. She meant it, no two ways about it. Damn, damn . . . damn! He knew he would have to go there with her just to keep her from doing something rash.

"All right," he said, "I'll go to Fran's with you. Mind you, Marty, you won't be able to scoot next door to have little heart-to-hearts with Miss McCabe. When you talked with her before, that was legitimate investigation. She's Curt Santorini's *witness* now. Grilling her now could be construed as tampering or harassment."

"I know," Marty said. "I'll just keep a weather eye out. I promise. Cross my heart." She had been a great little heart-crosser as a child. It hadn't always been a binding legal contract. "But, Dad," she added, "what was that guff you gave me about how you never minded taking a few risks for a client?"

There was no magic in the city lights as seen from the windows of the suite. Instead of winking with liveliness as they did when watched from his balcony, they smoldered as if they might go out and never come on again.

A storm was coming. Faint lightning flashed. Long seconds passed before the sound of soft thunder reached him. The storm must have made its first testing jab at Sandia Crest. Then the rain came, pelting the windows. It rained hard for perhaps ten minutes, then slackened to a drizzle, the kind that threatens to go on forever. It cut visibility in half, but his mind retained the

images of the grid of streets partly revealed in those seconds when the lightning flashed.

The case of Luis Esquibel had been like this storm, from the first weighted, uncertain, almost threatening moments with his client, through the flashes of distorting instinct Jack had gotten, into the obscuring drizzle of little bits and pieces that held no promise of revelation.

There hadn't been a murder on those streets down there since Lupe Sanchez died, not one that was reported, anyway. Or had there been? The perfect crime (as opposed to the merely successful one, as Lupe's murder seemed destined to become) was the one that looked like an accident, or a suicide, one where no body ever came to light, and always one that contained certain elements of luck. The real killer in this one had benefited enormously from Luis's arrival on the scene and the discovery of him with the body. Unless Heck testified, there would be no reason for the police to look beyond the satisfactory case they already had, and if he did testify they would only need to look further if the court believed him.

Even if it did, Valentino would still be obliged to bind Luis over for trial, and unless the judge reversed himself on the bond, Luis, well and out of the hospital, would return to D. Why did he have to think about *that* in the middle of a night like this? He knew.

"Forget room service," Jack said to Marty in the morning when she suggested breakfast. "Let's check out."

"Fran's, then?" she said. "No second thoughts?"

"Fran's," he said. "But lots more thoughts than second ones."

27

Three days after they moved into Fran's rambling house on Girard, using Fran's and Rudy's cars instead of the Z or the Imperial, they still hadn't had so much as a glimpse of Bonnie McCabe. Of course, they were in the office most of the day, where Marty closeted herself with Rudy in an orgy of work to get the caseload back in hand. Jack split his time between there and daily visits to BCMC to see Luis, where he tried to lift the boy's spirits as his own sank. He couldn't even rouse himself to much thinking about the two attempts on his life. He began to wonder if he had dreamed them. He knew, as he trudged slowly from the parking lot and ambled into the hospital, that he was getting careless in spite of Marty's daily cautions.

Luis asked for sketching materials, and Jack called Graciela to see if the cousin had a key to the studio. He breathed a sigh of relief when she said yes. He didn't want to go to the Esquibels and look at any more ruined faces than he had to. He made another search of the studio after he gathered the things Luis asked for. Again nothing.

Luis made a sketch of him one afternoon as they talked about everything *but* the upcoming hearing. The boy still couldn't grip

the charcoal with any strength, but he was on the mend. Jack felt a moment's panic, and held up the sitting until he found Saul Greenberg, and got—along with a glare—another assurance that Luis wouldn't be declared fit to return to D before the hearing. Good old Saul. Hang in there, doctor.

The picture Luis made of Jack shocked him. No wonder the boy wasn't asking about his chances in court. The outlook for Jack's client was written in every wrinkle and in the droop of his usually wiry beard. Maybe he should stop coming to see the boy. He thought repeatedly of calling Heck Velasquez to get his answer about testifying. He decided every time to wait and see if Heck would call *him*. Heck was, Jack was glad to learn, making regular visits to the hospital.

One bright spot: he found he was enjoying his stay at Fran's in spite of his misgivings. A ramshackle two-story frame with a wide front porch, set in a cluster of cottonwoods, the house reminded him more than a little of the old place he had shared with Jane and Marty and with Marty alone for a while until she opted for her own apartment. He didn't feel as much of an intruder as he had thought he would.

The dinners were pleasant, but by Marty's fiat they didn't discuss the Esquibel case, not even the spying she had urged him to undertake. "There'll be no shop talk, Dad. You and I can dine like civilized people for a change." Jack was willing enough to comply, but he was sure he detected a shadow of disappointment cross Fran's face. Perhaps Marty had missed something here. Fran seemed to Jack to be showing more interest in the defense of Luis Esquibel than she had in any of his cases in a long, long time, not that she had ever been inattentive, not even when he was defending someone as completely unappealing as Orville Blakely.

Orville. He had called Jack in such a rage about what he considered some kind of dereliction of duty on Jack's part that Jack could scarcely make out a word the man said. Orville had hung up without finishing, or else someone at the pen had taken the phone from him.

Five days after their arrival, on the first evening Marty didn't have something on, and Fran hadn't yet gone to her room, a car pulled into Stirling Ames's driveway. Unless there were two exactly like it in the city, it was the souped-up Plymouth Duster Jack had played torero to in the office parking lot.

Fran, Marty, and Jack peeked from behind the curtains in the side bay window. Emiliano carried a beat-up canvas suitcase and a corrugated carton to the front door of the Ames house; Bonnie had a clothing bag draped over one arm and under the other a guitar. Jack expected that the young Chicano might stay with the girl, but he came out after only fifteen seconds, went back to his car, and roared away with the sound of the exhaust shivering the cottonwoods.

"We're in business," Marty said. "I think you're excused from office duties, Dad. We'll need someone watching her all day." He began a protest, stopped when he realized the surveillance was either going to involve him or Marty. Better him.

A week of watching brought nothing. Bonnie didn't show herself. Jack soaked himself in solitude, breaking it only to go to Fran's kitchen once in a while to fix himself coffee. Fran's fancy German coffee brewer seemed too much work for one cup, and he contented himself with boiling water in a pan to make up a cup of the instant he had bought at Orlando's. Without an appearance on the part of the girl next door, and with Fran's library to keep him occupied, there was only Orlando's yellow E.F.F. label on the coffee jar to remind him of Luis and the impending hearing. Maybe this slowdown was good for him. Maybe he should try it as a regular thing. Maybe, as he had half-promised Marty, this should be his last case. Maybe.

On the Friday after he and Marty left the Hilton for Fran's, Emiliano showed up in the Duster, Bonnie left the house next door, and the two of them drove off. They were back within an hour. Bonnie got out of the car with a bag of groceries. Emiliano exited from the driver's side, and with hurried steps fell in beside her. Just before she reached the steps Bonnie turned and looked straight into the window bay where Jack sat watching. His heart

did a little shuffle until he realized the curtains screened him.

Bonnie stopped, still looking in his direction, and Jack saw that Marty had been right about her. While still retaining something of her all-American-girl prettiness, she looked like a sick young woman compared to the Bonnie he had first seen in Heck Velasquez's office.

A sack had dropped from her larger bag of foodstuffs. Emiliano bent to pick it up. She didn't notice. Then she turned her face to the Ames house, mounted the steps, turned back to the young Chicano, and produced a set of keys. They went inside. In no time at all they were back at the door again. He expected they would part with a kiss or some other token of physical affection. They didn't touch each other.

Jack looked at her companion. Emiliano wasn't maintaining that superb, sullen cool he had demonstrated in the courtroom. He looked worried. Bonnie went inside, closed the door behind her, and the boy stared at it for a few moments before he went to his car.

He rolled away, slowly, the boisterous muffler only mumbling. In half a minute he cruised by from the other direction at no more than five miles an hour. He made two more trips past the house.

"Has she come out by herself at all?" Marty asked that night at dinner.

"Haven't seen hide nor hair of her since Emiliano left."

"I still think this will pay off. Hope you haven't been too uncomfortable here, Dad."

"It's okay," he said. "Under the circumstances I'm as happy as a clam. Don't know when I've relaxed like this, Fran." He meant it, and it was good to see Fran's smile.

Suddenly, the days raced by like whippets.

No call came from Heck.

Fran still hadn't found Hassan Kareem, and contrary to that one really wild idea of Marty's, the black man didn't show up on

Girard nor in any of the few other places Jack's abbreviated routine took him to. Jack wondered if he had finally left the city.

Then something happened that only made things more complicated, and a hell of a lot more frightening. Jack, giving in to a rare attack of cabin fever, went down to APD headquarters to see if Gilman was still looking for Kareem, and whether he had found him. Neither the police captain nor Ben would be apt to tell him if they had, unless he made a stink about it; it wasn't part of the package. He parked Rudy's car in the underground garage next to City Hall and struggled up the one flight of stairs to the street rather than take the elevator that discharged passengers at the Civic Plaza level. It was just a short walk in the sun to the east side of the building, but his knees, set as if in concrete after the enforced idleness of the stay at Fran's, complained bitterly.

Gilman was expected in, but after passing a desultory half hour with his secretary, Jack decided not to wait any longer. When he reached the street again, he decided to take the elevator down to Rudy's car rather than risk even more pain. Maybe the damned knees would be better once he got to court. Sure they would.

Suddenly he wanted to get back to Fran's again and take up his post at the bay window. The elevator doors gaped open. He put on a touch more speed, but as he reached them he heard his name being called.

"Mr. Lautrec!" It was a man's voice, but high-pitched, a breathy squeak. He turned toward the caller. Hell's bells! It was that young ass, Curt Santorini, Ben Scanlon's stand-in. Perhaps Jack could get in the elevator, push the button, and make a getaway. The call came again. "Mr. Lautrec! Jack!" Well, what the hell. There was an outside chance he might learn something from this prissy yuppie wearing the de rigeur five-hundred-dollar suit and with a paisley tie knotted over an Adam's apple as pronounced as South Peak. He watched the elevator doors close in front of him.

Curt was beside him now, his pale hands holding a briefcase across his chest. The lumpy Adam's apple was bobbing wildly.

"Mr. Lautrec. Since we'll be at opposing tables at the hearing, I thought perhaps—" He didn't finish. Jack watched in astonishment as young Santorini suddenly staggered backward. The briefcase left his hands and leaped skyward just as Curt collapsed into a sidewalk planter holding a regiment of Spanish bayonet.

Then Jack felt a violent tremor charge his canes with life, felt the pavement beneath him administer a vicious bastinado to the thick, tough soles of his orthopedic shoes. The buildings across Tijeras began a quick, weird dance, or perhaps his vision did. His immediate, certain thought was—*earthquake!*

But the monster sound of the detonation that reached his ears next told him how wrong he was, a reassessment confirmed just seconds later when a greasy black cloud of smoke boiled from the entrance to the stairwell he had negotiated a half hour or forty minutes earlier. He knew then that a giant explosion, a manmade one, had just taken out a hell of a chunk of the first level of the underground parking lot. And he somehow knew that it had been meant to take *him* out as well.

They watched Channel 13's telecast of the devastation that night in utter silence. The *carne adovado* Marty had fixed turned cold on Fran's electric range, untouched—unserved, in fact. The screen showed them a scene that could have been sent by satellite from Beirut. The blast had blown up six cars and damaged a dozen others, buckled the pavement of the Civic Center, and sent flames shooting the length of the passangeway leading to the Galeria, the subterranean shopping center beneath the First National Bank, as well as through the auto exit to Tijeras. The girl who collected parking tickets and made change in the exit booth was in Presbyterian Hospital's ICU, with third-degree burns over most of her body. There was grave doubt among the medics at Pres as to whether she would make it.

There was a lot of dramatic footage of the burning parking garage, but no real close-ups. Apparently the heat was too intense to permit cameramen to get very near. A grim Bob Driscoll, in-

formation officer for the mayor, faced the Channel 13 Minicam in front of city hall. It couldn't have been too long after the event. "It is believed that one or more persons may be trapped inside. Police and fire department teams are fighting their way through the smoke and flames at this moment, and rescue attempts will continue until recovery of the body or bodies." Jack shuddered at the use of "body or bodies." Whenever the interview was taped, the authorities had already given up hope of finding anyone alive in the conflagration. Driscoll continued, "Witnesses at the scene report a deafening explosion prior to the outbreak of the fire. The fire department arson team is on the scene, and will begin an investigation as soon as it is safe. Chief Jaime Romero of the Albuquerque Fire Department estimates it may be late today before the fire is under control." Driscoll's statement was followed by a long shot of the mishap taken from a helicopter, and then an update bulletin. Two bodies, as yet unidentified, had been found. Evidence of a bomb had indeed turned up. It appeared to investigators that one of the two people killed had been installing it in one of the demolished vehicles when it went off. When a pizza commercial came on the screen, Marty got up and turned the television off. She and Fran looked bleached. Jack supposed he did, too.

"If it wasn't Hassan Kareem, it's someone working for him, Dad," Marty said. "I'll bet he's the man who shot at you. This looks just too rough for local talent."

"The only flaw in that, Marty," Jack said, "is that it had to be someone who knew something about us. I was driving Rudy's car, remember." Emiliano came to mind. "We've got to get out of here. We're probably putting Fran in danger, too."

Fran stood up. "You're not moving. That's final. If it's someone who knows something, they sure don't know everything, or they would already have tried here. You've been alone here for a long time."

"But Fran—"

"No buts! I want you where I can see you, both of you."

Damned if Fran didn't look . . . *commanding*. Scared as she was, she was still in control. Stalwart lady. Jack had to admit that she made sense.

"We're going to have to check our suspects and see if any of them is missing, Dad," Marty said.

It took Jack three phone calls to raise Ben Scanlon to tell him what he thought about the bombing of the underground parking lot. As Jack was sure he would, the D.A. discounted it, promising only to look into the matter from Jack's angle when and if the victims were identified, something the condition of the bodies made nigh impossible. "Jack," Ben said, "Marty called Phil about another so-called attempt on you. If you want us to take you two seriously, you'd better come cleaner with me than you have so far."

Emiliano came back to the house next door half a dozen times. Well, he and the girl, at least, weren't missing. It puzzled Jack that Emiliano never got inside. Only twice, from what he could see, did the girl even come to the door and on those occasions the young man in the Cuban cap trudged back to his car after no more than ten words could have been exchanged. The other times he left without seeing her after leaning on the doorbell for as much as a minute, even two.

Jack began to hope an odd little hope. He had had a pair of clients once, a young girl and her lover who had committed a series of burglaries together. Caught, they had been Darby and Joan; he had seldom seen two people bill and coo the way they had when Jack arranged meetings for them in the visiting room in D. Their clutches and embraces had embarrassed him. The closer they got to trial time, though, the more Jack had seen a cooling of their ardor. By conviction they had each gone ape trying to shift guilt solely to the other.

Maybe something like this was beginning between Bonnie and Emiliano.

Three nights before the preliminary hearing Marty cooked again for Fran and Jack, and trotted off to a dinner with Lester Gideon, dean of UNM law school, who was dickering with her

to do a series of lectures on medical malpractice litigation for his last-year students.

The dinner was the most leisurely he and Fran had eaten together and it was almost nine when they finished. They didn't talk beyond "please pass" this or that, but somehow he had a strange conviction that a lot of tiny things were somehow getting said.

Jack offered to do the dishes. "Thanks, Jack," Fran said. "I *am* beat tonight. I think I'll soak in a cool tub and get comfortable. If you want company later holler up the stairs."

Marty had cleaned up pretty well after her stint in the kitchen, and there was actually little in the way of mess, but it was dark out by the time he finished. Through the venetian blinds on the window over the sink, he could see the entire north side of the house next door. On other evenings and almost every day, heavy curtains had obscured the dining room and what had probably been called the parlor when the house was built. Today had been the hottest day of the summer, and tonight, to catch the light evening breeze, the curtains were all pulled aside, as were the ones here at Fran's.

He could see Bonnie walking back and forth through the three downstairs rooms on this side. She seemed to be wringing her hands, and from time to time she shook her head from side to side, a swift, jerky, almost vicious movement.

Suddenly she moved through the kitchen and dining room with even more speed. He shifted his eyes to the living room expecting to see her enter it. She didn't.

In about fifteen seconds a light appeared in an upstairs room. The glass on the window was frosted. The bath. Sure. He felt like a Peeping Tom, even though all he could see was Bonnie's silhouette with her arms over her head as she stripped off the blouse she was wearing. He watched her bend over to get out of her other garments. He could stop watching now. She would probably head for bed when she left the bathroom.

But he didn't stop watching. Her shadow was motionless. If he hadn't seen her moving about before, he could have sworn

she was a cardboard cutout. She finally did move, bending over apparently to run water in the tub, but it was such a slow thing he wondered if the girl might be ill.

Then it hit him . . . hard.

Bonnie McCabe wasn't in that bathroom to take a bath, not the kind of bath she would ever get out of!

With his heart thundering and his stomach churning he grabbed his canes from where he had leaned them against the kitchen table and raced, if his clumsy gallop could be called racing, for Fran's front door.

As he passed the stairway he shouted, "Fran! The key to next door. Get it fast and meet me there!"

As he careened along he pleaded, "Bonnie! Please . . . *don't do it!*"

He was hammering at the door of the Ames house when Fran joined him, wearing a terrycloth robe and with water still streaming from her wet head.

He stepped back as Fran turned the key and tried the door. It wouldn't open. The girl must have thrown a deadbolt. There were full-length glass lights on both sides of the door and after he pushed Fran clear he rammed a cane through the one on the lock side. Glass shards flew. He reached through, slid the deadbolt open, and turned the doorknob. *"Bonnie!"*

The staircase was straight ahead of him. He tried to take the steps two at a time and sprawled full-length halfway up. Fran, following close behind, fell on top of him. A cane clattered down the steps behind them. As he gathered himself and started up again he heard the sound of water running.

"Bonnie!" He stopped on a landing. A thread of light showed beneath the bottom edge of a door on the right. The bathroom. Was it locked, too? He felt his heart climb into his throat. He could hear Fran's breathing above the sound of the water.

The door stuck, but it wasn't locked. He launched a big shoulder at it and it opened. A wall of steam slammed against him.

When the steam rushed around them he saw the girl, naked in the tub, legs out straight, the hands beneath the slashed, bleeding wrists clasped between her knees.

"Bonnie!" She didn't look at him. Her eyes were wide open, and it seemed she breathed, but she didn't look at him. He heard Fran gasp. The water, pink already and darkening to brilliant red, had almost covered Bonnie's thighs.

He lunged toward the tub and dropped to his knees. The handle of the faucet as he turned it seemed hot enough to raise a blister. He flipped the drain lever and the water began to leave, carrying with it thick, crimson strings trailing from her wrists.

He grasped her two slim arms above the elbows and forced his thumbs into the soft flesh of the lower inside of her biceps, forced them in so hard he half feared he could push on through. "Rig tourniquets quick, Fran!"

He heard her open the medicine cabinet above the sink behind him and then she was kneeling at his side. In her hands she held Bonnie's nylon blouse that he vaguely remembered stepping on when he first went to the tub, and he watched her as she ripped it down a seam, twisted the two pieces into ropes around a small aspirin bottle and a tiny jar of deodorant. Sure, for the pressure points. He had asked for quick; he got lightning.

He looked down at the two lacerated wrists. Bonnie seemed to have done a miserable job on the right one, but her left wrist was opened like a furrow. Fran had seen the deeper one, too. She wrapped one of her tourniquets around the upper arm and knotted it. When he released his hold, blood surged in insistent floods from the severed artery. They needed a lever. The one cane he still had with him was too long, and he didn't think the toothbrush Fran was offering him would do the trick. There was a facecloth on a small plastic bar behind Bonnie's head and he reached up with his free hand and ripped the bar from its fixture. Fran took it, slipped it beneath the makeshift nylon rope, and twisted; two turns and the bleeding stopped.

He looked again at the other wrist. Yes, it could wait. All it needed was a bandage.

Bonnie was looking down at the arm with the tourniquet. The vacant look that had greeted them was gone, but the one that had come to take its place was only one of curiosity . . . and not much of that.

Then, although he had heard nothing but the sounds of the struggle Fran and he had made, he knew there was someone else standing in the bathroom door. He turned and looked into the eyes of Emiliano.

"What you *doing*, man?" Emiliano said. He had an open switchblade in his hand. Jack knew he should be afraid, but he had no time for fear. He looked at Fran. She had turned at the Chicano's words, but all her concentration was back on the girl again. Jack looked up at Emiliano.

"Don't stand there! Find the phone and call an ambulance. *Now!*"

Emiliano disappeared.

Jack's knees, pressed down into the hard tile floor with all his weight, were sending streaks of flame into his upper legs. He looked at Bonnie's face again. She was gazing down at her wrists. Her eyes still seemed dead, but a tiny smile curved her lips.

"Jack," Fran said, "we've got to move her. She's lost a lot of blood. Shock will set in if she cools down too fast." He nodded. He reached in and wrapped his arms around her limp body and tried to stand. Fran, hanging on to the tourniquet, couldn't help him. Somehow, with the girl in his arms, he staggered to his feet.

"The phone don't work, man!" It was Emiliano in the doorway again. Of course. Ames would have had it disconnected.

"Go to the house next door," Fran said. "The door's open."

Emiliano disappeared again.

Now he'll know we've been watching them, Jack thought. He could see the thought on Fran's face, too. She shrugged. Was this the same shy, quiet woman who had been mildly terrified of Jack Lautrec all the years she worked for him?

Fran found a blanket in a closet in the room he carried Bonnie to. She handed it to Jack and reached down and replaced his hand on the tourniquet he had taken charge of when he laid

Bonnie down. "She's lovely, Jack," Fran said. "It would be a tragedy if . . ."

"I know," he said. He covered Bonnie with the blanket. "She seems to be trying to sleep now. I don't think that's good, Fran." Fran patted her firmly on the cheek. The blue eyes opened. "Will you talk to us, Bonnie?" Jack asked. The girl shook her head like someone moving underwater, but the eyes stayed open. Jack looked at Fran. They had worked well together as he hauled Bonnie from the bathroom to the bedroom here across the upstairs hall, and they had done it without speaking, but there was no time to dwell on that. Now it was time to wonder about Emiliano. Had he used that ugly switchblade on Lupe Sanchez?

Jack turned to Fran to tell her to leave just as Emiliano came through the door. "They're supposed to be on their way," the boy said. "Twenty minutes, they *said*." He nodded toward the girl on the bed. "She going to be all right?"

"We don't know yet, young man," Fran said. "We think so."

Jack stared. The switchblade was gone . . . and so was the enemy. The Emiliano who looked at Bonnie now seemed no more fearsome than an altar boy.

"I've got to get my canes," Jack said.

"I brought the one up I found at the foot of the stairs," Emiliano said. "I leaned it against the wall by the bathroom door." He didn't look at Jack or Fran, just at Bonnie.

"Thanks," Jack said. He looked at Fran. She nodded.

"Jack," she said, "I noticed there's a first aid kit in the medicine cabinet. We'd better do a little more on these lacerations."

"Right," he said.

Emiliano kept on looking at the girl.

Jack got his cane from the wall and the other from the bathroom floor and went to the medicine cabinet for the first aid kit. Emiliano, if he had been, was no threat now, but Jack was still in a serious predicament.

Scanlon and Gilman and their Charlie McCarthy Curt Santorini would want to know what he was doing here . . . and the truth would hang him out to dry. He could take that if he had to, but

what would be the effect on his defense of Luis? Would he have to step aside and let Marty carry on? Would that be so bad? Of course not. But it wouldn't be all that good, either.

Secure on his canes again, he returned to the bedroom. Emiliano was sitting on the bed looking down at Bonnie. Jack watched him in silence for a moment. This was a different Emiliano . . . or else Jack himself had developed a different kind of vision. He made a decision. Somebody was going to have to start trusting somebody . . . now. He handed the first aid kit to Fran, who went to work with it.

"Emiliano?" Jack said.

The boy looked up. His eyes were moist. "Yeah, man?"

"With the ambulance on the way, Mrs. Crowley and I are going to leave. For reasons of my own I don't want anyone to know I've been here. If you want to tell them, I can't stop you. I'd be grateful if you didn't. Either way, it's your decision, but go to the hospital with Bonnie. Stay with her until you're sure she's out of danger. Then—and I don't care how late it is—I'd like you to come back to the house next door. I think we ought to talk, but even if you don't *want* to talk to me I'll want to know how Bonnie is."

Emiliano tried to smile. "Okay. I'll tell them *I* found her. Maybe I'll get a medal or something, huh?"

When Marty got in from her dinner with Gideon and heard their story her face went white. "Sounds like remorse, Dad," she said. "Maybe we're home at last."

"Maybe."

It was one in the morning when Emiliano, haggard, sat down in Fran's living room and answered questions.

"Nah," he said, "I never meant to kill you. Look, man . . . you don't *know* anybody who can handle a set of wheels like I can. If I'd wanted you dead, you'd *be* dead. I wanted to scare you. If I wanted to kill you . . . well, I seen you a dozen times this last three weeks when you ain't seen *me*."

"And you don't know who took that shot at me?"

"No, man. I swear it. I wouldn't ask anyone to kill for me, and I wouldn't use a gun . . . not while I've got my blade."

Jack shivered. "Why didn't you make any *more* phony tries and scare me good?" he asked.

"Bonnie told me to cool it after we found out you weren't after Hector any more."

"Who told you I wasn't?"

"Hector did."

Some fine day, Jack thought, I'm going to find out why some politicians have to talk so much. He should never have told these children *anything*. "Who do *you* think killed Lupe, Emiliano?"

Emiliano looked surprised. "Heck. Didn't he?"

Jack didn't answer.

"Emiliano," Marty broke in. "Why would Bonnie want to kill herself?"

"Don't you *know*?" Emiliano said. "Because of the lie she told the cops, the one about Luis threatening to kill Lupe. It's been eating her alive."

"Why didn't she just go to the police and *admit* she'd lied?"

For several seconds Jack thought there would be no answer. "Look," Emiliano said at last, "Bonnie's mind don't work good all the time. I don't want you to think she's ready for the funny farm. She's smart . . . but smart as she is, she don't think like other people. Things work on her. It ain't the first time she's tried to kill herself."

"Oh?" Marty said.

"None of your business about the other time."

"Sorry, Emiliano."

"Emiliano," Fran said, "what did the people at Pres Emergency say about Bonnie?"

The boy looked tortured. "They didn't say much, but I know what they were thinking."

"Will she be there long?"

"They're talking about sending her to that nuthouse upstate for observation once her wrists are healed. If they do, I'm moving up there."

"The state hospital?" There went Jack's chances of getting the girl to retract the statement she gave Gilman. Now he'd have to prove that she was of unsound mind when she gave it. Scanlon would give his puppet Curt a dozen stratagems to keep Jack from doing it.

When Emiliano left and an exhausted Fran finally went upstairs Marty turned to Jack.

"They didn't do it, Dad, either of them."

"I know."

"We're down to Hassan Kareem, aren't we?"

"Looks like it. For what it's worth."

"What are you going to do?"

"Right now I'm going to bed. When I get to the office in the morning I'm going to order flowers for the lady of this house."

They got up in the morning before Fran did, both of them as glum as when they went to bed. "Damn it!" Marty said, after fooling without success with Fran's fancy coffeemaker. "It's going to be a lousy day, but it will be lousier if I don't get a cup of coffee."

"I've got that instant I brought along," Jack said. He put a kettle on the stove and spooned crystals into the cups Marty placed on the kitchen table. They didn't speak again until after the water boiled and he filled the cups.

"Are we beaten, Dad?" Marty asked.

"If by beaten you mean can we keep Luis from going back to D, I'm afraid we are."

"And if he goes back there . . . ?"

"Let's not think about it now."

She sipped her coffee.

"For instant coffee, this stuff isn't bad," she said. "What kind is it?"

"It's Mexican," he said. "Tastes like French roast, doesn't it?"

She reached over and picked up the jar. "Where have I seen that label before? Looks familiar."

"E.F.F.," he said, "Esquibel's Fine Foods. I bought it when I went down to talk with Orlando about the bail."

Her brow wrinkled—then her eyes became saucers. "Dad!" she said. "I've never been in Orlando's store, *but I've seen that label.*"

They both stared at the coffee jar. "Yes you have," Jack said. "By *God,* you have! And I know where."

Esquibel's Fine Foods had slipped another notch, and a faint, sweet odor of rotting fruits and vegetables was in the air. Orlando hadn't lost all his trade, though. He was checking a customer out at the register and there were two others pushing carts through the aisles. Jack decided to wait until the grocer was completely free no matter how long it took. He walked back to the shelves he had started to look at three weeks ago. Sunflower seeds and jars of wheat germ were stacked cheek-by-jowl with natural fiber cereals, all of them carrying the label reading E.F.F.

Out of the corner of his eye he saw Orlando glancing in his direction. There was a cry in Spanish from the customer at the register. Apparently Orlando had overcharged her on a bunch of bananas.

It took almost ten minutes for the two other shoppers to get checked out. Jack tried to empty his mind of the things he had thought about on the drive to Fourth Street by way of Griegos and the talk with Julia Perez, Lupe's neighbor.

"I'm going in with you, Dad," Marty had said at Fran's, furious at his insistence he see Orlando by himself. In the end she had agreed to wait in Fran's car in the grocer's side parking lot, out

of sight. Jack had pulled his rented Ford directly up in front of the store. He had waved to Orlando as he fed the meter, waved to him again as he walked to the entrance. He wanted Orlando to be sure in his mind that he was alone.

At last the customers were gone and Jack moved the twenty feet past pyramids of detergents and stacks of paper towels to where Orlando stood behind the counter. He read a sign taped on the register he hadn't noticed before, WE RESERVE THE RIGHT TO REFUSE SERVICE TO ANYONE.

Jack drew a breath. He would make no feints, no jabs. He would go for the knockout with his very first roundhouse right. It might be the only swing he would get a chance at taking.

He leaned forward with his face close to Orlando's. It was the way he bent toward hostile witnesses. The man behind the counter was *more* than a hostile witness. Jack straightened up. "Orlando," he said, "you lied to me. You lied to me from the very beginning. You lied in my office when you and Graciela first came to see me, you lied to me at your home and at Luis's studio . . . and you've been lying ever since."

Orlando was silent. He didn't look surprised.

"You said . . . ," Jack went on, "that you didn't know Lupe Sanchez." Orlando looked as if someone had just lifted a burden from his shoulders.

"Lupe," Jack said, "was a customer of yours, wasn't she? She bought those high-priced health foods you keep on those shelves back there. Her cupboards were full of stuff with your label on it. And now Julia Perez remembers the one vehicle that came more often than any other to the girl's house . . . it seemed so ordinary . . . your delivery van."

There was never any way of telling how a caught murderer would act. Orlando seemed almost casual.

"When Lupe became your customer," Jack said now, ". . . was when you found out about her and Luis, wasn't it? Knowing how you felt about black people he didn't dare mention her around the house. That's why Graciela didn't know about her."

Orlando had begun to nod.

"You killed Lupe Sanchez, didn't you, Orlando?"

There were three or four more nods before Orlando stopped. Now will come the headshaking, the denials, the pleading protests.

Orlando Esquibel was motionless and silent.

"Yes," Jack said, "you killed her all right. It was bad enough that a black girl had your son . . . but when she took Hector it was too much, wasn't it?"

Orlando was getting ready to talk. The guesswork was over with. "Mr. Lautrec," he said, "you cannot prove this . . . any of it." He was smiling!

"My God, man! Do I have to? Won't you go to the police and tell them . . . and keep your son out of jail?"

"No."

Jack had to wait until the shudders of disbelief and then of disgust passed through him before he could speak again. "Esquibel! Luis is your *flesh and blood*. Do you realize what you'll be condemning him to?" There was no answer.

A customer came through the door and then another. Jack heard the grocer greet them both, greet them with typical retail merchant affability, as if nothing at all had taken place between him and Jack. Jack would have waited, tried once more, but his defeat was far too complete and bitter. With a leaden heart he started for the door.

"Mr. Lautrec," Orlando called to him, "you still do not understand. Luis did wrong. He will have to pay . . . for me and everybody."

Jack got in the Ford, drove around the block and back into the parking lot where Marty waited. When he told her, she looked as if someone had struck her. "I can't believe it," she said.

"Neither can I . . . although when I think about it I shouldn't be too surprised. I've seen strange killers, Marty: parricides without remorse; women who've smothered babies they've nursed. We're all closer to the slime than we are to the angels. I doubt Orlando meant Luis to take the rap at first, but when his bigotry

got working on him he began to see some kind of crazy justice in it."

"Can we send Scanlon after him?"

"No," Jack said, "for Ben this case is all wrapped up. Without a confession from Orlando we're shot to pieces."

"Could we get Graciela to talk with him?"

"First thing I thought of, but can you see her standing up to him? And maybe he's off his rocker. He could be savage with her."

"And you don't think there's a chance of his conscience coming to the rescue? That he *will* confess?"

"If the beating Luis took won't do it, what in God's name will?"

"What's left?"

"We'll struggle through the hearing. Maybe we can get something solid on Orlando before the trial. At the trial, if Bonnie isn't well enough to come to court with a retraction, I'll take as many swings at any deposition she might have given Ben as I can, try to get her mental condition read into the record or at least out where the jury hears it before I'm overruled. I'll put her on trial, and Orlando, of course . . . no matter how shaky the case against him."

"There's still Heck."

"Yes. As of now he's the only ray of hope we've got. If he would testify at the hearing, we might get Scanlon to reopen the investigation, however halfheartedly. He might anyway, if he takes my word about Orlando lying. The bombing of the garage might help persuade him, and he could figure that a refusal to cooperate with the defense might not look good on appeal. None of it will help at the hearing. And no matter how the trial comes out, Valentino's ruling on the bond means Luis will be behind bars for a long, long time."

"And I suppose you couldn't tell Heck about Orlando for the same reason you couldn't tell Graciela?"

"We'd probably put him in even more danger than his mother-in-law would be. Orlando can't be too happy with *him*."

"Did Orlando have someone try to get you at the Civic Center?"

"I wouldn't be at all surprised if it turns out that way."

"At least we know who we have to watch." She put her hand on Jack's shoulder. "Dad . . . Heck *won't* testify."

There seemed to be no point in asking her how she knew Velasquez wouldn't take the stand. Her voice told him everything.

As they sat in Fran's car they saw Orlando leave the store in a hurry. He got into the delivery van without looking at the parking lot and drove away.

The exhaust of the van roared like that of a racing car.

Jack smiled, bitterly.

"Listen to that, Marty," Jack said. "Orlando took that shot at me."

He woke up in the middle of the night not sure after the moves from the apartment to the Hilton and then to Fran's house on Girard just where he was.

He had been dreaming a nifty dream. Like Philo Vance he was proving to Ben and Gilman how Orlando had murdered Lupe Sanchez, proving it with logic and deduction.

Crap! Real-life murderers weren't caught by Philo Vance.

In real life, murderers were caught (if they ever were) by tough, hardworking cops like Gilman and on rare occasions by bad-tempered, half-crippled, chance-taking, grubby lawyers. And their crimes weren't neat almost to the point of being pretty.

Real-life murderers were more often Jack the Rippers than Lucrezia Borgias. They left behind them torn flesh, splintered bone, blood, disfigured faces, and obscenely broken bodies, corpses doused with gasoline and reduced to ash. That's what Philo Vance would find in Jack Lautrec's world, not the tiny hole left by the hypodermic needle. If a real-life sleuth came across a hidden needle mark it was in the armpit of a slobbering junkie . . . and as for locked doors, he opened them with fear and trembling. Deduction? Logic? Seldom were crimes solved by logic or deduction. Patient digging, mileage, and yes, hunches: those were the things that brought killers to the bar; those and a lot of endless sitting through the dreariest scenes of the human comedy . . . but

above all, the things that solved crimes were eyewitnesses and confessions.

Without eyewitnesses and confessions ninety percent of the convicted murderers in the pen and almost every one of those who had crumpled to clay when the pellets hit the acid would be free today. Where was the confession that would save Luis? It wasn't likely it would come their way. Was there *anything* Jack could do to force it from the killer?

What he and Luis needed now was the flare of trumpets as the cavalry rode in, or a deus ex machina lurking in the proscenium arch of this theater of the absurd.

He wished he could get back to sleep and play at being Philo Vance again.

By the time Fran and Marty got to work, he had been at his desk an hour.

One thing had become clear during the remainder of the night. It wasn't a god-from-the-machine he would have to nudge into action . . . it was a goddess.

Ana Velasquez. If anyone could bring pressure to bear on Orlando Esquibel it was his daughter Ana, and he had *never* promised Luis he wouldn't implicate his father. Only Heck and Heck's testimony were out of bounds.

Jack barely muttered good-bye to Fran as he left the office.

He expected to find the same demure lady he had met in Orlando's store. He didn't. *This* Ana Velasquez was resolute, unyielding, and as strong as the mountain ash they stood beneath in the front yard of the brick house on Las Lomas. "No, Mr. Lautrec," she said, "I *won't* talk to my father."

He had to go on trying. "You haven't been to see Luis, have you, Ana?" There was no answer. "If he goes back to the detention center it could happen again . . . probably will. I shouldn't have to draw pictures for anyone any longer about the danger Luis faces."

She walked away from him toward a swing set at the side of

the yard where the two children played. When she turned and came back her face was even more set, if anything.

"Luis is their godfather, I understand," Jack said.

She ignored that. "Look, Mr. Lautrec," she said. "Not one thing you've said proves my father did what you say he did. Why should I even *risk* his love by accusing him? At first you were sure it was Luis. Then you were just as sure it was my husband"— so . . . she knew—"and now it's my father. Is my *mother* next . . . or me?"

"Your father as much as admitted it, Ana. By trial time I think I'll prove it. Luis may be dead or ruined by then. Do you want to lose them *both*?"

Set before, her face had become frozen stone, but after Jack's last words it softened some. "Look, Mr. Lautrec," she said, "I know Luis didn't do this thing, but I know my father didn't either. The best thing for me to do is to let everything take its course."

"That's it, then?"

"Yes."

He turned and started down the walk. Her voice stopped him. "Hector tells me you're the best at what you do, Mr. Lautrec. He says you'll get Luis free tomorrow. I believe him. I've gone to church every day since Luis was arraigned. You won't need me to talk my father into anything." Some of her calm had fled. Her voice flirted with hysteria, but it didn't break.

He knew then there was something more he had to say. None of the people close to this business, not Heck, not Judge Cordoba, not even Gilman nor Scanlon, none of them, seemed to have the faintest idea of what prison was actually all about. How many times had Jack heard people like them, people who should know better than the ordinary citizen, say something like, "Well . . . he got off with five years, a pretty light sentence"? A *light* sentence? Five years? Five *days* could be an eternity in prison. Yes, he had to speak, even if he damaged this delicate woman beyond repair. "Ana," he said, "can you visualize what your brother's prospects are if I can't win his freedom at Judge Cordoba's preliminary hearing? The beating he took is nothing compared to the things

that will happen inside this boy. Sure, I'm still confident I can fix responsibility for this crime where it belongs by the time Luis comes to trial. I have to be. I couldn't go on myself if I didn't have such confidence, even if in the long run it's unjustified. He won't die in the gas chamber, but even that might be preferable to the suffering he'll endure while we're waiting for a jury to bring in a verdict on him. If he stays behind bars as few as six months, and it could be longer, you'll never see your brother again . . . not the one you know. Let me tell you what he faces. To begin with, he will have to—"

"No! No!" It was a thin, white, tortured scream. She clapped her hands over her ears, pressing so hard her forearms quivered. "Stop, Mr. Lautrec! I won't listen . . . I won't."

He couldn't stop. *Someone* had to hear this. It broke his heart that it had to be her.

Perhaps she didn't hear the litany of horror he let pour out. It didn't matter. She could see his face. When he finished he turned and walked to his car. He didn't look back. He felt crippled. The feeling wasn't in his knees.

He didn't tell Marty he had gone to see Ana. There was nothing about the meeting to discuss with her, no conclusions . . . no hope. He sat late in his office that night after Fran and Marty had gone.

30

"I trust you're not going to bring up anything new and startling, Jack," Cordoba said when he and Marty, Curt Santorini, and the others on the prosecution team met with the judge in the pre-hearing conference. "Why can't you put a name to this possible witness?"

"This witness feels being named would be, by extension, an infringement of Fifth Amendment rights. *I* damned well know it would." Pure bluff. His call to Heck this morning produced only silence.

"I also trust, Mr. Lautrec," Valentino said, "that we won't be hearing such language in my courtroom. As to your witness, I'll rule on that later. My first thought is that it violates the spirit of our gentlemen's agreement."

Watch it, Jack. That "damned well" was careless. Was he getting careless about big things, too? "Sorry, Judge Cordoba," he said.

"Apology accepted . . . conditionally," Valentino said.

"I will be careful, Your Honor," Jack said. "I respectfully reserve the right, of course, to introduce hard evidence I don't yet have . . . should it come our way this morning." Another bluff for

Santorini. It didn't work. Curt couldn't quite suppress a snicker.

Jack felt sick, physically sick. The remarks he had made notwithstanding, the only thing he was liable to bring up this morning that would upset the judge would be the breakfast he had forced down. Thank God Marty looked composed. Curt looked suspicious of her. She looked like a winner . . . all the way. She smiled when she reached the defendant's table. The broadest smile of all, though, when this thing was over, would probably belong to old Joe Santorini in the audience behind Jack.

More from habit than curiosity Jack looked around and in back of him. The trial birds had settled into place. The media people not working up front had found their seats and were trying to look important. Spectators were still filing in. Among them he saw Hassan Kareem. Nothing Jack had learned yesterday completely eliminated the black man from his suspicions about who had set the charge in Rudy's Cutlass. Was it too farfetched to imagine that Kareem was working for Orlando? He looked like a pro—cool, a Tonton Macoute behind those dark glasses.

Graciela came through the rear door of the courtroom and edged herself to the row in back of Jack as if she were enveloped in a cloud. Orlando wasn't with her. No surprise. Jack wondered what he had told her. It came as no surprise to him, either, that he didn't see Ana. After his talk with her yesterday, she was actually the last Esquibel he expected to see in the courtroom, but perhaps the only Esquibel he wanted here today, even if it risked having her watch him fail her brother Luis . . . and as a consequence, fail her. His last memory of her, the one he knew he would carry with him to the grave, was of her framed in his rearview mirror as he drove away from the Velasquez house on Las Lomas, standing beneath the ash tree, holding the tiny hands of the two children she no longer had the strength to whisk away to safety.

Hector Velasquez entered. He made his way to where Graciela was sitting and waited patiently for the man seated next to her to make a place for him. He didn't look at Jack.

"We can't use him?" Marty said. Hope must have revived in her since yesterday.

"No. He wouldn't be of much value at this point anyway." He hoped she wouldn't ask him to explain himself, although she certainly had every right.

There was nothing more in back of Jack he wished to see. He turned and faced the bench, knowing there was little he wished to see at that end of the courtroom, either. He looked at Marty instead. What a dismal entry into criminal defense. If only he could show her they had a fighting chance. He should never have burdened her with his horror of Luis going back to D. Making it so important only put more pressure on her. There would always have been plenty of that . . . when they got to trial.

"Dad," she whispered, "did you tell Luis about his father?"

"Thought about it. Decided not to." He had realized at the last second how berserk the boy could go were he to tell him of his new suspicions. Luis had seen his hotshot lawyer, as his sister had pointed out, go after nearly everyone in the city without result. He would then make the worst of all possible witnesses for himself when Jack put him on the stand. And putting Luis on the stand was just about the sum total of everything they had.

For the moment, too, Jack was trying not to think about Orlando's taking the shot at him, if it *was* Orlando and not Kareem. Marty, in their session last night, had put it down to the fact that Orlando at the time had discovered that they were after Heck. Jack could buy that, as he could buy the possibility that the attempt was intended, as with Emiliano, to be just another near-miss scare. The pictures of Orlando in the Esquibel home had shown a man familiar with firearms, one not likely to botch such a simple job. Like Emiliano, Orlando, if he meant to kill him, could have gotten to an unsuspecting Jack a dozen times since then. With Jack abandoning Heck as the prime suspect, Orlando must have felt his secret safer as the weeks went by . . . until yesterday. He might turn dangerous again in the weeks to come. Jack would have to face that when and if it happened. Would he

have to face Kareem as well? The explosion in the underground parking lot had been no mere *scare*.

Back to the things at hand. There could be no attack on Bonnie's statement at this hearing. Santorini couldn't introduce it, but its damage had probably been done. Valentino had read it. It was bound to influence him when he reconsidered bail, particularly without any testimony from Heck Velasquez.

"Marty," Jack said, "I told Ana about Orlando, Marty. She refused to talk with him."

"You're not serious," Marty said. "Was she afraid?"

"No, not afraid." He started to say something more, but a bustle of activity at the front of the courtroom told him they had brought Luis in. In the hospital yesterday he still had contusions and swellings, but he looked strong and vigorous. There would be little in his appearance to elicit undue sympathy from Valentino today, but hoping against hope, Jack had gone to Saul Greenberg again.

"I'm sorry, Mr. Lautrec." Greenberg's hard, professional look had gone soft with regret. "He'll be discharged completely in the morning. Actually, I should have returned him to the detention center three days ago. Just stubbornness on my part that I didn't, I guess."

Luis walked toward Jack and Marty, nodded to them, and then stepped (rather more nimbly than Jack would have wished) around the defense table to the railing which separated the audience from the rest of the court. Graciela was at the rail, her arms outstretched. Mother and son had no time to talk. The sheriff's man hurried forward, put his arm on Luis's shoulder, and turned him toward Jack, Marty, and the table. "My father and sister aren't here," Luis said. Maybe it was just a guilty conscience on Jack's part, but the words sounded like an accusation.

Someone tapped Jack on the shoulder. When he turned he looked straight into the level eyes of Phil Gilman.

"We just now made the pair who died in the parking lot, counselor," the police captain said. "One was a con named Billy Bob

Evans who just got out of Santa Fe two weeks ago. Looks like he blew himself away while he was wiring the charge to your partner's Cutlass. He was a cellmate of one of your ex-clients—Orville Blakely. The other body was that of a woman named Betty Blount. We're looking now to see if she was connected in any way. Sorry it took so long. It takes a while to run down dental records."

There was no time to consider it . . . the call came.

"All rise!"

Valentino Cordoba was at his bench.

The drone of Jim Blake, the police officer who with his partner Tibo Espinosa had arrested Luis that night in the bosque, would have made Jack drowsy despite his depression (after Curt Santorini's opening squeaks) if its matter-of-fact tonelessness hadn't somehow heightened the grisly picture he painted of what he and his partner found in the grave they discovered there.

The officer made a good witness. He drew no conclusions Jack could object to, and the way he steered around any accusation of the man he arrested in the moonlight made his testimony infinitely more damning. Nothing in the way of handholds for cross-examination presented themselves, and Jack let Marty take the witness when Santorini turned him over to the defense. He didn't permit himself any hopes for Marty's efforts. She sailed up to the attorney's lectern and microphone with a show of confidence she couldn't possibly be feeling. She spread the notes they had put together on the lectern and then put on a pair of glasses Jack knew for a fact she must have borrowed from Fran. She glanced at the notes, removed the glasses, folded them, tapped her teeth with them as she customarily did with her pencil, and flashed the young officer a dazzling smile. Her voice came over the speakers as soft as eiderdown.

Q. The defendant himself did not lead you to the grave, Officer Blake?

A. Well, he kind of—

Q. Please, Officer Blake. Just answer the question. Did the defendant *lead* you to the grave?

A. No, ma'am.

Q. The defendant did not say he had killed the deceased, did he?

A. He didn't say *anything*, ma'am.

Q. That's not what I asked you. Did he *say* he had killed her?

A. No, ma'am.

Q. How deep was the grave you found the body in?

A. Three . . . four feet. Thereabouts.

Q. How long do you think it would have taken someone to dig such a grave?

Curt Santorini was on his feet, objecting. "Calls for a conclusion on the part of the witness, Your Honor."

Cordoba sustained him. There was little else he could do. But he showed he saw the thrust of Marty's question. "Could you put it another way, counselor?" he said. Jack wondered if *he* would have gotten this second chance. Perhaps there were different rules for practitioners of "civil" law.

"I'll try, Your Honor. Thank you," Marty said. Sweet. If she had been his opponent, Jack would have retched.

Q. Officer Blake. Would you describe the grave for the court?

A. It was just a hole in the ground, ma'am.

Q. That's not enough, Officer. What is the earth like there? Caliche, sand . . . what?

A. Soft ground. Sand, I guess, and loam I think it's called. There were big rocks on top of the body.

Marty stepped to the exhibits table, picked up a photograph, and looked a question at Valentino. The judge nodded and she carried it to the witness stand. Away from the microphone she

would have to raise her voice, not for Cordoba, but for Jack and the spectators.

Q. Is this a photograph of the grave, Officer Blake?

A. Yes, ma'am.

Q. What are these round things protruding from its sides?

A. Roots, ma'am. Cottonwood roots.

Q. Count them with me, would you please? Do I make out perhaps half a dozen, each, say, four inches or more across?

A. Yes, ma'am.

Q. Were they, as they appear here, chopped off when you opened the grave?

A. Yes.

Q. Were they cut cleanly, or were the cuts of a more ragged nature?

A. Whoever did it had to worry them some, ma'am.

Not bad, daughter, Jack thought, not bad at all, considering that you're asking questions from a hole far deeper than that bosque grave. The way she was handling him she would have persuaded any *jury* that Patrolman Jim Blake was *her* witness, not the prosecution's. She wasn't likely to persuade Sweetpants, though.

Santorini was giving a goggle-eyed imitation of Rodney Dangerfield, trying to attract his witness's attention, but the young cop had his eyes glued on Marty.

Q. You say there were rocks in the grave. Is it rocky in that part of the bottomland?

A. Not particularly.

Q. Then the rocks would have to have been transported from some distance. Right?

A. I should think so.

Valentino stared at Curt Santorini, looking for the objection Jack, too, expected. None came. You sure dropped the ball this

time, Snotnose. Jack chanced a fraternal smile at Cordoba, wishing he had the nerve to wink.

Q. You're a powerful-looking man, Officer Blake. How long do you think it would have taken *you* to dig that grave?

A. Golly, ma'am. An hour, anyway . . . maybe two.

Santorini couldn't speak through what looked to be apoplexy. Jack nearly laughed out loud. None of this would influence the outcome of this hearing, but Marty had sure laid some groundwork for the trial. Blake couldn't retreat from his opinion, and the time involved in what happened in the bosque before the police arrived could trouble a jury. Jack could even consider putting the officer on for the defense, calling him even as an ostensibly *unfriendly* witness. Marty thanked the patrolman. He couldn't take his eyes from her as he left the stand. Good. The kid was smitten.

"Great, Marty, great!" Jack said as she returned to the table. She beamed her thanks.

Curt called the forensic expert, a solid, no-nonsense type named Homer Gray. Recovered some, the prosecutor led Gray through the scene at the house with unexpected patience. Curt wasn't, perhaps, so dumb after all. He was on comfortable ground here, and he obviously had learned something from Marty's performance. The expert ticked off his findings matter-of-factly: the bloody couch; the knife with Luis's fingerprints on it; the pickup's tire tracks; the shovel and pickax Jack knew Cisneros (another prosecution witness, damn it) would later identify as having come from the house; the whole incriminating works. "Your witness, counselor," Curt said. Yes, he had recovered nicely. He almost sneered as he took his seat.

Jack took the microphone himself this time.

Q. Mr. Gray. You say the weapon found at the scene was a butcher knife?

A. Yes, sir.

Q. Was it the one the state has asked to be labeled exhibit A?

A. Yes, sir.

Q. And there is no doubt in your mind that the fingerprints you found on it—in *dried* blood as I understand it—match those of the defendant?

A. None whatsoever. They were a *perfect* match.

Q. Has it occurred to you that the knife might have been picked up by the defendant sometime *after* the handle had become covered with blood, when the blood had begun to set, for instance? Or *had* set?

A. No. Such a thought did *not* occur to me.

Q. Does it occur to you now?

A. I suppose it could have happened that way. Not likely.

Q. But it could have happened *just* that way, couldn't it?

A. Yes, sir. But I don't—

Q. Thank you, Mr. Gray. Now . . . how much of the house did you check for fingerprints?

A. Every room. And every surface that would have taken prints.

Q. Did you find the defendant's fingerprints anywhere but on the knife?

A. On the doorknob. Nowhere else. Great pains had been taken to wipe things clean.

Jack excused the man. Maybe, just maybe, he had set Valentino's quick mind thinking. Why would a killer wipe everything in sight and forget the most damning things of all . . . the weapon and the doorknob?

Cordoba looked as if he had dozed off during the last part of Jack's cross-examination of the crime lab man. As Jack returned to the table the smug look on Curt's face told him the assistant D.A. had noticed, and concluded that Sweetpants had missed Jack's point. Beginner. Valentino will spring to full, tigerish wakefulness if either of us tries something funny. The little judge hadn't missed a thing and Jack knew it.

Marty had moved from Luis to the vacant chair on the other side of Jack's. As he sat down she leaned over and whispered in his ear, "Another Esquibel just showed up."

Let it be Ana, he prayed, dear Lord, let it be Ana . . .

He turned and looked across four rows of benches . . . straight into the eyes of Orlando Esquibel.

Santorini was calling the medical examiner Harding, the same sensible man Jack had talked with in the morgue, back in the stone age of this affair. Curt would only call two more witnesses today. Timothy Merryman would link Luis inextricably with the victim, and then Curt would finish with Cisneros.

Jack only half-listened to the coroner's man tell the court the things he told Jack in his office. Orlando. He fought hard to keep from turning and studying him.

Santorini finished his direct. At last night's meeting Jack had given the M.E. to Marty for cross-examination. Marty gathered her notes and began to rise. He put his hand on her shoulder, and pulled her gently back into her chair.

"I've got to take him, Marty," he said. "Sorry." She shrugged the shrug of the good soldier and handed him her notes. "I won't need them," he said. "I think we've just turned a corner I didn't want to turn."

He fussed and fiddled with the flexible microphone standard until he could speak through it while standing well to the side of the lectern and facing the back of the courtroom. He wanted to see Orlando's face, but not quite yet.

Q. Dr. Harding . . . you say the wounds of the deceased were caused by a knife, possibly the butcher knife the prosecution has introduced into evidence?

A. Yes, sir.

Q. And it was the first wound that was the cause of death?

A. Yes, sir.

Q. The three other wounds you described were merely window dressing, eh?

A. I wouldn't put it quite that way, Mr. Lautrec, but . . . yes.

Jack had looked at the M.E. as he questioned him. Now he turned and found Orlando's eyes before going on. *Don't turn away, Orlando.* He almost spoke the words aloud. *Just keep on watching me.*

Q. Now please consider my next two questions with the utmost care, Doctor. Would the wounds you examined on the body of the deceased have required an extraordinary amount of strength to inflict?

A. No, sir. Any reasonably fit, healthy person could have made them.

Q. All right, then, Doctor. In your opinion . . . could a *woman*, say five feet two or three, weighing about one hundred ten to one hundred fifteen pounds or so . . . *have made these wounds?*

A. Yes, sir. Quite easily. There's only soft tissue below the sternum, where the first, fatal wound was made.

Orlando Esquibel turned parchment white and sagged so heavily in his seat on the fourth-row bench that for a moment Jack thought he had fainted dead away.

"Hey!" Marty said when he reached the table, lifting her voice above the muttering from the spectators. "You sure blew *me* away. You didn't even hint you were going after Bonnie McCabe *today.*"

He shook his head. "I'm not going after Bonnie, Marty."

Luis was staring at him. This was the time of greatest danger. No, Jack decided, he hasn't doped it out . . . not yet.

Valentino Cordoba was gaveling his courtroom into silence. He was also fixing Jack with a look that seemed to say someone would have to pay for sensationalizing his preliminary hearing. *Tough, Sweetpants. You can't hurt me any more than I'm hurting now.*

Jack watched Timothy Merryman being sworn, but his mind was somewhere else. Then, out of the corner of his eye, he saw someone hand Marty a folded piece of paper. He half-saw her open it . . . and then he heard her gasp. There was something

triumphant in her gasp. She folded the paper up again and handed it to him. When he opened it himself, he read,

I will confess — Orlando

He folded the note and stuffed it into his vest pocket. Marty's eyes had followed his hand to the pocket. He pushed the note down deeper.

"Will you call him now?" Marty asked, her excitement shaking her. "Will Cordoba *let* us call him?" Luis looked lost.

"I don't think I'll ever call him, Marty," he said. "Let's listen to what Merryman has to say." Explanations would have to wait. He would beg her forgiveness later. Telling her they should listen to Merryman had been an evasion. He no longer had any interest in what anyone here today had to say, particularly Timothy Merryman.

Still, he listened to the art instructor. The man was glowing in the limelight Curt Santorini's questions bathed him in. Jack heard him tell a warped story of Luis's interest in the black model who posed in the life class in Corrales. Fueled by leading questions that led to even more leading questions a picture was emerging from the witness stand of an obsessed youth . . . one any listener would believe utterly driven to commit the crime he stood accused of.

Jack could feel Marty's eyes. She was wondering when he was going to object. He knew he should . . . for the sake of form, anyway. Valentino was giving him suspicious looks. There was a low, soft, ominous buzz from the quasi-experts in the audience. The old hands back there were expecting something from him, too. Let them. He couldn't save Luis Esquibel in Valentino Cordoba's court today. Perhaps he couldn't save him next time, either, and perhaps there would be little left of him to save. Jack Lautrec might have reached a lower point in his career. He couldn't remember it.

Then the sounds of the muttering and squirming behind him

changed their tenor. He turned and saw Fran—his and Marty's Fran—opening the gate that led from the spectators' section to the courtroom proper. She held an envelope in her hand.

"It came an hour ago, Jack . . . hand delivered," she said as she slipped into the chair beside him. "At first I thought it could wait . . . I was alone at the office. When I looked at the return address I figured the phone could go unanswered for a while."

Jack nodded, took the letter from her, and dropped it on the table in front of him. He turned and looked across Luis to Marty. She had seen the letter, but it only held her eyes for a moment before they were back on him, burning with accusation. Merryman was still giving Santorini even more than he wanted. Luis, from the look of him, must have begun to realize what everyone else in the courtroom already thought they knew. His lawyer had quit on him.

"Dad!" Marty's stage whisper must have carried clear to Valentino's bench. "Are you going to step in here or *not?*"

"He's all yours, Marty," Jack said as Curt finished. He watched her go to the lectern, saw Luis's eyes follow her. He picked up the letter. His name and the office's address were slashed across it in a wild hand . . . but a woman's hand. He turned it over and read the return address. It seized his eye as it must have seized Fran's, but not the street and number . . . the name of the sender was quite enough: Ana Esquibel Velasquez. He tore the letter open with fingers suddenly too thick and began to read. As he read, not a word of Marty's cross of Merryman, nor the infuriated objections of Curt Santorini, got through to him. When he finished he rubbed his eyes. They seemed as gummy as if he had been asleep for a thousand years. He stood up when Marty released Merryman from the stand. "Your Honor," he said to Valentino, "may we approach the bench?"

"Is it necessary at this time, counselor?" As always, Sweetpants's courtroom voice dripped nectar. Acid, was it to come, would come in chambers.

"If the court pleases," Jack said, "the defense believes it to be

absolutely vital." He prayed he could *make* it to the bench . . . and wherever else the day would take him.

Valentino Cordoba didn't relish trips to chambers with opposing counsel when his courtroom clock was ticking away on schedule as it was today. The little judge had certainly planned this hearing as a short, one-day affair, perhaps shorter, one without even a lunch recess. The hike on his stubby legs with the prosecution team and the two defense attorneys trailing behind him had put him all out of countenance . . . but no more so than what he had perceived going on from his bench.

When Jack and Marty had reached the bench with Curt Santorini, Jack had whispered to the judge, "The evidence I spoke about has come our way, Your Honor."

With an exasperated sigh Cordoba had ordered them all to chambers. Once behind his desk he had fixed Jack with the glare that had scorched a generation of attorneys. "Before I hear what you have to say, Mr. Lautrec, let me tell all of you—both sides— that I am most disturbed with several of the turns this hearing has taken. First to Mr. Lautrec. I most certainly do not condone your insinuations, without witnesses or evidence, that someone else is guilty of this crime. You were assuming a latitude in your cross of Mr. Harding I'm not yet sure I would grant you in a *trial.* And Mr. Santorini. I must take you to task severely for your examination of Mr. Merryman . . . and I would never allow *that* in a trial . . . even *without* the objections counsel for the defense should have made. Furthermore . . ."

Get it over with, Valentino, Jack pleaded silently as Cordoba raged on. He wanted to break into the judge's lecture, but . . . patience . . .

"Now, Mr. Lautrec," the judge was saying, "this 'new evidence' you alluded to when you approached the bench had better be legitimate. I know you're doing the best you can in a hopeless cause, but I won't have any more desperate, theatrical attempts to cloud the issues playing havoc with my procedures. That said, what do you have to show us?"

Jack's heartbeats seemed like those of a funeral drum. He gripped the canes and began, "I have a letter here from Ana Velasquez, sister of the defendant, Your Honor, which was delivered to me after court convened. The defense had no knowledge of its contents before that time, or we would have made a copy available to the court and the prosecution. I would like you to read it, Judge Cordoba, or, with your permission I should like to read it aloud, in order that my associate and Mr. Santorini and his people can all be made aware of its importance at the same time. May I?"

"From the defendant's sister?" Valentino said. "Mr. Lautrec . . . if this letter is in the nature of a testimonial as to the character of the defendant, it will have no validity in today's proceedings."

"It's substantive, Your Honor."

"Do I have your word on that, Mr. Lautrec?"

"Yes, sir. You do . . . as a human being, and as an officer of the court."

Cordoba thought it over. It was hard to believe that the baby face Jack looked at could hold eyes as hard as blue steel shot. Jack held his breath. The repetition of "Mr. Lautrec" had left him with a queasy feeling.

"All right," the tiny judge said at last. "Read."

The letter was fluttering in Jack's hand. For a moment he was terrified that he wouldn't be able to make out Ana's writing again. Then he felt Marty's hand on his shoulder and he began . . .

Dear Mr. Lautrec—

As you read this, tomorrow I expect, I should be in the district attorney's office, telling him the same things I am telling you.

I killed Lupe Sanchez.

This is not a trick to free Luis. I shall tell Mr. Scanlon things that will make him believe me.

The knife I used is from my own kitchen. There is an odd chip in the handle I will describe to him. Since there have

been no published pictures of the knife he will conclude that I am familiar with it, to say the least.

I am presenting other evidence to him. I am taking him the things I took from Lupe's house that night.

To prevent the discovery of the relationship between Lupe Sanchez and my husband Hector, I took most of the contents of the medicine chest in the bathroom. Hector kept personal articles there I didn't want found. In taking them away I inadvertently took things of hers, including a prescription for what I think are sleeping pills, with her name on it. There is no other way I could have gotten any of these things.

I also have a bracelet I took from her wrist after I killed her, an expensive gold bracelet it should be easy to prove Hector bought her. I had a difficult time removing it. Are there not tests that will reveal traces of her skin? And, of course, I am willing to take a lie detector test.

You must be wondering why I did not come forward sooner.

Until you talked with me today, I was supremely confident that you would work some miracle and get Luis freed. I fully intended to confess were Luis ever convicted, but I felt in my heart it would never come to that. Of course I deluded myself. I must have wanted to.

One look at you this afternoon and I knew you and Luis were going to lose, not only at the hearing, but perhaps at the trial, too. And then you opened my eyes to things I had blinded myself to. I could wait no longer.

My father is blameless in this crime as is Hector. I am sure Hector is still not aware that I knew of his infidelity. Some men can keep such things a secret from their wives. My husband Hector couldn't. I would have let this affair run its course, but when she threatened to make it public and someone in Heck's office sent me an anonymous letter I knew I had to act.

Simply warning her away was not the answer. I knew her nature well from talks with Luis. He spoke of little else when he went with her. And I knew her habits.

I also knew I had to do something fast before she wrecked my husband's career . . . and my marriage.

Oh, I did try to talk to her that night. She refused to give Hector up. I was ready for that.

I was surprised at how easy it was to do. It might have been more difficult had she been afraid of me.

Perhaps now I can begin to get this off my soul.

Ana Velasquez

No physical effort in his life had drained Jack as had the reading of that letter. He looked at Valentino. "Well, Your Honor," he said, "will the court entertain a motion for dismissal?" Cordoba's eyes, closed while Jack read, opened wide and then narrowed again.

"Of course not, Jack!" he snapped. "You know better than to ask. I'll need more than that letter. Even freely given confessions are only evidence . . . not proof."

"I didn't really expect you would dismiss," Jack said. "Would you permit the prosecution to drop charges, then?"

There was a muted sound of strangling from Curt Santorini. Cordoba pursed his lips. This might take time. Sweetpants had to be *judicial*. He sighed. He clasped his pudgy little hands and circled the thumbs around each other. He sighed again. "All right," he said, "that I would do. Reluctantly, I assure you, Jack, but . . . yes, that I would do."

Jack turned to Santorini. "Did you hear that . . . *counselor*? If I were you I'd get on the horn and call my boss." Jack turned back to Valentino. "That is, of course, if it pleases the court, Your Honor."

Valentino nodded. He hadn't yet run out of sighs, either.

Jack watched Santorini lift the phone on the judge's desk.

After Curt listened to Ben Scanlon on the phone, Cordoba and the prosecution worked out the details. While they dickered, Jack motioned Marty to a corner. She still appeared to be suffering

mild shock. "Marty," he said, "can you finish things up when Valentino reconvenes? I'm not ducking out on you and Luis, but there's something I've got to do which I may never get to do if I go right back in court."

"Sure, Dad." She blinked as if she were waking up. "How much do I tell Luis?"

Good question. The boy had to know everything sooner or later and it was Jack's responsibility. "Don't tell him anything. He's not going to be any happier than when I started after Heck. Less, if anything. I'll be in the hall when you leave court. Bring him to me . . . and I'll break it to him." She looked disappointed.

"Oh, hell," he said, "tell him as much or little as you want. After all . . . you're a full partner." He was sure from the look on her face he had made the right decision. He watched her follow Santorini into court, made his thanks to Cordoba, and went out the side door of chambers into the corridor.

He found a good place to stand and wait between the rear door of the courtroom and the bank of elevators. An armed guard nodded to him as he leaned back against the wall. This would be another first. For the first time he wouldn't stand beside his client for an acquittal or a dismissal. It was always a good moment. He hated missing it.

He heard bits and pieces of the last part of the hearing: Marty's clear voice; less of Santorini's now subdued and wounded squawk; the roar of disbelief when Valentino announced dismissal and adjournment.

The doors opened and the crowd began filing out. Some of them, almost certainly members of the press and other media people, ran past him, the women's heels clicking on the hall floor as they raced each other for the pay phones beyond the elevators. He knew he wouldn't see Heck or Graciela in this first lot; they would be at the defense table with Luis and Marty now, learning as Luis did, exactly what had happened. Orlando? Maybe, maybe not.

Joe Santorini was among the first two dozen people through the door. He didn't look at Jack. Fine. He wasn't the man Jack was waiting for.

The corridor was becoming choked, the crowd jamming up against the elevator doors, heads turning to look at Jack. Once the hall back-filled to the courtroom door he could miss his man. He stepped into the center of the mob. Two or three people looked as if they wanted to talk with him, but something in his face, he guessed, must have warned them off.

Then he saw the man he was waiting for.

The black man tried to edge past him, but Jack spread his arms and herded Hassan Kareem against the wall. He shot his canes out waist-high, and their rubber tips thudded against the marble, the canes and his thick arms making a cage of sorts around the man in the black suit and the opaque glasses. He turned his face toward Jack, and Jack saw himself mirrored darkly in the glasses. "Hassan Kareem?" he said.

The black man lifted his right hand and Jack braced himself. Try it friend. This is *my* turf. The man removed the glasses.

The sinister look vanished. Jack saw red-rimmed eyes crusted with the salt of tears. He was looking at a middle-aged man who was suffering some unknown agony.

"I haven't been Hassan Kareem for a year, Mr. Lautrec," the man said, his voice so soft Jack had to bend to hear him. "My name is Jackson . . . Ralph Jackson. I'm Cissy's . . . Lupe Sanchez's . . . father."

Jack lowered the canes.

People behind him were pounding him on the back, offering congratulations. Sally Bentley was clamoring for a statement and the TV cameras and their blinding lights were bearing down on him. "Mr. Jackson," he said, "I want you to come to my office tomorrow . . . make it this afternoon. You know where it is. I want to see you." Ralph Jackson nodded. Jack turned to Sally. "I'll give you everything you want, Sal," he said, "but as you know, I haven't spoken with my client since the

charges were dismissed." Jeanne Wayland was going to get this first, anyway.

He turned back to Jackson, but the man was gone.

When he reached the door to the courtroom the crowd had thinned. A few men and women still occupied the benches . . . the diehards, the real buffs who wouldn't leave until the last echo of the gavel had long since faded into silence. His own people were standing at the defendant's table. He had seen *happier* groups at dismissals. Even Marty looked wretched, no longer as confident and buoyant as when they had come here today with all the cards stacked against them. Graciela and Heck (and Orlando, too, by God) were between him and Luis, screening him, and Jack didn't see the boy for a moment. The sheriff's officer who had brought him over from BCMC had just turned to leave.

Then Heck stepped away to talk with Marty and the gap he left in the circle gave Jack a clear look at his client.

Luis saw Jack, too.

Well, Jack had to face the boy sooner or later. He pushed his way through the last of the spectators toward the group at the defendant's table. Luis's eyes never left him.

Lord, but he hates me now, even though he's free.

Then, even as it happened, Jack almost laughed out loud at how life was imitating art again . . . bad art. It all took place, it seemed, like the done-to-death slow motion of TV melodrama. Luis . . . leaping slowly toward the retreating sheriff's man . . . Luis . . . prying the revolver from the guard's holster . . . Luis turning the gun on Jack . . . Marty reaching Luis just as the flash blossomed at the muzzle of the gun . . . Jack *drifting* back . . . feeling the shot *bore* its way through his upper arm . . . all as slow as night falling . . .

The scorching pain, though, came fast enough, but it was nothing to the pain he still felt at the look from Luis Esquibel.

≡ 31 ≡

He found a letter on his desk from Orville Blakely telling him he had been rehired. Apparently he hadn't listened to Jack when he called him from the hospital. Orville had readily admitted he had sent Billy Bob Evans to blow him away. He had offered an apology of sorts—"Sorry, Lautrec. Kind of lost my head for a few days"— as if it had been nothing more than bumping into someone. Betty, not even knowing what Orville had put Billy Bob up to, had only driven the ex-con around. Orville in the letter hadn't put the rehiring of Jack as a request. There was just the flat, simple statement, "You're my lawyer, buddy. Get your ass up here." For a moment Jack didn't know whether to hide, laugh, or cry. He decided on the laughter. Oh, well . . . maybe he could get up the interstate to the penitentiary some time next week.

The flesh wound in his upper arm hadn't gotten the least bit infected as Marty and Dr. Steve Gregg feared, and he had been able to drive the Imperial, although not without a bit of discomfort, from the moment he left the hospital. He still fumed that Marty and Steve had talked him into staying overnight, and the rack would never get it out of him that he had slept for fourteen straight hours when he reached his apartment. Marty had called,

of course, and he had alibied his not answering the phone by telling her he was probably walking Marie-Louise. Well, he had done that . . . once.

Somebody from the Downtown Optimists, he saw in a note from Fran, had called to ask him to speak at lunch a week from Friday. Maybe he could con Marty into taking that one. He had done enough of that stuff in his time. Nice to know somebody wanted him again, though. Maybe.

A memo from Rudolfo said that Judge Bateson in Ponderosa County wanted to be remembered. Pretty cute, Rudolfo. You must have won your case up there or you wouldn't have passed the judge's greeting on. Congratulations. We'll have to add a name to that ridiculous sign . . . and soon.

Damn it! He sure wished he could have had a longer face-to-face talk with Ralph Jackson before he left the city instead of merely the one in the hospital room when Jack was still groggy. Funny how you could establish kinship with some men in less than half a minute.

"He's gone back to New York?" He blurted it out as Marty walked through his door.

"Who?" she said, looking blank, then, "Oh sure, Ralph Jackson. Yes, he left late yesterday."

How could Ralph have slipped her mind even for an instant? The man had kept fear and suspicion alive in her for over a month, and the moment he turns out to be a "real sweet man" (her words) he's forgotten. That was the young for you, so anxious to leap into tomorrow they swept today aside, and as for yesterday? Forget it, Pop . . . ancient history.

"Yep," Marty was saying, "Strong and Thorne cremated her after he claimed the body, and as soon as he picked up the ashes he hit the road. It was right after he bought me lunch. He'll take her back to the old neighborhood in Harlem. Scatter her ashes off some tenement roof, I guess." She shuddered. "Poor Cissy. Cruddy end for all that glamour."

Cissy? Sure. Why not. There always had been a touch of "good riddance" to "Akidha" and "Lupe Sanchez." If she was Cissy to

Jackson and his family, she should be Cissy to all the world, even dead . . . especially dead.

Jackson, it turned out, was who the girl had been talking to from the motel in Las Cruces when Heck had walked in on the conversation. Out of habit, Jack guessed, she still hadn't told her father where she was when she called him, or hadn't quite believed him when he told her the Scimitars—which he had quit himself—were no longer looking for her. Ralph had heard the operator say "Las Cruces" and "Doña Ana County" and the name of the state and he had gone there on his vacation to surprise her.

Drawing a blank in Las Cruces he had used the downstate city as a base while he searched for her, and that was why Fran hadn't found him. It would have been easy if she had looked in that direction. He must have been the only black visiting in or near Las Cruces then.

He had read the story of the "bosque murder" in the *Journal*'s downstate edition and on a sickening hunch had come to Albuquerque looking for her. When he found Jack was Luis's lawyer he had tracked him, first at the office and the apartment and then at the house in Griegos, which, after the police pronounced it the scene of the crime, he had been trying to work up enough nerve to break into himself.

"He should have made himself known to us," Marty said.

"Well, Marty, he didn't *know* the murdered girl was Cissy, and then, face it, this is white man's country, and to Ralph Jackson pretty damned peculiar white man's country. And he did try, here in the office with Fran."

Marty laughed. "Do you remember how she said he 'made' her tell her where we were and that she couldn't explain it?"

Jack laughed, too. "I suppose it was an odd combination of his fundamental decency and the fact that those dark shades made him look like so sinister. He doesn't appear the least bit vindictive. Willing to let the law deal with his daughter's murder. All he wanted to do was take her home."

"Pity he didn't get here sooner and take her home alive."

"Never was much chance of that," Jack said. "My guess is that she had already made up her mind to fly with Heck, and in the open, the first moment she ever felt she was off the hook with the Scimitars. She was a victim from the beginning."

"Do you give much thought to the victims when it's over, Dad?"

"Depends who the victims are. Cissy? Sure. This one's got lots of victims, though. Luis. He went through hell, and he's starting another trip through it because of what's apt to happen to Ana. The Esquibels. Ralph."

"Heck, too, I suppose," Marty said. "He's washed up. In more ways than politics."

"Can you handle that?"

"Sure, Dad. I actually handled it earlier . . . and better . . . than I knew. But thanks for asking."

She was studying him as they spoke, and he knew there was something else on her mind. He could tell the exact moment when she decided to let it out.

"There's a victim we haven't talked about," she said.

"Who's that?"

"You."

"Me? How so? You mean this little nick?" He tapped his arm.

"No, not that. I'm talking about a bigger wound."

He wasn't entirely sure he liked the way this little chat was going, but he felt powerless to stop it.

Marty went on, "This case turned out to be every bit as bad as I thought it would. You staked everything, went through agonies, just to keep that kid from serving another day in jail . . . and the damned fool puts himself right back in D. I know he won't be there long, particularly since you've asked Ben to go easy on him . . . but the thought of him being there at all . . . well, don't kid me, I know it hurts. It must hurt, too, that of all the attempts on your life the one that came closest was made by the client you rescued."

"Breaks of the game. Way the ball bounces." He tried for a laugh. It didn't come. "It's not a total loss. He'll be free. As for

me, I'm alive . . . thanks to the way you hit his arm and then held him until that guard jumped in."

"You knew it was Ana before the letter arrived, didn't you?"

"Yes."

"When exactly?"

"Unconsciously, right after I asked her to talk with Orlando. I didn't want to believe it. Then, against all my expectations, Orlando showed up in court. When I suggested in my cross of the M.E. that a woman might have done it, and Orlando promptly offered to confess, I knew he'd figured it out, too."

"Why did Orlando take that shot at you?"

"As we thought, because I was after Heck, or so he says. I wonder. Perhaps he knew Ana was the killer even then. Now I realize he was actually relieved, happy, when I went to the store and accused him. He's still trying to tell Gilman *he* did it. The real irony of all this is that if people hadn't been trying so hard to protect other people, we would have ended up with an unsolved murder."

"How do you think it will go for Ana?"

"Hard to tell, Marty. A lot depends on what she gave Scanlon in her statement."

"But her letter to you—"

"Doesn't count. It wasn't read into the record in court, remember. Valentino was so miffed about Ben dropping charges he forgot to ask me for it. When it comes right down to it, nobody's seen it but you and me."

"Dad," Marty said, "how are *you* now?"

"Me? Fine. Just fine."

"No letdown?"

"A little, maybe. Nothing I can't take in stride." Damn it! She was getting back on *him* again, but he could hardly tell her to lay off without putting her nose out of joint.

"Why don't you take some time off?" she said.

He shrugged. "Might."

"Might? What's there to stop you?"

"Got a few things to do." It sounded evasive to him, too. He got an idea. He told her of Orville's letter. She laughed. Good.

"If it was anyone but Orville I'd be worried. He'll probably fire you again before you can get up to see him."

"Yeah."

"What *are* you going to do now, Dad?"

He squirmed a little. Beautiful and caring or not, he wished to hell she would get off this tack and go file a breach-of-contract brief or something.

Fran buzzed and when her voice came over the intercom his heart fell. He hadn't meant to leave the speaker on.

"Call for you on line one, Jack. From the detention center. Woman's voice. Wouldn't say who she was."

Marty stared at him, her eyes perfect circles.

"Dad! You promised. You said Luis would be the *last*."

"Never promised. Said he might be."

"Who is it?" Her voice was thin, piercing . . . deadly.

He didn't answer.

"It's Ana, isn't it?"

"Well . . . ," he said, "I . . . I . . . suppose so. Yes." He was *stammering*. He had better hurry and get it all out. He might not get another chance to speak. "You see, Marty, I've got this idea Ben might have hell's own time making a charge of murder one stick. If Ana's been as uncooperative as Luis was, or anywhere near it, I might get any initial confession thrown out. And maybe there's a self-defense angle we could exploit." The "we" had slipped out, but it might not be a bad tactic to let it stand. "Sure are plenty of extenuating circumstances. Ana's *home* was threatened. That stuff goes over big with a jury, and of course *her* case will get that far. We can pack the box with nice family ladies, the kind most panels are heavy on because they're the good citizens who don't shirk jury duty. What it comes down to is that everyone is entitled to the best—"

". . . *Defense they can get!* Balls! Balls and baloney! God damn it! Don't you realize that taking Ana Esquibel on as a client after dragging her into this mess is *unethical*?"

He stood mute. It didn't save him.

"You S.O.B.! You low-life, dirty, rotten, double-dealing . . . you *fink!*"

There was more, lots more. Some of it wasn't quite that nice. Where on earth do they *learn* such language? He lifted a cane as if to defend himself and at last she stopped. "Daughter," he said, "why don't you get married and raise a family?" She sputtered, but couldn't bring herself to start again, and he went on, "Would you mind leaving my office now? I have a call to take . . . from a client."

She stormed out, uttering a choked cry of frustration.

Fran, he figured, must be scared witless.

He was wrong, he discovered as he left the office. Fran was shaking with laughter.

On the way to the Imperial he reflected that the defense of Ana Esquibel would be a lot different from that of her brother. Well, in some ways it was easier to defend the guilty than the innocent. You knew where you stood at any given moment, and as Samuel Johnson once said, your powers of concentration were improved enormously.

He would begin putting her at her ease by telling her how decent Ben was being about Luis. A suspended sentence and probation after pleading guilty on the assault charge was the worst the boy could expect. He wouldn't tell her he had already phoned Malcolm Colberg, the lawyer who was handling things for Luis on contract with the public defender's office, and that Colberg, a good man and attorney, was ecstatic when Jack offered help from behind the scenes. He would have liked Ana to know this, but that would make three of them in on the secret. Marty might sniff it out.

In the middle of the parking lot he stopped.

Yes, he could feel it. Marty must have come into the lobby to watch him leave. He could feel the laser beams of her blue eyes in the middle of his back. Ah, well. Perhaps she would feel kindlier toward him when she unburdened herself to Fran as he knew she would, and discovered that he was taking Fran to Trombino's

for dinner when he returned from D. It was only, he told himself, a way of saying thanks to Fran for her help with Bonnie McCabe that awful night. That truly was all it was, wasn't it?

Still, there was a shade more spring in his old legs than there had been in weeks. There wasn't, of course, enough for him to dance a full-scale jig for Marty's benefit, but . . .

. . . Maybe, if he planted the canes just right, he could manage a little soft-shoe time-step . . .